SOUTINE'S PORTRAITS

Cooks, Waiters & Bellboys

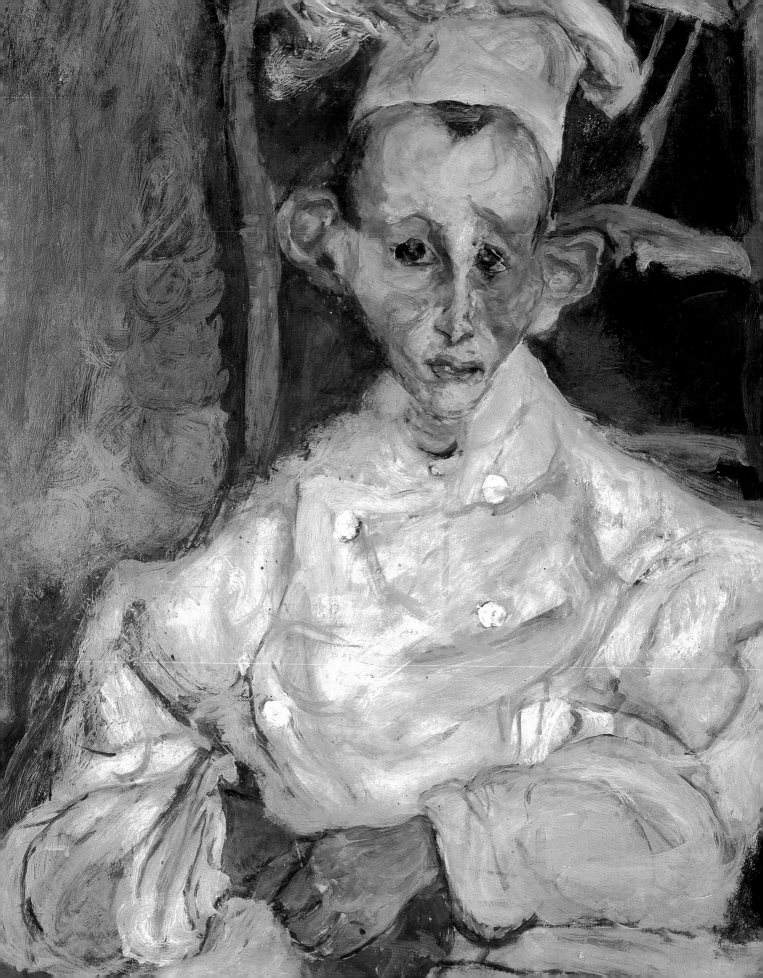

SOUTINE'S PORTRAITS

Cooks, Waiters & Bellboys

EDITED BY
Karen Serres and Barnaby Wright

CONTRIBUTORS
Merlin James, Karen Serres
and Barnaby Wright

THE COURTAULD GALLERY
IN ASSOCIATION WITH
PAUL HOLBERTON PUBLISHING

First published to accompany the exhibition

SOUTINE'S PORTRAITS
Cooks, Waiters & Bellboys

The Courtauld Gallery, London
19 October 2017 – 21 January 2018

The Courtauld Gallery is supported by the Higher
Education Funding Council for England (HEFCE)

ISBN 978-1-911300-21-2

British Library Cataloguing in Publication Data

A catalogue record for this book is available from the British Library

Produced by Paul Holberton Publishing
89 Borough High Street, London SE1 1NL
WWW.PAULHOLBERTON.COM

Designed by Laura Parker

Printing by e-Graphic Spa, Verona

Front cover: detail of cat. 8
Back cover: detail of cat. 4
Frontispiece: detail of cat. 4

CONTENTS

Chaïm Soutine (1893–1943)

FOREWORD

Although I can claim no credit for this wonderful exhibition, it is nevertheless the fulfilment of a longstanding personal ambition. In 2005, accompanied by Barnaby Wright, one of the exhibition's co-curators, I was invited to view Chaïm Soutine's *Pastry Cook of Cagnes* (cat. 4) prior to its sale at auction. The immense pathos and dignity of Soutine's anonymous and awkward young cook in his oversized uniform made an indelible impression on me. We began to consider what might be learned from an exhibition uniting Soutine's portrait series of hotel and restaurant workers, to which the picture belongs. It was striking to discover the degree to which Soutine's oeuvre remained under-researched and, equally, that there had not been an exhibition of his work in the United Kingdom for some 35 years, let alone one dedicated to this outstanding series which had helped launch the artist's career. The Courtauld Gallery seemed an ideal setting for this project. Not only is it home to paintings by Soutine and his close friend Modigliani, but also by Van Gogh and Cézanne, with whom the artist was often compared, as well as the earlier traditions of painting out of which much of his creativity sprung.

Soutine's Portraits is an eloquent expression of The Courtauld Gallery's particular approach to exhibitions, which distinguishes itself by its combination of quality and close focus. Paradoxically, such focused projects are often more challenging to arrange than larger exhibitions, as their integrity depends on the group of works under consideration being presented more or less in full. In meeting this conceptual and financial challenge we rely heavily on the generosity of our supporters and the goodwill of lenders from around the world. The Courtauld is profoundly grateful to the institutions that have so very generously shared important works in their care. Many of the paintings in the exhibition remain in private hands and we wish to record our deep gratitude to their owners for the vital contribution that each has made to this project. Colleagues and friends helped in arranging a number of loans, and particular thanks are due to Nicholas Maclean.

For this exhibition we have once again received generous support from the Garcia Family Foundation, whose loyalty to the Gallery has been an important part of its successful programme. The Friends of The Courtauld have, as always, proved themselves indispensable. We also thank the Robert Lehman Foundation for its support of the catalogue. Equally, I would like to record my thanks to Daniel Katz for his long-term sponsorship of the post of Curator of 20th-century Art at The Courtauld, without which activity in this crucial area of the Gallery's collection would be very much reduced. We are greatly indebted to these and other supporters for sharing our ambition to realise this project at the highest level of quality.

The exhibition is the achievement of The Courtauld Gallery's immensely dedicated professional staff: technicians, registrars, conservators, marketing and publications colleagues and others. I am pleased also to thank Merlin James for his insightful essay. *Soutine's Portraits* has been led by co-curators Karen Serres and Barnaby Wright of The Courtauld Gallery. Their deep critical engagement with the works themselves and their energy and determination have resulted in an exhibition that The Courtauld feels immensely privileged to present to its visitors.

ERNST VEGELIN VAN CLAERBERGEN
Head of The Courtauld Gallery

EXHIBITION SUPPORTERS

The exhibition has been sponsored by

The Friends of The Courtauld

The Garcia Family Foundation

Support for the exhibition catalogue has been provided by

The Robert Lehman Foundation

Daniel Katz Curator of 20th-century Art

The post of one of the exhibition's curators,
Dr Barnaby Wright, is funded by Daniel Katz. The
Courtauld would like to thank him warmly for his
continued and generous support of this position.

The Government Indemnity Scheme

This exhibition has been made possible by the provision
of insurance through the Government Indemnity
Scheme. The Courtauld Gallery would like to thank
HM Government for providing indemnity and extends its
thanks to the Department for Culture, Media and Sport,
and Arts Council England for administering the scheme.

SAMUEL COURTAULD SOCIETY

ACKNOWLEDGEMENTS

It is a pleasure to express our gratitude to the many individuals and institutions that have made this exhibition possible. Thanks are due to museum colleagues who have generously lent their works to the show: Janne Sirén, Holly Hughes and Cathleen Chaffee (Albright-Knox Art Gallery, Buffalo); Sarah MacDougall (Ben Uri, London); Matthias Frehner (Kunstmuseum Bern); Christoph Heinrich and Rebecca Hart (Denver Art Museum); Fanni Fetzer and Heinz Stahlhut (Kunstmuseum Lucerne); Bernard Blistène and Brigitte Léal (Musée national d'art moderne, Centre Pompidou, Paris); Laurence des Cars, Cécile Girardeau and Sylphide de Daranyi (musée de l'Orangerie, Paris); Brian J. Ferriso and Sara Krajewski (Portland Art Museum); Matthias Waschek and Jon Seydl (Worcester Art Museum). We are equally grateful to the Im Obersteg Foundation and to Kunstmuseum Basel for facilitating their loan; to the Lewis Collection; and to other private collectors who agreed to entrust their works and share them with the public. In assistance with loans, we benefitted from the invaluable help of Nicholas Maclean, Jörg-Michael Bertz, Simon Capstick-Dale, Stephane Connery, Claudius Ochsner, Pilar Ordovas, Thomas Seydoux, Simon Stock and Jay Vincze, as well as MAGMA Europe.

Many people have offered support, advice and expertise for this exhibition project at various stages of its development. We are particularly grateful to Jérome Delatour, Vincent Gille, Alison de Lima Greene, Michel LeBrun-Franzaroli, Bruno Mottin, Jean-Baptiste Pisano, Pierre E. Richard, Roxane Sperber, Alexandre Tessier, Nina Zimmer and the staff of the Bibliothèque nationale de France and Bibliothèque historique de la ville de Paris. At The Barnes Foundation, Sylvie Patry, Amanda McKnight, Barbara Buckley and Anya Shutov were generous with information and support. We also wish to thank Maurice Tuchman and Esti Dunow for their encouragement and benevolence.

The catalogue was enriched by Merlin James's insightful contribution and we would like to express our thanks to him. For their work on the production of this catalogue, we are immensely grateful to Paul Holberton and Laura Parker. Belinda Moore undertook the exhibition graphic design with her usual creativity.

Exhibitions at The Courtauld Gallery are always the result of teamwork. We wish to thank in particular George Mogg for her organisational expertise, Graeme Barraclough, Julia Blanks, Emily Dodgson, Kate Edmondson, Rosamund Garrett, Amy Graves, Annabel Harrison, Jack Kettlewell, Karin Kyburz, Gerlind Lorch, Caireen McGinn, Matthew Thompson and Ernst Vegelin van Claerbergen. Our thanks go to Henrietta Hine and her Public Programmes team: Stephanie Christodoulou, Helen Higgins, Anne Puetz and Mark Willetts. We are greatly indebted to Kary Kelly and her colleagues in the Development Office, notably Margot Black, Sophia James, Lila Kanner, Pia Rainey and Giulia Sartori Conte, and to the press relations team at Sutton.

Detail of cat. 10
Overleaf: details of cat. nos. 14 and 18

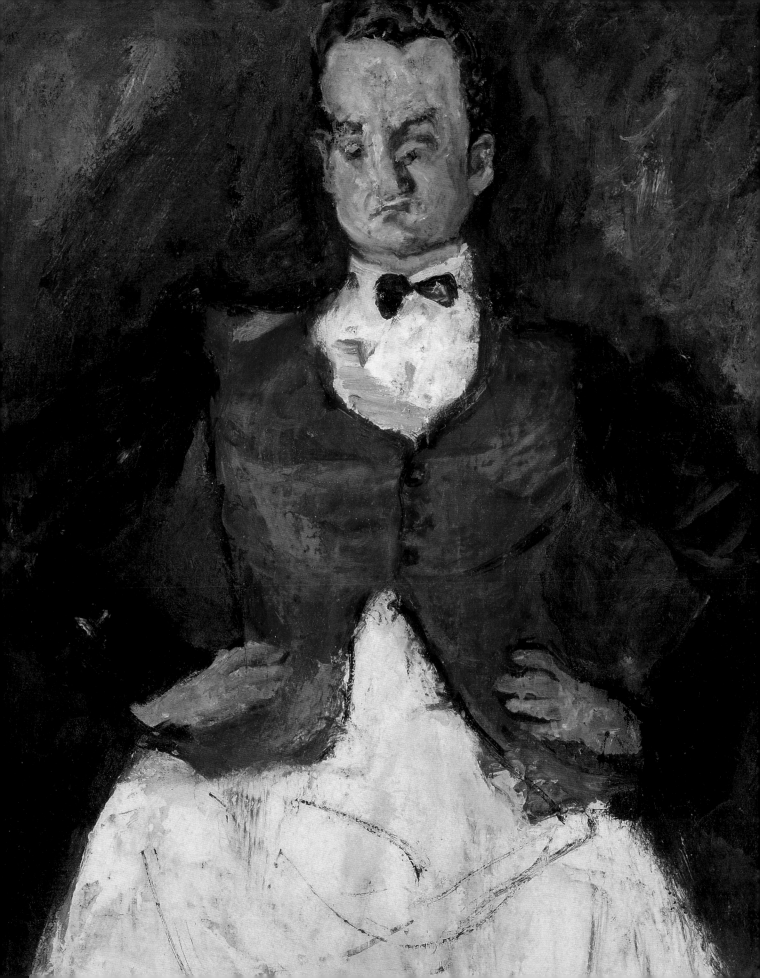

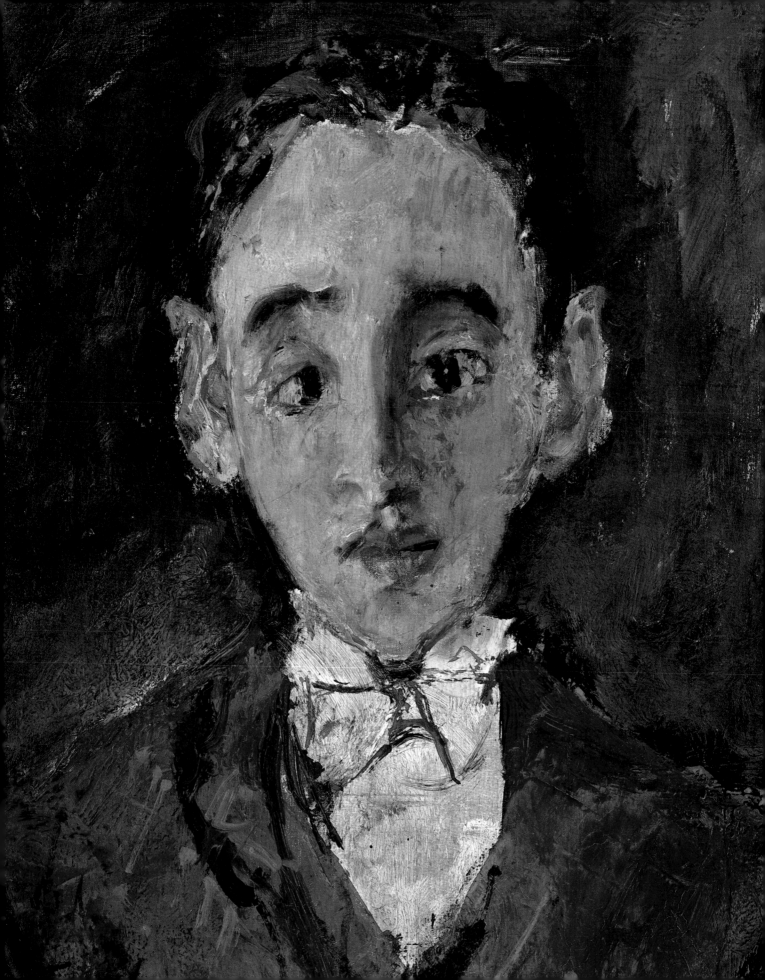

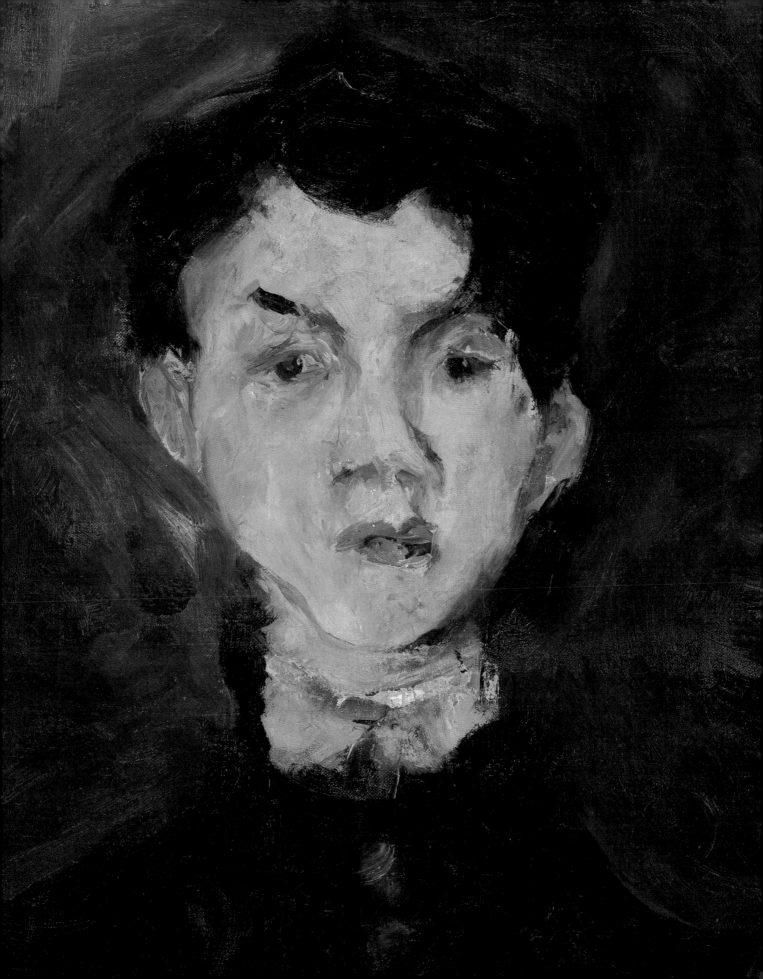

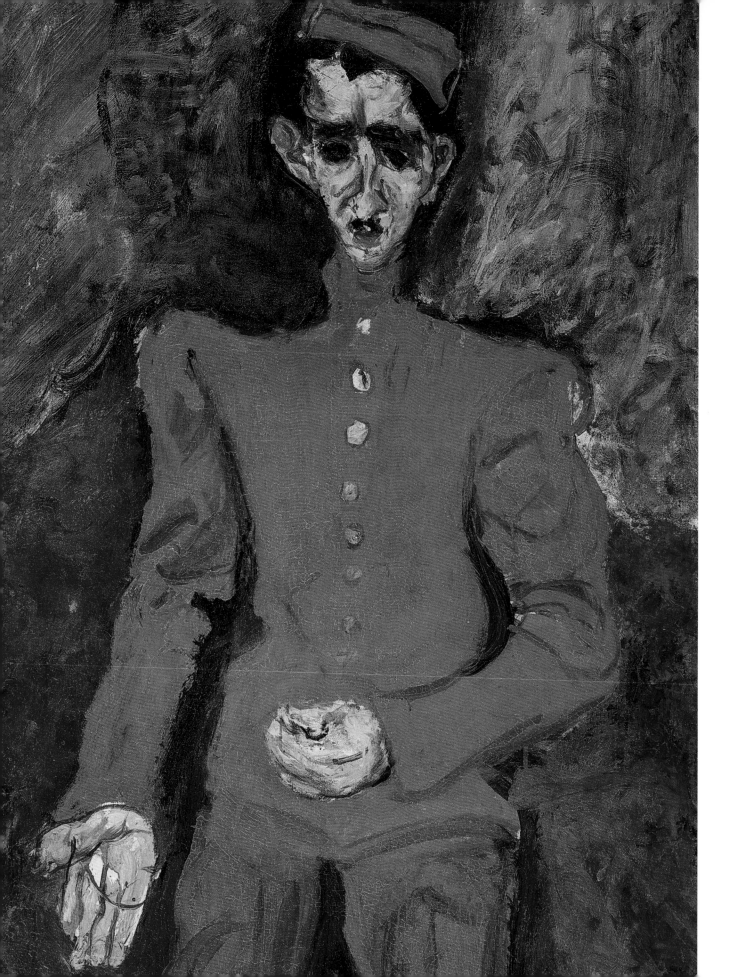

INTRODUCTION
SOUTINE'S MISFITS

Barnaby Wright

IN THE SPRING OF 1913, Chaïm Soutine (1893–1943) arrived in Paris as a penniless young artist from the Lithuanian region of the Russian Empire.[1] Originally from the small town of Smilovitchi, the twenty-year-old had recently completed studies at the art academy in Vilnius. His ambition now – along with that of many others who made similar journeys to Paris from around the world at that time – was to become a painter in the capital of the arts. Among the many sights he will have encountered were the uniformed lives of the countless working men and women of the hotels, restaurants, cafés, clubs and shops that populated the city. Like Soutine, many of these workers were immigrants in the modern metropolis in search of opportunity. Their particular uniforms – from kitchen whites to bellboy reds – identified the role and place they had each found, for now, within the vast working life of Paris. Such people would become one of Soutine's major artistic preoccupations. His extensive series of portraits of them are unique and highly distinctive contributions to painting in the twentieth century. Over a long decade, throughout the 1920s and early 1930s, pastry cooks, cooks, butchers, waiters, grooms, valets, room service staff, bellboys, page boys and maids are recurring figures in Soutine's painting. He completed at least thirty canvases from these subjects, each painted directly in front of the sitter. These uniformed people proved to be a vital motif for Soutine to which he returned repeatedly in order to test and further his powers as a painter.

These portraits also played an important role in establishing and furthering Soutine's reputation as an artist. Indeed, one of the very first of these paintings, *The Pastry Cook* (fig. 1), was instrumental in transforming Soutine's fortunes, elevating him from obscurity to fame in the Parisian art world when, in 1922–23, after seeing this work, the American collector Dr Albert Barnes made the dramatic

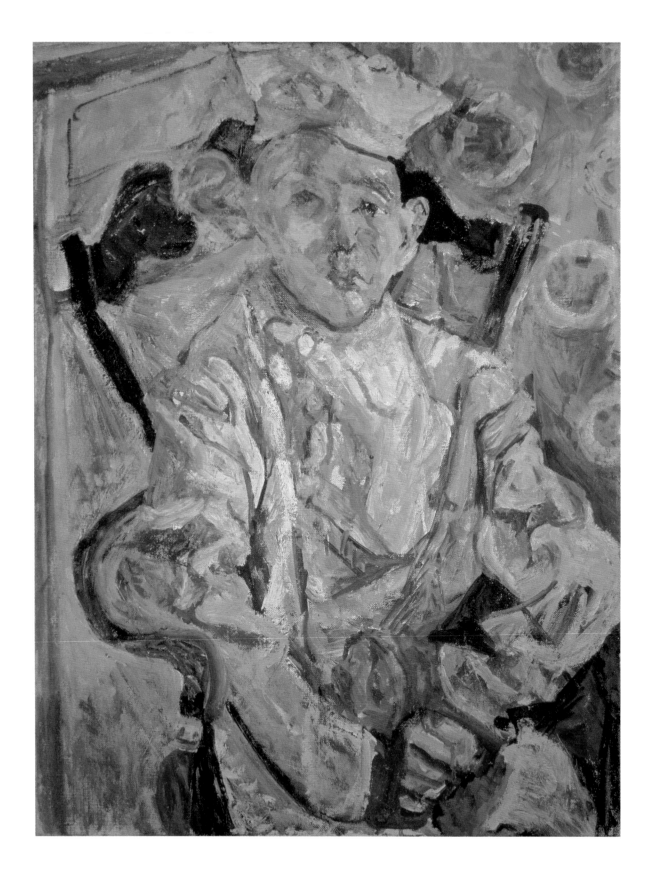

purchase of more than fifty of the artist's canvases. Soutine's hotel and restaurant worker portraits have long been closely associated with his name. In large part this is because the motif is unique to him – no other artist of the period made these modern workers a significant subject of their art. Also, from the outset, works from the series have featured prominently in important publications and exhibitions devoted to him. His *Page Boy at Maxim's* (cat. 9) featured as the front cover image of one of the earliest monographs on him, published in 1929, and his *Little Pastry Cook* (cat. 6) was the catalogue cover for the influential retrospective exhibition at the Museum of Modern Art, New York in 1950, which made a significant impact on artists and writers associated with Abstract Expressionism. Another pastry cook (cat. 4) featured as the front cover of Soutine's first major museum retrospective in Paris in 1973.[2] Despite acknowledging the portraits' importance, the writers on Soutine who shaped his reputation during his lifetime and posthumously tended to focus their discussions on other motifs within his oeuvre, such as his landscapes and his group of beef carcasses. More recent accounts and exhibitions, which have almost always been surveys of Soutine's career, have recognised the prominent place of these portraits without examining them in greater depth.

In this publication – and the exhibition it accompanies – we have brought together for the first time a large and representative group of these paintings of hotel and restaurant staff. We have done so in order to try to better understand their context and significance as modern portraits; to consider why this unusual motif in its various guises was so compelling for Soutine; and to examine their particular qualities as paintings. In the essays that follow, Karen Serres looks in detail at the occupations and working lives of Soutine's uniformed sitters in order to extend our knowledge of the contexts that frame his representations of them. Merlin James gives fresh and close readings of the paintings to elucidate how they operate as portraits capable of carrying the weight and shifting forms of human experience. In this introduction, I set the paintings within Soutine's artistic life and development, and the particular culture of French art during the years of national recovery after the First World War. My aim is not to fold the works back into his biography as the determinate of their meaning, but to demonstrate

how rich and multifaceted they are as portraits, especially when thrown into relief by the wider context in which they came into being. This project is an opportunity both to explore the significance of the hotel and restaurant worker paintings specifically and, more generally, to advocate the rewards of looking again at Soutine's achievements as a modern painter.

SOUTINE painted his boldly liveried hotel and restaurant staff during a period of recovery and reassessment in France after the devastation of the First World War. The rebirth and flourishing of the French leisure industry that occurred during this time – from its bohemian cafés to its stately grand hotels – were important parts of the country's economic and cultural rehabilitation. Behind the glitz and glamour of the Roaring Twenties in Paris were deep anxieties about the make-up of French national and cultural identity. Like the classical façade of one of its grand hotels, there was a desire to project a newly emboldened image of French culture as solid and rooted in past tradition. But like the inside of that same hotel, such efforts had to accommodate a complex social, cultural and international mix.

Discourses within the French art world during this period often revolved around questions of what constituted a French tradition of painting and how this might be translated into contemporary practices. There was much discussion about identifying fundamental – often classically inspired – aesthetic values, such as harmony, order and structure, that might define a distinctly French culture. Furthermore, was it possible truly to be part of this culture if you were not French? This question of cultural assimilation of non-nationals became a major issue, reaching fever pitch during the later 1920s and 1930s. The Parisian art world, with its huge influx of foreign talent, was an important testing ground for these concerns.[3]

As a Jewish émigré and an uncompromising modern painter, Soutine became caught up in the crossfire of these cultural debates as he rose to prominence in Paris. From the outset, he painted turbulent and emotionally intense canvases across a range of genres, from landscape to portraiture and still life. To his detractors, his work appeared wild and violent – "monstrosities" and "multi-

coloured nightmares", according to one critic.[4] However, his supporters argued strongly for the vitality and visceral authenticity of Soutine's approach. His early champion Élie Faure described his paintings as "an embryonic organism of Soutine – a human face, a piece of clothing, landscape, still life – gives off a profound heat, which makes the open flame of the brightest coloured decorations look pale in comparison".[5]

Influential early writers on Soutine got carried away with describing him as an untameable outsider.[6] He was said to have rebelled against his Jewish background, with its assumed prohibition on image-making, and, coming to Paris from Lithuania, to have been unleashed as a highly instinctive artist who set upon his subject-matter in a frenzy of expressive hunger and passion: according to one critic, "Soutine received the gift of painting at birth, but this gift burned his eyes and brain like a red-hot branding iron. He loves his torment, but it is a torment. He makes the canvas, the colours, the world of his pain suffer."[7] He was deliberately run against the grain of his times, at odds with those post-War reconstructive values of structure and harmony rooted in the French artistic tradition.[8] As his early supporter Waldemar George put it, "Soutine owes nothing to France, except his thirst for internal harmony, which, thank God, he will never attain".[9]

This image of Soutine as the rebellious outsider was further heightened by the fact of his deep engagement with exactly the same European artistic tradition – enshrined at the Louvre – that was venerated by many as underpinning core values of French cultural identity. The Louvre was a vital inspiration and touchstone for Soutine and he visited the museum regularly. His early reception sketched a picture of Soutine dining at the same table as his French contemporaries but as the excitingly (or despicably) uncouth foreign guest. None of Soutine's works fit this image better than his series of canvases of beef carcasses (see, for example, fig. 2), made in emulation of Rembrandt's *Flayed Ox* (1655; Musée du Louvre, Paris), but painted from a real carcass, hung up bloody in his studio. It is no surprise that these and other related works garnered much early attention.

Soutine was not the only immigrant artist in France to find himself hotly debated as an outsider, of course. At the moment of his rise to

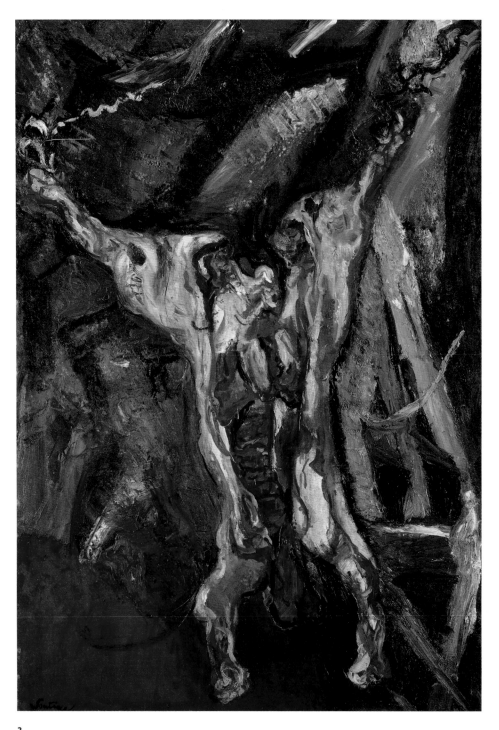

2

prominence, in the middle of the 1920s, the enduring designation 'École de Paris' was coined in order to describe stylistically disparate artists (often Jewish), including Soutine, Amedeo Modigliani and Marc Chagall, who worked in the capital but were not necessarily French. However, Soutine's reputation was perhaps the most unsettled of all the École de Paris artists and his work the most disruptive for many. As Christopher Green has concluded of Soutine in his major survey of twentieth-century French art, "No foreign artist in France in the period related more intensely yet awkwardly to the French world he lived in …".[10]

Soutine was a misfit. Looking along the line-up of his portraits of hotel and restaurant staff, it is clear that they are misfits too. Far from resembling the ostentatious façade of the grand hotel, they appear uncomfortable in their uniforms. Awkwardly posed in emulation of great men from historical portraits, they do not seem quite to belong to the world of portraiture. The sitters are often young and gawky, and at the outset of their working lives. They may appear innocent and vulnerable, edgy and brash or prematurely aged. Those that are older are either world-weary or else stand-offish and confrontational. Sometimes opposing characteristics are present in a single portrait. Usually depicted against a blank or nondescript background, the individuals are divorced from their places of work. Out of time and place but still in their historically inspired liveries, they somehow look both modern and anachronistic as working people and as portraits.

The obvious thing to say is that Soutine was drawn to these people because he saw something of himself in them, or something of his own situation – an outsider who did not quite fit the mould. Perhaps he did, but aside from the paintings he left us no account of his personal interest in these sitters. What the paintings reveal is an artist deeply affected by the traditions of portraiture and highly sensitive to the fraught reality of painting directly from a living person.

Getting sitters to pose in their occupational liveries, Soutine set himself the triple challenge of painting a specific individual but as a uniformed type and within templates of artistic tradition.[11] If Soutine's beef carcasses were seized upon by early writers to build an image of him as a raw and highly impulsive artist working

in a frenzy, then the layered complexity of these portraits is less straightforward to account for in such terms. Perhaps this is the reason they were not given such critical attention; they did not quite fit the projected image.

As I hope to demonstrate in this account of their development, these portraits reveal, in their creative misfits of depiction, that whilst Soutine may have painted with urgency and great intensity, he was a profoundly considered artist who thought deeply about the nature and artifice of painting. The portraits are redolent of the complexities of their times, with issues of tradition, modernity, cultural identity and dislocation all agitated by the emotion and intelligence of Soutine's brush.

SOUTINE produced a number of figure paintings during his first few years in Paris but it seems he did not paint working people in uniform during this initial period. Food and flowers were recurring motifs for him at this time, perhaps out of wishful thinking as he scratched a poverty-stricken existence with friends on studio floors in Montparnasse through the appalling years of the First World War. He first bunked with other artist immigrants at La Ruche ('the Beehive'), a studio commune set up to give struggling artists a start in life. It was flea-ridden and filthy but home to considerable young talent: Chagall, Ossip Zadkine and Alexander Archipenko were all neighbours there. In 1915, Soutine was introduced to Modigliani and the two artists quickly became close friends. Modigliani firmly believed in Soutine and championed his work. Whilst others found Soutine's character disagreeable and his painting ugly, Modigliani saw something profound in both.

Weathering considerable scepticism, Modigliani persuaded his own dealer, Léopold Zborowski, to take on Soutine, and their combined support saw him through the war years. Despite very few sales, in 1919 Zborowski agreed a contract with Soutine, providing him with a tiny daily stipend of five francs. In August of that year, Zborowski sent four of Soutine's canvases, along with works by Modigliani and others, to London, for an exhibition of contemporary French art at Heal & Son's Mansard Gallery in Tottenham Court Road.[12] Although rarely cited, it is probably the

very first time Soutine's work appeared in a public exhibition. In 1919, Zborowski also arranged for Soutine to leave Paris for a period; he would stay for about three years in the southern French town of Céret in the Pyrénées, with various trips back to Paris and to Cagnes-sur-Mer on the Côte d'Azur. Céret was already part of the story of one of modern art's recent major breakthroughs, Cubism, with Pablo Picasso and Georges Braque having worked there previously. Zborowski must have hoped something of its magic would rub off on Soutine.

Soutine's years in Céret did indeed prove to be a time of significant artistic development for the painter. He greatly extended the expressive range and intensity of his painting, producing landscapes, portraits and still lifes there. He also painted what is probably his first portrait of a worker in uniform, *The Pastry Cook* (fig. 1).[13] The young man of this portrait was one of a number of local people in the town who agreed to sit for Soutine. He has been identified as Rémi Zocchetto, a seventeen-year-old apprentice pastry cook at Céret's Garetta Hotel (fig. 17).[14] The portrait would lead, over the next decade and more, to Soutine painting other cooks and a wide variety of different types of hotel workers from a range of establishments in Paris and elsewhere. However, Zocchetto is the only uniformed sitter to have been securely identified by later research and associated with a particular hotel. Soutine must have got to know these sitters to some degree but he chose not to attach their names to the portraits.

This Céret pastry cook was an important part of Soutine's deepening interest in the possibilities of portraiture during these years. It was probably preceded by his *Self-portrait* (fig. 3), in which Soutine presents himself standing in front of a canvas with a painting of a man on the back of it. It is a sort of double portrait of the artist and his work. It is also a knowing identification with similar self-portrait conceits by old and modern masters, from Rembrandt and Goya to Vincent van Gogh and Paul Cézanne. Cézanne's *Self-portrait with a Palette* (1885–87; E.G. Bührle Foundation, Zurich) is particularly close, with its own smudgy suggestion of an image on the back of its depicted canvas. Soutine may have also had in mind one of France's most celebrated artists, Nicolas Poussin, whose famous *Self-portrait* in the Louvre (1650)

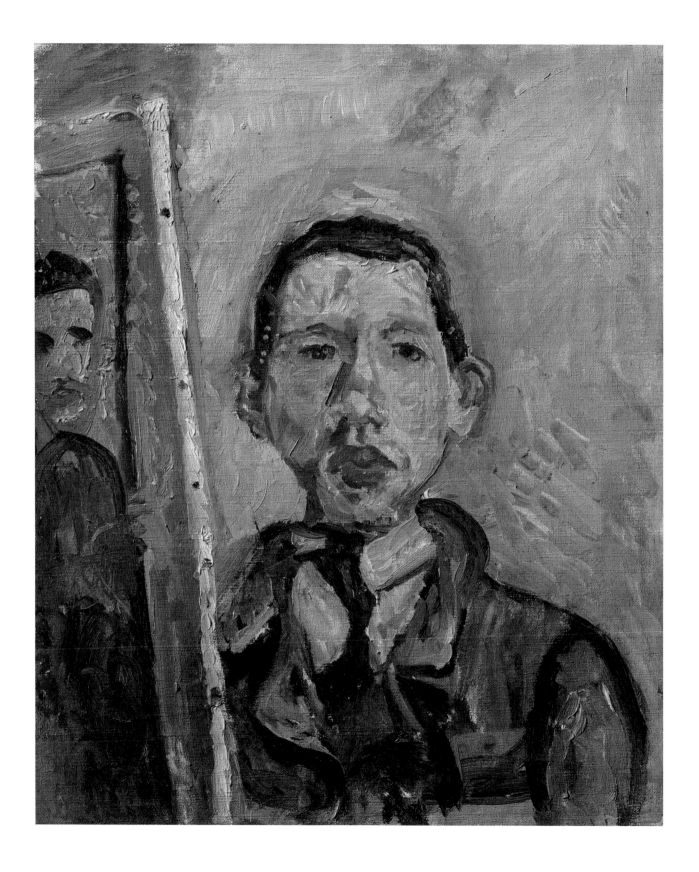

presents the painter amidst a stack of his own canvases, one with a painted figure to the left edge. The play of mirroring and doubling that Soutine engages with in his own *Self-portrait* was a familiar expression of artistic contemplation. But it is significant that he acted it out for himself at this time, when his ambitions for his own contribution to the tradition of portraiture were growing. The painting is more than self-reflection, it works across the territory of portraiture as a genre; Soutine moves between the roles of artist, sitter, painting and viewer. He was clearly thinking hard about where he stood as an artist and how his work might define him.

THE THEME of the relationship between an individual and their work carries into the first Céret pastry cook and is continued throughout the series of uniformed portraits (Soutine's *Self-portrait* could almost be considered one of the group). Central to these works is the interplay between our sense of the sitters as individuals and as working types in uniform. From the outset with Zocchetto in his cook's whites and continuing with the later portraits, Soutine seems to feed off the tensions between the idiosyncrasies of the person and their presentation in the standardised packaging of the uniform. In the case of this early portrait, it was surely the white of the uniform itself that gave Soutine an appetite to make the painting. Breathing life into a single concentration of colour challenges a painter to look deeply and to resist the deadening pall of monochrome. Here, white has the potential to bleach out and return the blankness of the canvas, just as the uniform threatens to snuff out the individuality of its wearer. In Soutine's hands, the uniform is anything but pure white. The jacket becomes a deeply riven landscape of numerous greys and coddled whites, cut through with slashes and strokes of blues and muddied yellows. His attraction to the possibilities of monochrome would continue in the years ahead as he moved through the palette of uniforms worn by his many subsequent sitters.

The Pastry Cook (fig. 1) is a particularly full expression of the highly original approach to painting that Soutine was developing rapidly in Céret at this time. His way of working is most often discussed in relation to the landscape paintings he made from motifs in and

3
CHAÏM SOUTINE
Self-portrait, c. 1918
Oil on canvas, 54.6 x 45.7 cm
The Henry and Rose Pearlman
Foundation: on long-term loan to the
Princeton University Art Museum

around the town and neighbouring villages. The now celebrated Céret landscapes are painted visions of the world undergoing seismic upheaval. Soutine discovered ways of pulling, stretching and cleaving his paint to set off a process of transfiguration on his canvas. The finished works are not neat resolutions of this process but rather present compelling moments of energy and activity that are both spatially and emotionally turbulent. Much later, the critic David Sylvester would call them "some of the most Dionysian paintings in the history of art".[15]

Although the Céret pastry cook is more immediately legible than some of Soutine's contemporaneous landscapes, such as *Le Chemin de la fontaine des Tins, Céret* (fig. 4), it is as energetic and agitating in its variety of restless marks and shifting colours that at once define and rupture form. What saves these compositions from falling apart is Soutine's fixation on certain contours, features or details that he pulls out from the cacophony of painted sensations – the remarkably enlarged ear of the pastry cook that joins the rhythmic pattern of the chair back, for example, or the prominent curves and angles overpainted in the landscape, which also feature strongly as the chair arm and elbows in *The Pastry Cook*. Like the cook's eyes, Soutine's paintings from this period involve radical shifts of focus. Soutine's particular visual fixations are to some degree idiosyncratic and unexpected. In his portraits, they can have the double effect of expressing his artistic individuality and the individuality of his sitters – you cannot sprout a magnificent ear like that and be considered a 'type'. But they also relate to the compositional needs of the painting itself – would the ear look like that if Zocchetto were sitting on a different chair? In this sense both artist and sitter are at the service of the work.

In Céret, around the same time as *The Pastry Cook*, Soutine produced a full-length painting of another cook in whites, posed in front of a red curtain (cat. 2), and two canvases thought to be of butchers (cat. 1 and fig. 41). All three probably sat for him in Céret. This would prove to be the beginning of Soutine's work on the motif of uniformed workers as a series that developed over the next decade into hotel and restaurant staff more broadly.

4

SOUTINE'S UNIFORMED SITTERS of the Céret period established a motif that was clearly fertile territory for him. However, he was deeply dissatisfied with much of the work he made during his time there. There are accounts of Soutine having bonfires of his canvases close to his Céret studio.[16] Modigliani had died in 1920, depriving Soutine of his most ardent supporter and Zborowski remained largely unimpressed with the paintings he was producing. Soutine would leave Céret for good at the end of 1922. A significant number of paintings did make it out of Céret and to Paris, where some began to be shown and sold. In April 1921, one of his landscapes was hung in a large group show on the walls at the Café du Parnasse, which is usually cited as his first recorded exhibition in Paris. A couple of months later he was included in another mixed show, but this time at the Galerie Devambez, known for its bold exhibitions of modern art.[17]

The Pastry Cook (fig. 1) was one of the paintings that reached Paris. Recollections differ slightly and details are sketchy, but by 1922 the canvas was in the possession of the influential young dealer-collector Paul Guillaume, who had earlier represented Modigliani. Guillaume recalled visiting an artist's studio to look at a Modigliani painting and, whilst there, spotted "in a corner of the studio a work that immediately filled me with great enthusiasm. It was a Soutine; and it depicted a pastry cook – an amazing, fascinating, genuine, vibrant pastry cook, afflicted with a huge and magnificent, unexpected and accurate ear; a masterpiece. I bought it."[18]

In December 1922, the Philadelphia-based modern art collector Dr Albert Barnes came to Paris on one of his regular buying trips. Soutine's work was unknown to him but when Barnes set eyes on The Pastry Cook (probably in Guillaume's gallery, although Barnes later recalled it was hanging in a bistro) he is said to have fallen for it immediately, declaring: "But it's a peach!"[19] What followed is now the stuff of modern art legend. Barnes bought The Pastry Cook and requested to see more of Soutine's work. Guillaume arranged for him to meet Zborowski and, in an act of remarkable confidence in an artist completely unfamiliar to him, Barnes acquired fifty-two, or perhaps fifty-four, canvases in a decisive transaction.[20] News of Barnes's acquisition spread quickly, not least through Guillaume writing the first ever article on Soutine, which was published at

almost the same time, in January 1923. It coincided with a group exhibition of Barnes's recent acquisitions, including, of course, Soutine, at Guillaume's gallery in Paris. Later in the year, Barnes took a version of the exhibition to the Academy of Fine Arts in Philadelphia, where he showed nineteen of Soutine's canvases, among them *The Pastry Cook*.

The name 'Soutine' was quickly gaining currency. Like a character from a rags-to-riches tale, his story soon preceded him. The riches were not immediate: Barnes bought cheaply and initially Zborowski only modestly increased Soutine's allowance. But, crucially, with the strong advocacy of Barnes and the Paris dealers now sensing potential, a market for his work was being established and demand for his paintings was growing.[21] His prices increased markedly during the course of the 1920s and Soutine was able to live without financial worry. However, his stormy temperament and obsessive, often despondent dedication to his art remained.

WHEN HE HAD LEFT CÉRET behind and was working now in Paris and Cagnes, Soutine's paintings show him reconsidering and developing his approach. This is most apparent in the landscapes he painted in Cagnes, which are less frenetic, sharp and eruptive than those of Céret. He seems more attuned to a sense of the landscape as a living organism, shaped by the forces of nature over time rather than reconfigured by his own riot of emotional sensations in front of the motif, which perhaps he felt had been too heavily imposed. In the new Cagnes landscapes, billowing, fluid curves express his changed sensibility most obviously and become a painterly language to speak of durations of natural and temporal forces. This change of approach registers more subtly in Soutine's portraits because his earlier paintings of people were generally not as visually disruptive as his Céret landscapes. However, during this period of transition he produced two paintings of pastry cooks (cat. nos. 3 and 4) that clearly mark his shifting approach. Both are thought to have been painted in Cagnes and they take up a similar pose to his first Céret pastry cook (fig. 1), with the sitters in an equally distinctive French country chair. However, the kitchen whites are now more fluid swathes and strings of colour rather than fissured ruptures. The cooks' faces

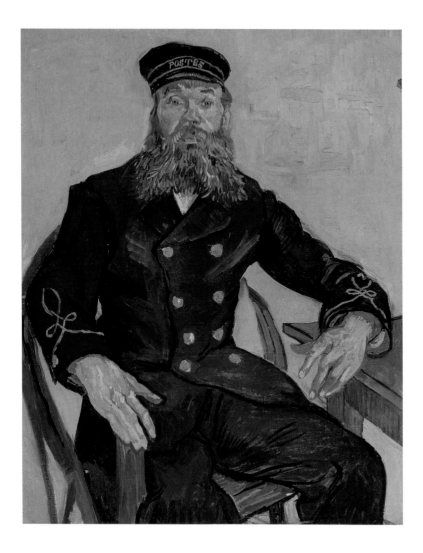

5

VINCENT VAN GOGH
Postman Joseph Roulin, 1888
Oil on canvas, 81.3 x 65.4 cm
Museum of Fine Arts, Boston

present flesh as bloody and malleable; their enlarged ears now feel irregularly grown rather than distorted for the composition. Soutine achieves an even greater depth of visceral expression and immediacy in these works, one that he would continue to strive for in his uniformed portraits of the later 1920s.

Soutine likely painted these two canvases after Barnes and Guillaume had propelled his earlier *The Pastry Cook* into the limelight. Dealers and collectors will have surely been pleased that Soutine was continuing with the subject that had helped to make his name and market (in fact, Guillaume would go on to buy both of the Cagnes pastry cooks). Soutine's persistence with uniformed sitters was now clearly a serial concern. Soutine liked to

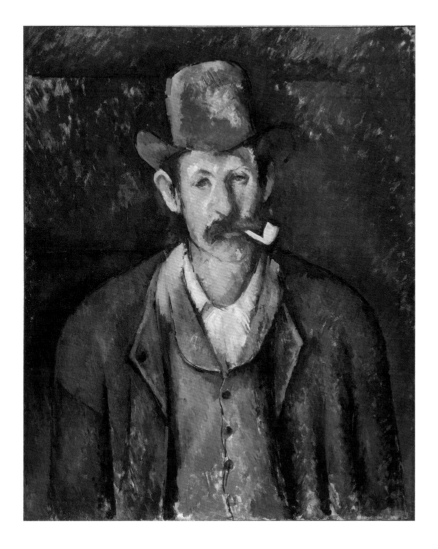

work in series and did so across a range of motifs. These were often tightly focused variations, such his paintings of a praying man from his Céret period and his well-known beef carcasses. The series of uniformed sitters as a whole is a broader set of variations, within which are concentrations of particular types of worker. Soutine conveys a surprisingly wide array of characterisations through the repetition of his portraits.

The more he explored the subject of uniformed sitters the more prominently the paintings wove themselves into traditions of portraiture. The most obvious reference points for the seated Céret and Cagnes pastry cooks were Van Gogh's portraits of rural sitters, notably the uniformed *Postman Joseph Roulin* (fig. 5), and Cézanne's

series of Provençal peasants, such as *Man with a Pipe* (fig. 6).
Surely one of the reasons Barnes was so immediately enamoured
of Soutine's *Pastry Cook* was because it has such clear visual
connections to these comparable portraits by Cézanne and Van
Gogh – artists who were keystones of his collection. References
to these modern masters were made in the early writings on
Soutine.[22]

The surprising elevation of lowly rural workers to the status of
portraiture was one of the themes that Van Gogh and Cézanne had
established – unconventional portraits for unconventional ways
of painting that blurred the boundaries between portraiture and
rural genre scenes, individuals and types. In the 1920s, Soutine
told people that he rejected the example of Van Gogh, and he later
disowned Cézanne,[23] but, with the Céret and Cagnes pastry cooks
in particular, it seems as if he was working through them towards
something all his own. Soutine was perhaps initially measuring
himself against Van Gogh by finding his own rural people to sit for
him on country chairs but also distancing himself in his handling
of paint. The boldness of Van Gogh's application of paint and his
colouring find some parallel in Soutine but the similarities are
superficial. Soutine's agitated paintings share nothing with Van
Gogh's structured and built-up surfaces. Cézanne's questioning,
sometimes provisional way of handling paint – continually assessing
his marks against his shifting visual sensations – has a more
profound connection to Soutine's sensibility. However, the urgent
and fugitive character of Soutine's brushwork makes Cézanne's
Man with a Pipe look concrete and immutable.[24]Cézanne's and
Van Gogh's paintings of rural French people offer similar accounts
of their sitters, albeit by very different means. They both give
deadpan portrayals of the pride, stoicism and steadfast characters
of their subjects that add up to a form of monumentality. Soutine's
treatment of his pastry cooks has none of these venerating qualities.
His restless brushwork resists solidity of form and idealisation. The
awkward-looking features of Soutine's young sitters, who have not
yet grown fully into their uniforms, are the adolescent riposte to
Cézanne's admission, "I love above all else the appearance of people
who have grown old without breaking with old customs".[25]The
idealisation of rural France – its regional people and landscapes

– was a significant cultural and national theme that re-emerged at the end of the First World War, as the art historian Romy Golan has so compelling demonstrated.[26] In very broad terms, it went with the so-called *rappel à l'ordre* (call to order) that saw many of the stridently modernist avant-garde artists of the pre-War years reconstruct themselves through classicising styles and seek deeply rooted values within a nation trying to rebuild after the devastation of world conflict. Manifestations of these tendencies can be seen in a whole spectrum of artists – from celebrated figures of the pre-War avant-garde, such as André Derain and Picasso, to now lesser-known but once prominent modern painters such as Marcel Gromaire – who aligned with this reconstructive post-War ethos. The modernist father-figures, Van Gogh and Cézanne, who inspired the rupturing breakthroughs of Fauvism and Cubism respectively before the War, were now more likely to be valued for their rural authenticity and the robustness of their vision. Modigliani was the artist closest to Soutine who found such qualities in Cézanne and gave clear expression to them in paintings such as *The Little Peasant* (fig. 7). Soutine's pastry cooks played their part in establishing him as a prominent figure in this post-War culture of French painting, but he was an awkward fit. Soutine's misshapen and bloodied faces sometimes come close to the way he paints slaughtered meat; unsettling and injured in contrast to the serenity of Modigliani's fresh-faced young peasant. They are faces that seem to carry tough histories rather than convey a spirit of renewal.

SOUTINE'S SUBSEQUENT GROUP of uniformed sitters shows him extending the expressive character of his portraiture and intensifying his engagement with traditions of painting, but in ways that remained rebarbative. In the second half of the 1920s Soutine painted a wider range of uniformed sitters, drawing on subjects such as bellboys, waiters and valets, who were associated with the high life of hotels, restaurants and clubs in Paris and other cities and towns in France. The production of these new paintings corresponds with the significant shift in Soutine's personal circumstances. Commercial success meant that he now led a very different life than he had in the frugal years living and working between Montparnasse,

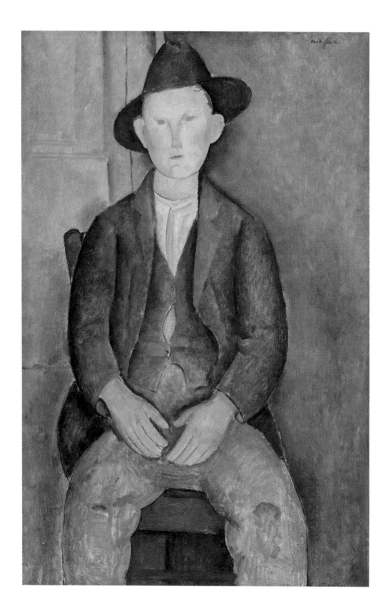

Céret and Cagnes. From 1923 onwards he based himself principally
in Paris, where he could now afford good accommodation and
studios. He soon developed a taste for fine suits and started to
lead a life that looked, in part, like that of an affluent bourgeois.
One imagines – although details are vague – that he frequented
decent restaurants and cafés in Paris, participating in some of the
excitement of the Roaring Twenties. Soutine certainly took vacations
in fine hotels, including with Zborowski in the spa town of Châtel-
Guyon in the Auvergne region and probably elsewhere, hoping to

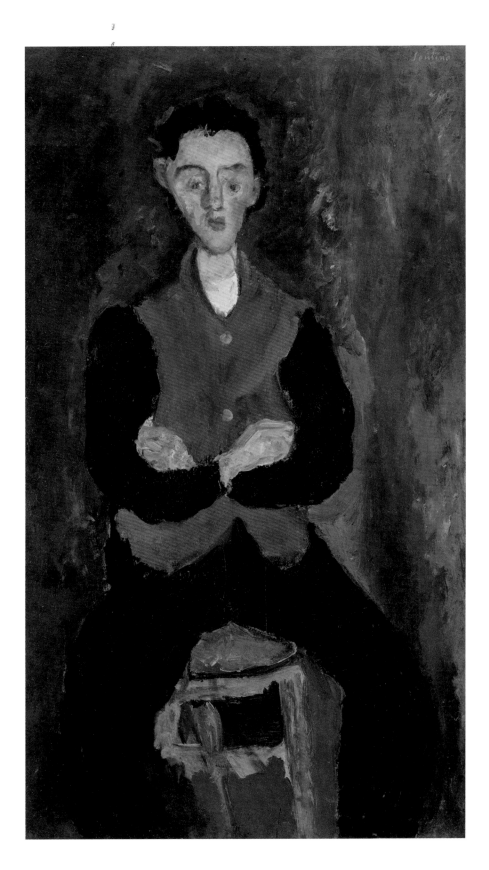

8
CHAÏM SOUTINE
The Valet (Le Valet de chambre),
c. 1927–28
Oil on canvas, 109.2 x 63.5 cm
Private collection

find relief for his painful stomach ulcers. With Zborowski's driver at his disposal, Soutine also made trips to other areas of France, sometimes to paint and sometimes to see friends. He is also known to have visited museums in London and Amsterdam.

Soutine's newly wealthy life brought him into regular contact with the legions of uniformed staff who ran the formidable and famous hotel and restaurant industry in France. Nothing is known of the details of the sittings but it is clear from the paintings that he persuaded at least ten different people to sit for him in uniform. He typically produced a number of different paintings of each type of uniformed worker and sometimes produced several paintings of an individual sitter, as in the waiter series (cat. nos. 10–13). Unlike his rural pastry cooks and butchers, these new subjects were urban service staff, people whose job it was to greet, carry and attend. Consequently, as viewers, we engage with the portraits somewhat differently, unable to shake the feeling that these people are at our service. This sensation is amplified by the fact that Soutine choose to pose them in a more staged manner than before. In the full-length *Page Boy at Maxim's* (cat. 9), the man seems to welcome us, as if we have just arrived at the restaurant door, and yet he stands within an awkwardly tilted and nondescript setting; there is nowhere to go. Several sitters, such as the bellboy (cat. 8), adopt an assertive pose, hands on hips, that seems incongruous and even insolent to us as 'hotel guests'. These are the poses typically reserved for the swagger portraits of kings, knights and noblemen of the distant past, and of political and military leaders and of the rich and famous of more recent centuries – certainly not for anonymous bellboys and waiters, however prominent their role in modern Paris might have been.

Even when Soutine poses his subject more conventionally, as in *The Valet* (fig. 8), the sitter seems uncomfortable. The valet looks like he is perched on a borrowed chair, as if taking a few minutes between shifts – never quite off the clock. Compare this painting to Modigliani's *The Little Peasant* (fig. 7) to which it could almost be a direct response. How much more natural and at ease the peasant seems – comfortable in his own skin and belonging to his surroundings, despite Modigliani giving him only the mere suggestion of a room. Soutine seems incapable of convincingly integrating his sitters within a setting, such is his extreme focus on

painting the person. His valet hardly touches the chair and in other works, such as *Bellboy* (cat. 8), Soutine removes the chair from the painting altogether: the man is left unsupported in a void. It often feels as if Soutine's posed staff have been cut out from something else – another painting or a different situation – and isolated for scrutiny on his canvas.

Indeed, in an important sense, these portraits do come from other paintings. During this period, Soutine visited the Louvre extensively and became preoccupied with certain artists – Rembrandt, Jean-Baptiste Siméon Chardin and Gustave Courbet being among the most revered. Soutine produced a number of canvases in direct emulation of other paintings, such as Rembrandt's *Flayed Ox* and Chardin's *Ray* (1728; Musée du Louvre, Paris). These are not copies or studies in a conventional sense, but rather ways for Soutine to channel into his own work qualities he considered vital – painterly directness and immediacy being paramount in his estimation.[27] His uniformed portraits can be considered part of this practice. Soutine's portraits are saturated with the legacy of European art. There are many paintings within them, but Rembrandt was one artist whom he considered prime. Soutine's painterly concern for the fleshy faces of his sitters – so crucial for the uniformed subjects – owes much to Rembrandt's example. Also central for Soutine was an earlier artist, Jean Fouquet, the fifteenth-century French court painter. The sculptor Jacques Lipchitz recalled Soutine's delight at having purchased a large reproduction of Fouquet's portrait of Charles VII (fig. 9), which he proclaimed to be his favourite painting in the Louvre.[28] Around 1923–24, Soutine painted a portrait of his friend the sculptor Oscar Miestchaninoff (fig. 10), which is often cited as based on Fouquet's portrait. Its influence can also be discerned to varying degrees in his uniformed portraits. When the French painting department at the Louvre reopened after the First World War, in January 1920, it had been rehung to give that school greater significance. Fouquet's *Charles VII* was accorded a newly privileged place as the founding painting of the French school.[29] Its importance lay in Fouquet's ability to dispense with symbolic trappings of royal power and instead to project the king's God-given status on earth through his physical presence and through the unflinching treatment of Charles's far from heavenly face. Fouquet's challenge was to make

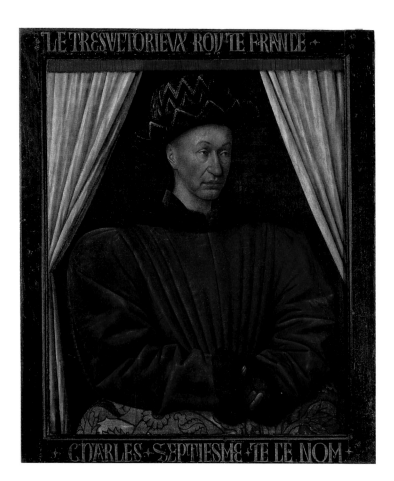

the King simultaneously a real individual and a divine type. To this end, his handling of the relationship between the king's unidealised yet compelling facial features and his assertive red jacket was seen as central to the painting's originality. It is something of these qualities that Soutine tries to emulate in the Miestchaninoff canvas and in many of his uniformed portraits, most obviously in the Cagnes pastry cooks (cat. nos. 3 and 4) and *Bellboy* (cat. 8). In Fouquet, Soutine found a celebrated French predecessor addressing similar artistic challenges in his portraiture, for which Soutine's own hotel and restaurant staff in their regal liveries proved such an awkward yet gripping modern equivalent.

Detail of cat. 8

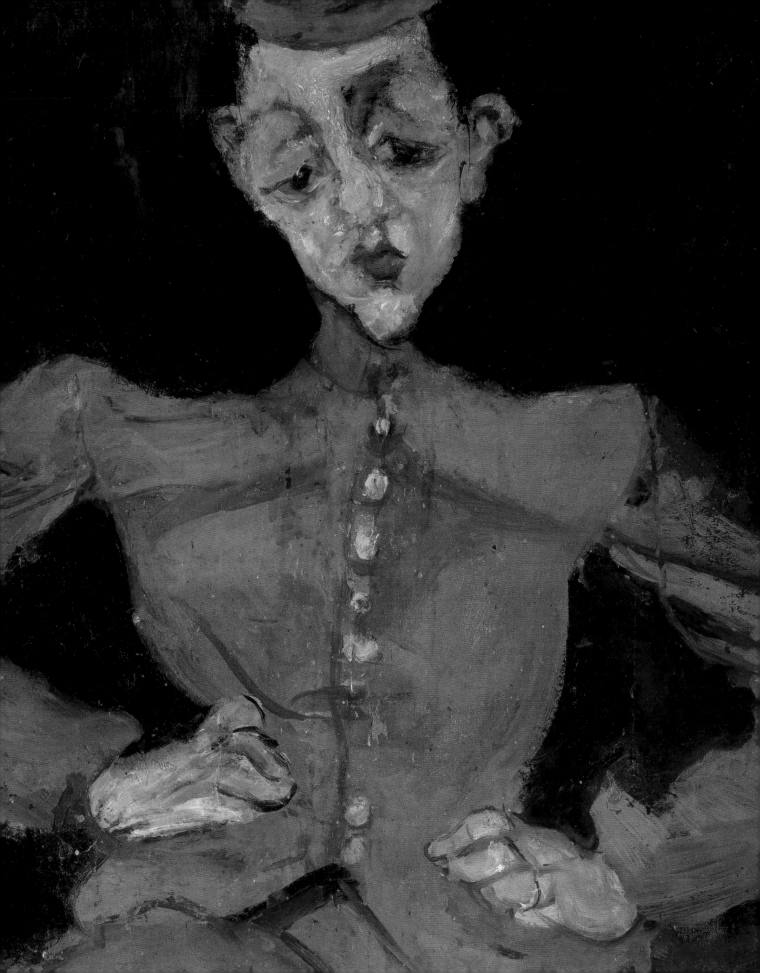

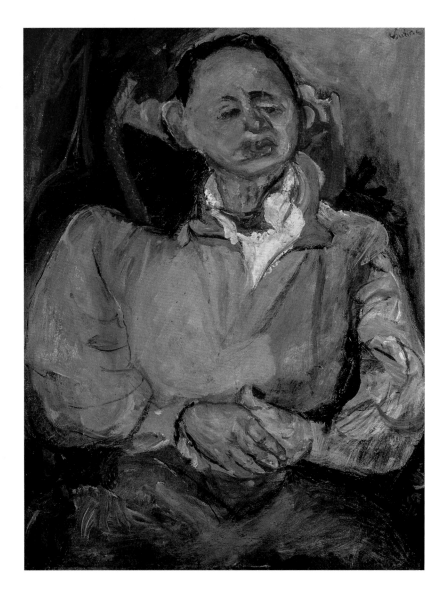

10

CHAÏM SOUTINE
*Portrait of the Sculptor Oscar
Miestchaninoff (Portrait du sculpteur
Oscar Miestchaninoff)*, c. 1923–24
Oil on canvas, 83 x 65 cm
Musée national d'art moderne,
Centre Georges Pompidou, Paris

THERE IS NO WHIFF of parodic or political intent as Soutine
reverses the social order by elevating his service staff into the realm
of royal portraiture. As Monroe Wheeler, an influential curator and
scholar of Soutine's work, observed, "What a boon for Soutine that
the servant class in France should have kept so many archaic styles
of garment, fancy dress without frivolity, which enabled him to
strike that note of pitiable grandeur that was compulsive in his mind
and heart …".[30] 'Pitiable grandeur' is a good description but does not
fully cover the character and emotional experience of the paintings.
What it misses is the sense of the works as uncanny (in its meaning

as somewhat familiar but unsettlingly out of place). One aspect of this is the way the sitters try so earnestly to belong to a tradition of grand portraiture that was so clearly not created for them. This does not just inspire pity, it destabilises the genre.

Compounding this is the way the works, from the outset, set up an oscillation between the sitters as individuals and as types, which we as viewers struggle to resolve. Unsettling too is the incongruity of Soutine's workers being in their uniforms but out of their professional setting, so that codes of conduct – between viewer and subject, customer and staff – are disrupted. These paintings are distinctive within Soutine's oeuvre for the type of mismatches that they generate. They contrast, for example, with the series of paintings of choirboys that he also produced in the second half of the 1920s (see, for example, fig. 11). These young 'servants of God' are close to the service staff portraits in many ways and yet Soutine's approach conveys more fittingly their associations with spiritual devotion and the profound weight of religious service on their young shoulders. His choirboys sometimes have a hint of mischievousness cutting through the solemnity of their duty, but this does not destabilise their roles and identities as it does with their secular counterparts from the hotels and restaurants.

Reviewing Soutine's series of uniformed portraits as a whole, it seems that it has many of the aspects that might fit comfortably within the prevailing reconstructive ethos of French culture of the period. The works are rooted in the accepted French canon, speak of the values of figurative painting and cast a group of modern workers within the traditions of art and history. However, their rebarbative characteristics resist straightforward categorisation in these sorts of terms. As the art historian Kenneth Silver has demonstrated convincingly, Soutine's art found a prominent place in the Parisian art world precisely because it offered an alternative and compelling response to the French tradition. He puts it succinctly: "When was the last time in French art that a choirboy looked this innocently devout, or a bellhop this surly, or a landscape as if it were heaving to the music of the spheres?"[31] Perhaps more than any of his other motifs, Soutine's uniformed sitters are the subjects that most fully embody the complexities of his efforts to find a voice within the tradition of European painting.

BRINGING TOGETHER Soutine's series of hotel and restaurant staff portraits for this exhibition and publication is not a fulfilment of the artist's intentions. He did not paint them as a discrete group nor did he try to have them shown as a set. However, the undertaking does have the advantage of bringing them into focus as a highly distinctive and unique series of modern portraits. These workers were so ubiquitous in Paris and throughout Europe, embodying a new type of economy and ways of living, and yet Soutine is the only artist to engage with them seriously as a subject for contemporary painting – seeing them together underscores this.

Assembling them also has the effect of creating a sort of hotel. Most of the essential staff are present, from the lobby to the bedrooms and from the kitchen to the restaurant. It emphasises the fact that Soutine was painting an experience of hotel life, drawn in part from his newly bourgeois lifestyle of the 1920s. That term, 'hotel life', achieved a certain circulation in America during this period through the writings of the sociologist Norman Hayner, who sought to analyse the psychological and societal effects of the rapid expansion of hotels as a now ubiquitous part of modern life.[32] His research concluded that hotels created depersonalised and transitory spaces that led to new forms of social interactions between guests and staff and between guests themselves. Indifference and anonymity characterise these relations. People are brought within close physical proximity in the welcoming arms of the hotel but social relationships are put at a distance. Hotels allow guests a greater sense of personal freedom than they might experience, for example, at home or in the workplace, but the price is often alienation, restlessness or the cultivation of what he called a "blasé" attitude. The culture of hotel life affected not only guests but hotel staff as well, whose attitudes were shaped in response to these new behaviours and environment.

We do not need to try to map Hayner's conclusions directly on to close readings of Soutine's hotel staff portraits, but it is illuminating to put the paintings in the context of hotel life as a modern phenomenon where the character of social relations is at stake. It is a context that extends widely and well beyond Hayner, with hotels playing an increasingly important role as a social site in modern culture throughout the twentieth century and into our own,

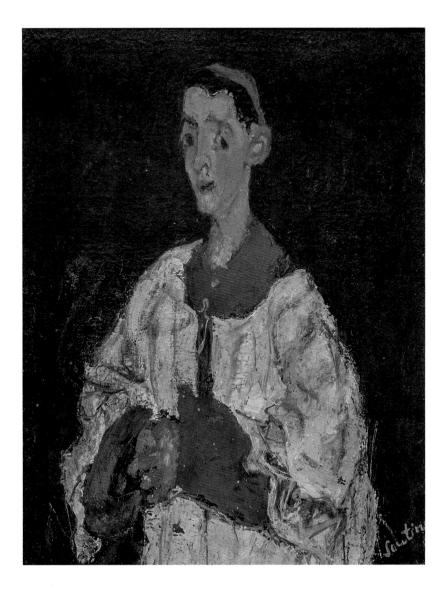

11

CHAÏM SOUTINE
Choirboy (Enfant de chœur), c. 1927–29
Oil on canvas, 63.5 x 50 cm
Musée de l'Orangerie, Paris

especially in film.[33] Soutine was one of many people experiencing the affecting modernity of the hotel, but one of the few to give such profound expression to it. Another was the author Joseph Roth, who was writing about the peripatetic hotel life he was leading as he travelled across Europe at exactly the time Soutine was painting his portraits. The parallels between their work are striking. In 1929, Roth published a series of articles in which he professed his deep affection for the anonymity of hotels and the unsentimental and well-acted conduct of their staff.[34] "Other men may return to hearth and home, and wife and child; I celebrate my return to the lobby and

chandelier, porter and chambermaid ...".[35] He goes on to pen
a number of character studies of individual hotel staff types.
Roth writes in unexpected ways about the beauty of the impersonal
nature of his relationship to them – of the room-service waiter:
"His professional eagerness is confined to his tail-coat – in his
breast under the starched shirt front is human warmth; persevered
for me ...".[36] In a further remarkable passage he reads a life story in
the face of the chief receptionist:

> Only when a guest steps up to his desk to make an order does he gently
> incline his head – not the better to hear it, but only to disguise his
> superiority which guests do not like to have their attention drawn to.
>
> Because, make no bones about it, he is their superior. I find in his
> powerful head, the wide white brow, where the hair at the temples is
> already beginning to silver, the wide-set pale-grey eyes above which the
> heavy eyebrows form two complete arches, the deep-lying root of the
> powerful, beaky nose, the large and down-curving mouth, shaded as
> the eyes by their brows by the curve of the pendulous pepper-and-salt
> moustache, the massive chin at the heart of which is a lost little dimple
> that has survived from childhood: for me this face echoes the portraits
> of great noblemen, a fixed expression of proud aloofness, an aura that
> spreads over the whole visage like a transparent layer of bitter frost.[37]

Roth's hotel writings remind us that Soutine's portraits of
bellboys and waiters, cooks and valets are, ultimately, deeply engaged
character studies. They can be read as life stories, which are made
all the more compelling by Soutine's deep sensitivity to his sitters
as misfits whose complex individuality rubs against the uniformed
façade of their hotel lives. It is telling that, once his own hotel life
drew to a close in the first half of the 1930s, so did the series.

Staying for extended periods with his patrons Marcellin and
Madeleine Castaing at their large property near Chartres, during the
1930s, Soutine turned his attention to domestic staff in a number
of paintings of house cooks and maids (see, for example, cat. nos.
19–21), which would prove to be the last of his portraits of servants
in uniform. When the Germans occupied France in 1940 and Jews
were being rounded up, Soutine's situation became increasingly
dangerous. In 1941, he fled Paris. His bourgeois travels and hotel

life of the 1920s turned into a nightmarish struggle to hide from the Nazis and survive in temporary lodgings. In 1943, despite the dangers, he returned to Paris for urgent medical treatment for his fast deteriorating stomach condition. He was too late. On 9 August he died following an emergency operation. Soutine was buried in Montparnasse cemetery, close to where he had first settled in the city as a young man thirty years earlier.

NOTES

1 There is comparatively little documentary evidence to chart Soutine's biography in detail. A significant part of his life story and accounts of his personality have been constructed from later recollections of people who knew him and are of varying degrees of reliability; it must therefore be approached with caution. In this publication, we have principally drawn on the following publications: Tuchman, Dunow and Perls 1993; Kleeblatt and Silver eds. 1998–99; Krebs, Mentha and Zimmer eds. 2008; LeBrun-Franzaroli 2015.

2 Faure 1929; Wheeler 1950–51; Leymarie ed. 1973.

3 For major art historical accounts of this period and its cultural themes, see Silver and Golan eds. 1985; Silver 1992; Golan 1995; Green 2001.

4 Adolphe Basler, *Indenbaum*, Paris, 1929, quoted by Sophie Krebs, 'Soutine – A Case Apart', in Krebs, Mentha and Zimmer eds. 2008, pp. 39–62, at p. 49.

5 Faure 1929, p. 14.

6 The most prominent of these was Waldemar George, who wrote the first monograph on Soutine in 1928.

7 Drieu La Rochelle 1930, p. 4.

8 George 1928, p. 19.

9 For a full analysis of Soutine's place in the Parisian art world of the period, see Kenneth E. Silver, 'Where Soutine Belongs: His Art and Critical Reception in Paris Between the Wars', in Kleeblatt and Silver eds. 1998–99, pp. 19–40.

10 Green 2001, p. 226.

11 For an overview of Soutine's approach to portraiture, see 'Portraits: Introduction', in Tuchman, Dunow and Perls 1993, vol. 2, pp. 509–13.

12 See *Catalogue of Exhibition of French Art* 1919: it lists Soutine's four works as *Violin*, *Rabbit* and two Cagnes landscapes.

13 The dating of Soutine's paintings is notoriously difficult because he did not date his works and early records are scant. Most dating relies heavily upon his stylistic development as laid out in the catalogue raisonné (Tuchman, Dunow and Perls 1993).

14 For a thorough account of Soutine's time in Céret, see Matamoros ed. 2000.

15 David Sylvester, 'The Mysteries of Nature within the Mysteries of Paint', in Güse ed. 1981–82, pp. 33–47, at p. 38.

16 Matamoros ed. 2000, pp. 44–46.

17 For an account of his early exhibitions, see Sophie Krebs, 'Soutine, entre rejet et intégration', in Restellini, ed., 2007–08, pp. 33–43, at pp 34–35.

18 Guillaume 1923, p. 6.

19 Barnes's reaction is recounted in Guillaume 1923, p. 6.

20 For a recent and complete account of the circumstances of Barnes's discovery of Soutine, see Kathryn Porter Aichele, 'Albert C. Barnes, Chaim Soutine, and the Art in Seeing', in Aichele 2016, pp. 37–68.

21 Gee 1978, p. 267.

22 Guillaume 1923; Barnes 1927; George 1928.

23 In 1923, Guillaume made a point of noting that Soutine 'hated' Van Gogh, suggesting that such comparisons were prevalent at that time; see Guillaume 1923, p. 6. In 1938, the dealer René Gimpel recorded that Soutine had told him he had now moved beyond Cézanne's example but once believed in his art; Gimpel 1966, p. 437.

24 For two interesting discussions of comparisons between Soutine, Van Gogh and Cézanne, see David Sylvester, 'Introduction', in Sylvester and Tuchman 1963, pp. 4–15; and Silver in Kleeblatt and Silver eds. 1998–99, pp. 19–40.

25 Recalled by Jules Boréli in 1926, and reprinted in Michael Doran ed., *Conversations avec Cézanne*, Paris, 1978, p. 21.

26 Golan 1995.

27 Gimpel 1966, p. 437.

28 Tuchman 1968, p. 27, and Warnod 1988, p. 98. As early as 1929, Waldemar George wrote of Soutine's admiration for this painting: George 1929, p. 161.

29 Maingon 2016, pp. 213–14.

30 Wheeler 1950–51, pp. 73–74.

31 Silver in Kleeblatt and Silver eds. 1998–99, pp. 19–40, at p. 38.

32 Hayner conducted his research during the 1920s and published 'Hotel Life and Personality' as an article in the *American Journal of Sociology* (vol. 33, no. 5, March 1928, pp. 784–95), followed by a book-length study of the subject, *Hotel Life*, in 1936 (Chapel Hill, University of North Carolina Press).

33 A recent publication has taken up Hayner's theme and expanded its scope up to the present time: Caroline Field Levander and Matthew Pratt Gurterl, *Hotel Life. The Story of a Place Where Anything Can Happen*, Chapel Hill, University of North Carolina Press, 2015.

34 These articles were originally published in *Frankfurter Zeitung* between 1929 and 1930. They have recently been translated and published as a collection in Roth 1929–30 (2015).

35 Roth 1929–30 (2015), p. 155.

36 Roth 1929–30 (2015), p. 157.

37 Roth 1929–30 (2015), pp. 161–62.

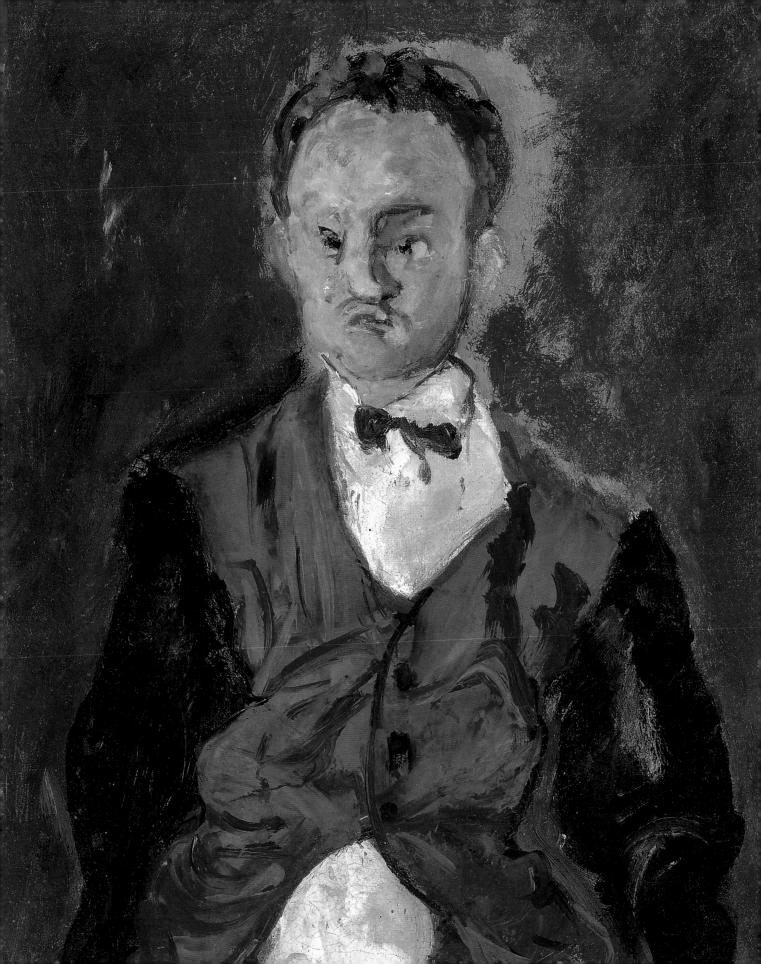

MODERN WORKERS
SOUTINE'S SITTERS IN CONTEXT

Karen Serres

AT FIRST GLANCE, the portraits of uniformed workers painted
by Chaïm Soutine in France throughout the 1920s conjure up an
age of grand hotels and fashionable restaurants, where armies
of staff attended to their guests' every need. It quickly becomes
apparent, however, that these depictions are much richer than a
simple gallery of types. Soutine's sitters are a motley crew whose
personalities undercut the glamour and willing servitude of their
uniforms. The striking formats, bold colours and animated surfaces
that characterise Soutine's representations of valets, bellboys,
chambermaids, waiters and cooks endow his portraits with an
unexpected and profound emotive power. These are complex
representations of their subjects and, by extension, of the gilded
world of the French leisure industry from which they are drawn.
These portraits are also unique in the history of modern painting:
while other artists have occasionally tackled this type of subject-
matter, Soutine stands alone in his sustained and multifaceted
interest, in making these figures – ubiquitous at that period –
a major subject of his art. Offering a variety of rich associations that
goes beyond the straightforward depiction of specific individuals,
his works have an unprecedented complexity and depth that explain
the enduring appeal of the series.

Contemporary viewers would have been attuned to the status of
the workers posing for Soutine and to the connotations they carried.
It is therefore surprising that the social and cultural contexts of
his hotel and restaurant staff have never been considered in detail
before. To do so enriches and deepens our engagement with the
portraits. This essay sets out to explore the working lives of Soutine's
sitters, to address long-standing confusion about their roles and to
survey the visual culture they inhabited. Although very little is known
about them as individuals (only one sitter has ever been securely

named), there remains much to say about the types they embody and the fertile associations they conjure as 'modern servants'.

In past centuries, servants had been a mainstay of genre painting, defined by their setting and symbolic function. For example, a moralising intent and comment on the importance of social order often lay behind the playful depictions of servants sleeping or stealing in seventeenth-century Dutch painting, as in Nicolaes Maes's *Idle Servant* (1655, The National Gallery, London). These figures were contrasted with virtuous servants, who assisted their masters or assiduously carried out their given task. In the paintings of eighteenth-century French artists such as Jean-Baptiste Siméon Chardin, devoted servants represent peaceful domesticity, caring for the children of the household or preparing meals (fig. 28). In all these examples, servants are generic characters that constitute but one element in a larger composition. The same narrative functions appear in the works of the popular late nineteenth-century genre painter Joseph Bail, who, emulating Chardin, specialised in sentimental depictions of quiet maids and naughty kitchen workers (fig. 12).

Servants could also be the subject of individualised portraits, and there was a long tradition of employees of all types, from the beloved family cook to the old butler, sitting for painters.[1] The portraits were almost always commissioned by their master, as a testament of their affection or a signifier of the family's wealth and status. Even though the depiction focuses on their features, their uniform remains ubiquitous: these figures are defined by their work and not portrayed as singular people.

Soutine's series could not be further from the servant as an exemplary type or from commissioned portraits of loyal employees. The humanity and presence of his sitters seem to jump out of the canvas even though they remain frustratingly anonymous. In this, Soutine may have been influenced by several portraits painted by his close friend Amedeo Modigliani around 1916–18, depicting shop girls, apprentices, servants and young peasants (see, for example, figs. 7 and 13). However, Modigliani's treatment of his unidentified figures in professional garb is empathetic, almost tender – a stark contrast to Soutine.

The novelty of Soutine's endeavour lies both in the type of service staff he chose and in the approach he adopted. The fascinating

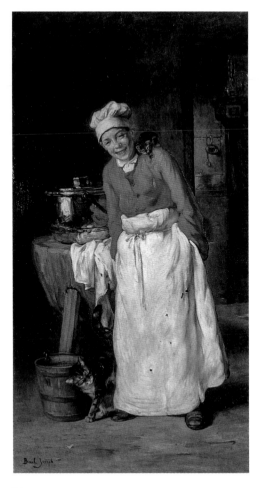

12
JOSEPH BAIL
The Little Cook (Le Petit Cuisinier),
1890s
Oil on canvas, 120 x 65.4 cm
Private collection

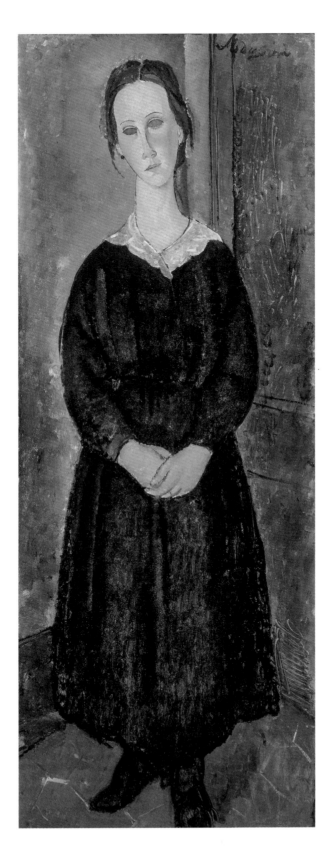

13

AMEDEO MODIGLIANI
Servant Girl (La Jeune Bonne), c. 1918
Oil on canvas, 152.4 x 61 cm
Albright-Knox Art Gallery, Buffalo

working environments his sitters summon adds to the complexity: their professions were not completely new but underwent a profound mutation and a marked proliferation at that period, shifting from a domestic environment to the commercial world of hotels and restaurants. Unlike Chardin's scullery maids or Paul Cézanne's labourers (see, for example, fig. 6), Soutine's valets, bellboys, cooks and waiters are far from immutable: they embody a certain type of urban modernity and allude to the social shifts taking place in early twentieth-century France. They personify the advent of what we call today 'the service industry', catering to a growing society of means and the demand created by the development of leisure, travel and consumption. They embody the seismic changes undergone by French society during La Belle Époque and especially the Roaring Twenties, a mark of the optimism and boom years that followed two devastating wars on French soil.

Soutine was not the first artist to depict the working class in the early twentieth century. This subject-matter allowed artists at that period to explore the dramatic technological advances and social transformation that characterised their changing modern world. Most famously, Fernand Léger painted construction workers as optimistic symbols of progress and of the benefits of industrialisation.[2] Representations of labourers could also be a site for social criticism: at the turn of the century, Maximilien Luce and Constantin Meunier, for example, depicted exhausted and faceless workers, brought down by harrowing working conditions and caught in the accelerating pace of modern life. Soutine himself did not specifically aspire to represent modernity as a subject. His portraits fit into neither of these categories and resist any kind of simplistic, one-dimensional reading. Any attempt to unravel their full complexity must include an exploration of the culture from which they arose.

Paris was perhaps the most exciting city in the western world in the 1920s. This was certainly the feeling of the myriad of visual and performing artists, writers and intellectuals who flocked to the capital, attracted by its vibrant cultural scene. Following the destruction and despair of the previous decade, it was a city transformed and transfixed by new ventures. Its inhabitants gathered in the latest cafés, nightclubs and restaurants; attended

theatre, dance halls, cinemas and sporting events; shopped in fashion houses and lavish department stores. Even those living in dire circumstances felt the energy around them and found a city in which their meagre means could offer a stimulating existence. Ernest Hemingway, James Joyce, Ezra Pound and Henry Miller all wrote of their formative time there as struggling writers while, in *Down and Out in Paris and London* (1933), George Orwell described his experiences as a (deliberately) destitute labourer, working as a dishwasher in the kitchens of upscale hotels and restaurants in Paris a few years earlier. It is full of vivid accounts of life behind the scenes, where Orwell could have bumped into some of Soutine's sitters.

Created in the mid nineteenth century, grand hotels truly flourished at the dawn of the twentieth century, serving an expanding leisure society for whom travel and tourism became fashionable pursuits. In Paris, a record number of hotels opened after the First World War, as the number of international visitors doubled in the 1920s.[3] These travellers were often wealthy and expected hotels – their home away from home – to provide the level of service they were accustomed to. They thus spurred the development of luxury hotels, characterised by the elegance and comfort of their surroundings, colossal scale (300 rooms were not uncommon) and vast personnel (up to 400 employees). This enormous workforce was divided into highly specialised tasks and run like a military operation. Orwell described his own experience working at a Parisian hotel: "Our staff, amounting to about a hundred and ten, had their prestige graded as accurately as that of soldiers, and a cook or waiter was as much above a *plongeur* [dishwasher] as a captain above a private".[4] The period also saw the publication of the first professional manuals, which sought to structure and systematise the industry.[5] As shown in one of these instruction guidebooks, Lucius Messenger Boomer's 1925 *Hotel Management*, every aspect of a hotel's operation and its armies of staff was targeted towards the paying customer, "the satisfied guest" (fig. 14). The manager, at the centre of the chart, held all the strands together, as the hierarchies of the different services unfolded along the various axes, from the steward to the dishwashers, from the maître d'hôtel to the room service pantries. *Hotel Management* was

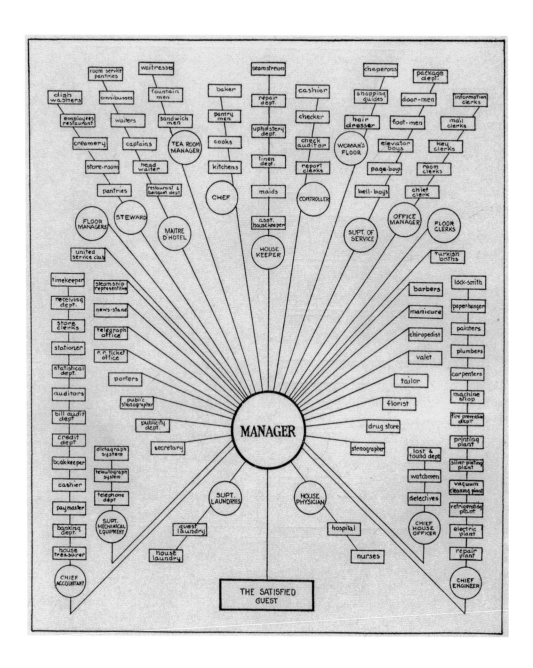

adapted in French in the early 1930s and remained highly influential throughout the period.

Indeed, grand hotels offered a level of comfort and service no longer found in traditional upper-class households. Trade catalogues for staff uniforms clearly demonstrate this shift: in the late 1910s, the suppliers' principal clientele swung from prominent families to hotels, restaurants and nightclubs.[6]

14
Organisational diagram of 'Hotel Services' published in Lucius Messenger Boomer, *Hotel Management: Principles and Practice*, New York, 1925

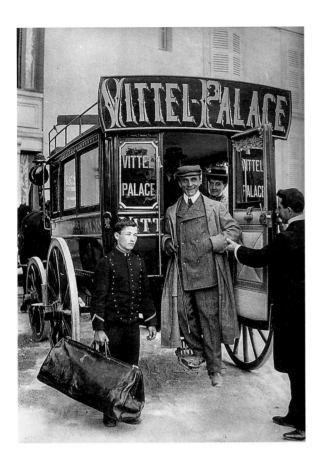

15
A guest arriving at the Hôtel
Vittel-Palace in the spa town of
Vittel in north-eastern France,
early 20th century

It was therefore in these establishments that some nobility and the bourgeoisie – which included Soutine following the sharp upsurge in prices paid for his work from the mid 1920s onwards – enjoyed a luxurious lifestyle, if only for the duration of their stay.

A contemporary industry publication noted that "travelling is one of the most presing needs of our time It allows one to discard, for a set period, the worries that come with running a household, clashing with one's servants, fighting with the suppliers, all social obligations are also interrupted. Life at the hotel must therefore be a respite for one's nerves, and a true period of tranquillity and rest."[7]

This "period of tranquillity and rest" began before reaching the hotel itself, when a dispatched chauffeur collected guests from the train platform or dock upon arrival (fig. 15). Outside the hotel, an army of doormen, footmen and porters ensured that guests never had to open a door or carry a piece of luggage. The frenzy of activity continued in the lobby, buzzing with concierges assisting clients;

page boys running errands; bellboys escorting guests to their rooms; telephone, telegraph and post clerks taking messages, etc. Another specialised attendant was found in the lift ("under no circumstances must the lift operator allow guests to use the lift alone" warned a manual)[8] and more service staff lived in the upper floors, supervised by a floor manager, clerk or housekeeper. These last oversaw the room attendants responsible for the cleanliness and order of each suite. Valets and chambermaids also cared for guests' belongings, pressed their clothes, shined their shoes, drew their baths and tidied their personal effects. Finally, the hotel restaurant, often a destination in itself, had similar levels of staffing. The kitchens of the most prestigious establishments could count up to three dozen people. From the stewards who oversaw the pantry to the chefs who cooked hundreds of meals a night, the waiters who weaved around the dining room, the service clerks who brought breakfast and other orders directly to the rooms and the dishwashers who cleaned the plates, each role was defined, allocated and monitored. Hotels were microcosms that ensured guests barely had to leave their premises to have everything they needed.

However, the emergence of the hotel as feeder of the capitalist leisure industry came with a dark side. Service personnel worked long hours with no regulatory oversight. Children as young as twelve were employed as page boys, lift attendants and messengers. Eager to maximise space (and profits), hotels no longer offered their employees room and board. A 1919 law attempted to regulate the industry by stipulating that employees would be allowed twelve hours of rest for every twelve hours of work, and a break of two hours during their shift. Leave days or extended time off were not permitted at the height of the season. The earliest strikes in the hotel and restaurant industries took place in 1920, and the ensuing decade saw an emerging awareness of workers' rights, although with no transformational effect.[9] The rate of staff turnover in the professions painted by Soutine was thus very high. There was, however, no shortage of workers ready to claim the uniform left vacant by a departing employee. Soutine's portraits have often been interpreted as depicting the harrowing nature of the sitters' occupations. According to one writer, the painter, in portraying a page boy (cat. 9), was "able to identify with this proletarian and

his frustrations" and thus focused on the exhaustion on his face
and the roughness of his large hands.[10] This rather stereotypical
interpretation ignores the range of emotions that Soutine's portraits
conjure. The long sitting sessions engendered a multiplicity of
sensations (for both Soutine and his sitter), which resist any one
conclusive reading. Soutine often conveyed a variety of conflicting
emotions in his sitters, from mockery to pride; from modesty to
arrogance; from fatigue to nervous energy.

A characteristic of the industry in the early twentieth century was
the fact that a large portion of the staff was composed of immigrants;
they made up a sizeable share of both the trained personnel
(Switzerland, Germany and Austria, in particular, had renowned
hospitality schools) and the unskilled staff lower down the ladder.
Orwell facetiously noted that "there is hardly such a thing as a French
waiter in Paris".[11] This was also true of luxury establishments outside
the capital: statistics from hotels of the spa town of Châtel-Guyon
in the centre of France, for example, reveal that, in 1927, more than
63% of their personnel was foreign.[12] Châtel-Guyon specialised

in treating digestive problems and Soutine spent at least three consecutive summers there on cure, from 1926 to 1928 (fig. 16).[13] He had long suffered from stomach ulcers, a condition that would eventually kill him, and friends reported that he was careful about his diet. His sustained interest in the personnel of fine restaurants is thus somewhat poignant, as are his still lifes of meat, fish and game. In Châtel-Guyon, Soutine stayed at the newly built and lavish Palace Hotel, where he would have certainly come in contact with valets, maîtres d'hôtel, bellboys and others. One of his biographers claimed that Soutine painted some portraits on vacation there, an assertion repeated by later authors.[14] The plain background of the portraits could give the impression that Soutine simply asked his models to pose in a side room during their break or to come to his suite. This scenario, however, is unlikely. Soutine's artistic practice was famously intense and all-encompassing, not to say shambolic: it would not have been easily accommodated in the hotel's elegant setting nor fit with the therapeutic aims of his sojourn.[15] In 1923, the dealer and collector Paul Guillaume recounted that Soutine found it impossible to paint even in a shabby hotel room that he once rented. After trying to set up a makeshift studio there, Soutine had quickly left because its "excessive luxury weighed on him". As he told friends back at the café La Rotonde, "can you imagine ... hot water, it made me feel uneasy; and also, I cannot paint where there are rugs!"[16] Thus, it is perhaps more likely that Soutine's sitters generally modelled for him in his various studios rather than in their places of work.

This does, however, raise the question of the nature of Soutine's relationship with his sitters and how he gained access to them. Soutine's life was peripatetic in the late 1910s and 1920s. In 1918, he accompanied Modigliani on a cure to Nice, where he stayed for six months. From 1919 to 1922, Soutine shuffled between small family-run hotels and rented rooms in Céret and Cagnes in the south of France. Back in Paris, he frequented cafés and bars with friends and, when money was no longer an issue, dined out in the capital's fashionable restaurants. In the latter part of the decade, Soutine travelled to spa towns such as Châtel-Guyon, was provided a summer rental by his dealer Zborowski in the small town of Le Blanc (in the centre of France) along with a cook and a chauffeur, and stayed at the country estates of patrons such as Élie Faure in the Dordogne

region and Marcellin and Madeleine Castaing in Lèves (a couple of hours south-west of Paris).[17] This nomadic existence would thus have brought him into constant contact with the service staff who catered to guests and travellers.

Unfortunately, neither the names nor the workplaces of Soutine's sitters are recorded and it remains impossible to ascertain how they would have met the painter. Only one sitter from the series has been identified: fittingly, he is the earliest pastry cook painted by Soutine, in the picture that so appealed to his first influential collector, Dr Albert Barnes (fig. 1). The portrait dates from Soutine's years in Céret, a community close-knit enough for an enterprising journalist to track down the sitter fifty years later. Rémi Zocchetto was a young apprentice chef of seventeen, working in the kitchen of the small family-owned Hôtel Garetta, when he sat for Soutine (fig. 17). Of Italian origin, Zocchetto's family had settled in the region two generations earlier. Half a century later, Zocchetto recounted that "Soutine promised him ten *sous* a sitting, but he never had ten *sous*, and after six sittings offered him a painting instead. 'I was a fool to refuse,' said [Rémi], 'I can understand that now, but his paintings seemed to me awfully bad'."[18]

This identification, however, remains an exception.[19] The status and specific roles of Soutine's anonymous figures must be gleaned almost exclusively from their uniforms. Indeed, the prominence of their liveries constitutes a particular marker of this series. A white jacket – which, in Soutine's hands, turns into shards of colour, evoking the different hues of light falling on the thick cloth – identifies its wearer as a kitchen worker. Standard white uniforms were a relatively recent development in the culinary professions; they had started a century earlier in royal kitchens and were slowly adopted more widely. They marked a novel attention to hygiene, as stains would be immediately noticeable (although chefs' jackets were famously double-breasted so the flaps could be switched to conceal spatter if needed). Hats were also a recent attribute, designed to absorb the perspiration generated in the sweltering kitchen. Soutine's cooks don either a short, rigid skull cap or the more recognisable floppy toque. The red kerchief several of them clutch (cat. nos. 3 and 4) had the same function and could also be worn around the neck.

17
Photograph of Rémi Zocchetto, c. 1921, a few years after he modelled for Soutine

Of the ten known figures painted by Soutine sporting the closed double-breasted white jacket, two wear no headgear and have traditionally been identified as butchers (cat. 1 and fig. 41). This identification is plausible and may stem from oral accounts. It could also have been influenced by the forceful – at times overwhelming – presence of red in the representation rather than any specific detail in their attire. Butchers usually wore long aprons but, by the end of the First World War, they also sometimes sported the short white blazer worn by chefs and their garments were often indistinguishable (save for the variable hat).[20] Anecdotes of Soutine painting the store front of the local butcher's shop in Céret, as well as beef carcasses at the nearby slaughterhouse, must have also influenced how these portraits were perceived.[21]

The identification of the young figures in white as 'pastry cooks' is also somewhat fluid: apprentices in small kitchens (such as those of the Hôtel Garetta, where Zocchetto worked) performed a variety of different functions, and in the larger, more specialised ones no specific attributes differentiated the chefs assigned to the bread and pastry stations from the others. What is more, these portraits are often called 'Le "Petit" Pâtissier' (The 'Little' Pastry Cook), an expression of endearment that stemmed from cultural associations beyond Soutine's paintings. Soutine did not care much about the titles of his works (nor indeed about signing them, often leaving it to his dealers) and it is likely that most titles were bestowed by the dealers who marketed the paintings or by the critics and biographers who wrote about them. In many ways, they are revealing of – and unwittingly tainted by – contemporary popular perceptions and tropes related to the professions Soutine depicts. The moniker 'le petit pâtissier' was applied specifically to the swarms of boys that delivered or sold bread and pastries on the streets of Paris, where they quickly became fixtures of urban life and where their pristine kitchen whites ensured they stood out. Advertisements, postcards and popular songs celebrated both their innocence and resourcefulness, qualities that were also applied retrospectively to Soutine's sitters.[22] In addition to Bail (see fig. 12), academic painters such as Paul Chocarne-Moreau specialised in charming genre scenes featuring mischievous pastry chefs acting their age and swaying from their more adult responsibilities (fig. 18). Shown

18
PAUL CHOCARNE-MOREAU
The Wine Thieves (Les Voleurs de vin), 1890s
Oil on canvas, 55 x 46 cm
Private collection

at the Salon and widely reproduced in prints, these sentimental vignettes were extremely popular and contributed to the stereotypes associated with young pastry cooks. Chocarne-Moreau paired his *petits pâtissiers* with other working youth – chimneysweeps (whose soot-stained clothing provided a striking contrast with the apprentice bakers, covered in white flour) and choirboys. The latter were also a favoured theme for Soutine (see, for example, fig. 11) but these earlier, saccharine representations, bordering on caricature, throw his portraits into sharp relief. In his choice of subject-matter Soutine did not tread on neutral ground but instead ventured into the very fabric of French society and its visual tropes. Like previous artists, he seems to have favoured young employees from the lower rungs of the hierarchy, perhaps relishing the awkwardness created by the contrast between the sitters' youth and their professional

responsibilities. His interest may also have had a practical dimension: apprentices were probably among the few workers who had time to pose for the painter, withstood the gruelling hours he imposed and valued the meagre compensation they received. Whatever the case, Soutine's portraits lift their sitters out of any reductive association. They feed off such tropes as the child in adult clothing or the boy becoming a man through work, but Soutine adds an undeniable intensity to his representations and a depth to his sitters, who appear alternately shy and aggressive, humble and arrogant, clueless and savvy.

The page boys, waiters, valets and chambermaids Soutine painted later in the decade were also subject to such cultural superimpositions. Service staff in households and hotels alike was a mainstay of the comedy entertainment of the period, whether in magazines, novels, plays, films or songs. They often take the place of, clash or fall in love with their aristocratic patrons.[23] The immediacy of Soutine's portraits, their perceived grotesque appearance and their eye-catching uniforms inevitably associated them with such stock characters. The bellboys in red (cat. nos. 8 and 9 and fig. 43) were linked by critics and writers with the famous Parisian restaurant Maxim's, a fashionable hotspot that had opened in 1893. However, its employees at the time wore blue trousers with their red jacket, unlike Soutine's models.[24] What is more, it is not known to what extent Soutine frequented Maxim's and the landmark restaurant was certainly not alone in employing bellboys; they were so conspicuous at that period, not only in hotels and restaurants but also in shops and nightclubs, that they embodied the very notion of service and symbolised more widely the excitement and energy that engulfed the city during Les Années Folles. In a contemporary painting by Marcel Gromaire (fig. 20), the vacant, puppet-like bellboy serves as an appendage of the fashionable couple, an attribute that places them in the vibrant setting of the glamorous cabarets and restaurants of Montmartre. Soutine's figures were most likely linked to Maxim's because bellboys were (and remain) its flamboyant trademark, as seen in the playful image by the caricaturist Sem (Georges Goursat) that adorned its menu (fig. 19). *Le Chasseur de chez Maxim's* was also a famous vaudeville play, first performed in 1920 in Paris and adapted for the screen in 1927 (four more

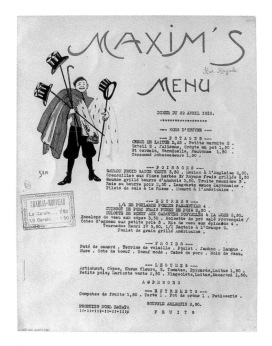

19
Menu from the restaurant Maxim's
dated 1916
Bibliothèque historique de la ville
de Paris

20

MARCEL GROMAIRE
La Place Blanche, 1928
Oil on canvas, 130 x 96 cm
Musée Carnavalet, Paris

versions followed). The use of this specific title from 1930 onwards in designating Soutine's portraits of bellboys thus demonstrates the influence of contemporary culture on their reception.

The perceived correlation between Soutine's figures and popular entertainment raises the issue of authenticity and artifice: did Soutine portray actual hotel and restaurant workers or were his models playing dress-up? The question remains ambiguous in the case of his depictions of choirboys; their traditional obligation to leave vestments in the sacristy made it difficult for them to pose in full dress for Soutine. Biographers have recounted stories of village children 'borrowing' ecclesiastical outfits at the painter's request, although these anecdotes remain speculative.[25] We can, however, be certain of the paramount importance that Soutine attached to working from the live model and the taxing sessions he imposed in the studio.[26] The identification of Zocchetto as the Barnes *Pastry Cook* supports the artist's commitment to authenticity and presence and it is highly likely that all of his sitters are depicted in their true professional clothing. What is more, Soutine imbues his sitters with a genuine sense of agency and pride. Their assertive poses – frontal, close-up, hands on hips – recall those found in the photographs that young apprentices sent home as postcards upon completion of their training (see, for example, fig. 21). They recur in contemporary artistic photography, as in André Kertész's double-page spread, *L'Élégance du métier* (The Elegance of the Trade),[27] published in the photo-reportage magazine *Vu* in April 1933 (fig. 22). It is composed of eight photographic portraits of workers taken by Kertész a few years earlier in the streets of Paris. Counting among others a chef, a dairywoman and a butcher, the vignettes feature manual workers in their professional uniforms. The pride and flair with which they wear their occupational garments are a witty allusion to the rest of the volume, devoted to fashion. Soutine's series finds some echo in the work of Kertész and his compatriot Brassaï, both Hungarians who settled in Montparnasse in the mid 1920s and sought to highlight life in the side streets and underbelly of Paris. Like Soutine, they ventured in markets, restaurant kitchens and the back corridors of hotels; all three artists shared an interest in pulling figures out of the shadows, in capturing distinctive individuals who also embodied modern urban life. However, the photographers' approaches, focused on

21
Postcard of the apprentice pastry cook Maurice Boniz, addressed to his uncle and aunt, 19 November 1909

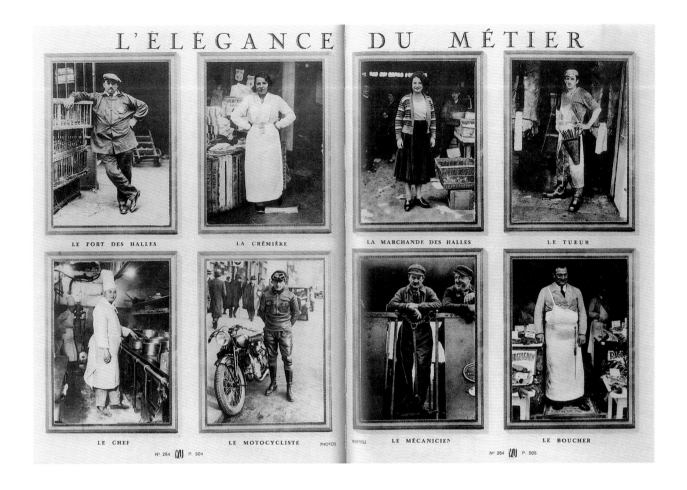

LE FORT DES HALLES LA CRÉMIÈRE LA MARCHANDE DES HALLES LE TUEUR

LE CHEF LE MOTOCYCLISTE LE MÉCANICIEN LE BOUCHER

N° 264 VU P. 504 N° 264 VU P. 505

mapping society and on drawing out types in an almost documentary fashion, were less ambiguous and equivocal than Soutine's.

 The strong, proud poses of some of Soutine's sitters find one additional resonance: they stem from the grand portrait tradition, as explored by Barnaby Wright in his essay above, and recall to some extent the swaggering attitude of immortalised aristocrats and kings – or, in the case of one especially striking portrait of the modern period, of another 'master of his domain'. The subject in William Orpen's *Le Chef de l'Hôtel Chatham, Paris* (fig. 23) seems to burst out of the canvas, his bright, immaculate chef's jacket and hat strikingly set against a dark background. A still life of his trade – a bottle and a glass of red wine, raw meat chops, a knife resting on a tea towel – are laid out on the thin ledge separating him from the viewer. In spite of this, he does not look like a worker; rather, his striking pose, with hands on hips and indexes tucked in his apron, his pensive expression, not

22
ANDRÉ KERTÉSZ
L'Élégance du métier, in *Vu*, no. 264,
5 April 1933

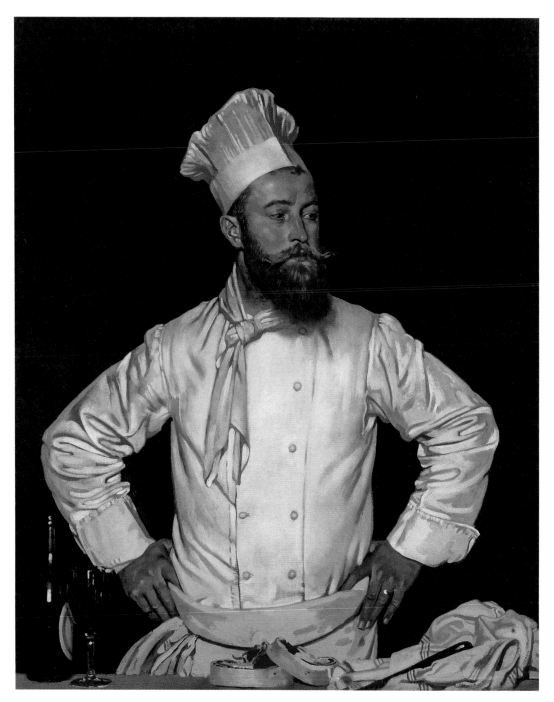

23
WILLIAM ORPEN
Le Chef de l'Hôtel Chatham, Paris, c. 1921
Oil on canvas, 127 x 102.5 cm
Royal Academy of Arts, London

Detail of cat. 6

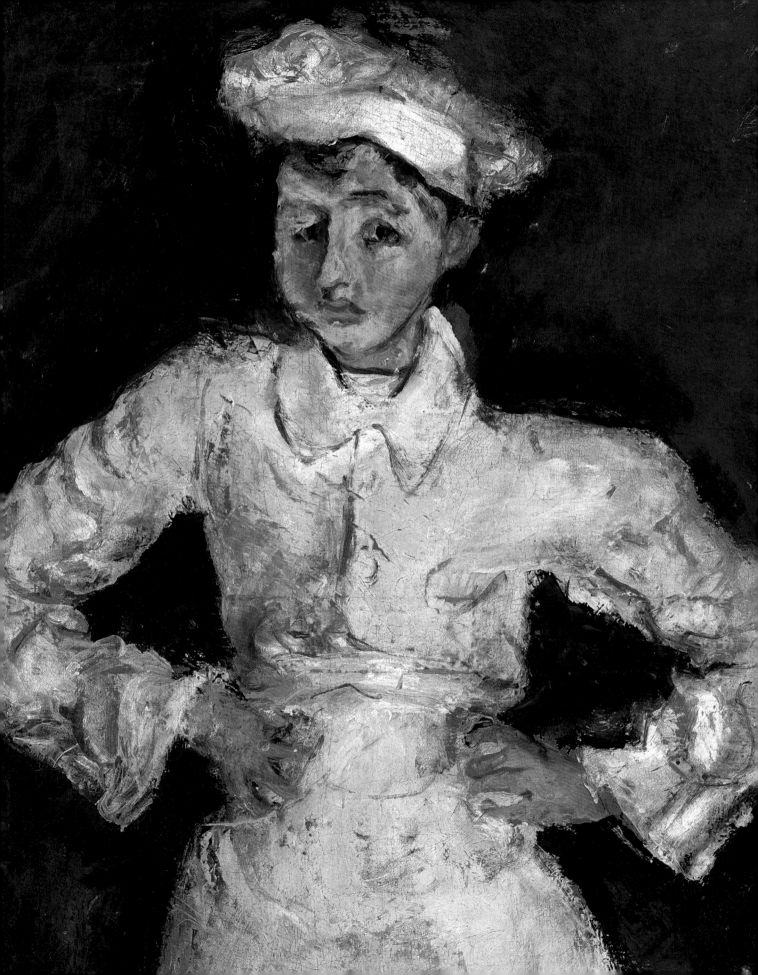

to mention his neat beard and long moustache, conjure the authority and monumentality of a nobleman. The painting is very unusual, most notably for depicting a famous chef, one not attached to an aristocratic family but working for paying customers. Even though Orpen differs strongly in terms of attitude and approach, his painting stems from the same broad cultural context as Soutine's series.

In contrast to the chefs' whites – professional garments imposed by tradition and practicality rather than by their employer – the 'front of house' staff Soutine painted from the mid 1920s all don formal and elegant uniforms intended to signal their role and rank within the organisation. These specific and compulsory liveries echo the principle of military uniforms but relate even more closely to the attire worn by their spiritual predecessors in the service of aristocratic families, a reflection of the fact that the very organisation of grand hotels and restaurants was modelled on those of noble households. Unlike aristocratic landlords, however, hotel guests were not familiar with the vast personnel waiting on them; it was thus critical that uniforms clearly conveyed function and matched each employee with their task. The uniform had to be both universally recognisable, adhering to codes that spanned hotels around the world, and distinctive enough to set the specific establishment apart. This was partly achieved by having the name of the venue embroidered on a cap or cast on the gold buttons of a blazer (fig. 24). Uniforms could be custom-made in-house by resident tailors or purchased from dedicated suppliers.

24

SÉEBERGER FRÈRES
*Uniforms of the porters and bellboys
of the Hôtel Édouard VII, seen from the
front and back,* 1926
Gelatin silver print
Médiathèque de l'architecture
et du patrimoine, Paris

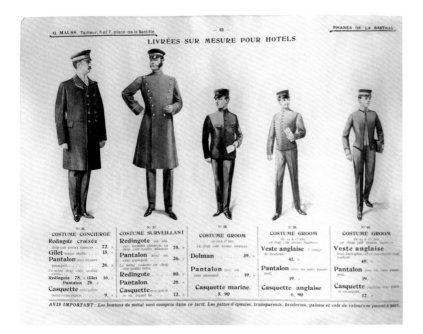

G. MAUSS, Tailleur, 5 et 7, place de la Bastille — 10 — PHARES DE LA BASTILLE

LIVRÉES SUR MESURE POUR HOTELS

N° 36. COSTUME CONCIERGE	N° 37. COSTUME SURVEILLANT	N° 38. COSTUME GROOM	N° 39. COSTUME GROOM	N° 40. COSTUME GROOM

25
Page of the trade catalogue published by the tailor G. Mauss advertising 'Liveries made to measure for hotels', 1907

As advertised in the trade catalogue of a specialist tailor, bellboy uniforms were meant to fit fourteen- to fifteen-year-old boys and came in all colours (fig. 25). Indeed, the choice of hues for uniforms depended on whether the wearer was meant to stand out (in order to be easily hailed across the lobby, as a page boy in a red jacket) or blend in (a waiter in a black suit gliding through the dining room for example). In the words of one author, the grand hotel "is populated by a remarkable species of human: optimally trained to be both present and absent at the same time ... never overbearing but always at hand when needed, and organized in a strict hierarchy".[28] Professional garments for hotel and restaurant workers were also available off the peg, although they were reserved mostly for staff in smaller establishments or back of house. As its catalogue attests, Maison Braillon catered to cooks, waiters, valets, chambermaids and many others (fig. 26).

As mentioned, it is likely that Soutine painted his sitters in his studio and not at their workplace: despite all their amenities, hotels could not provide Soutine with the absolute isolation and space he needed to work. Soutine's prolonged sojourns in country estates from the end of the 1920s, however, offered more favourable conditions. To one of Soutine's early biographers, a witness reported

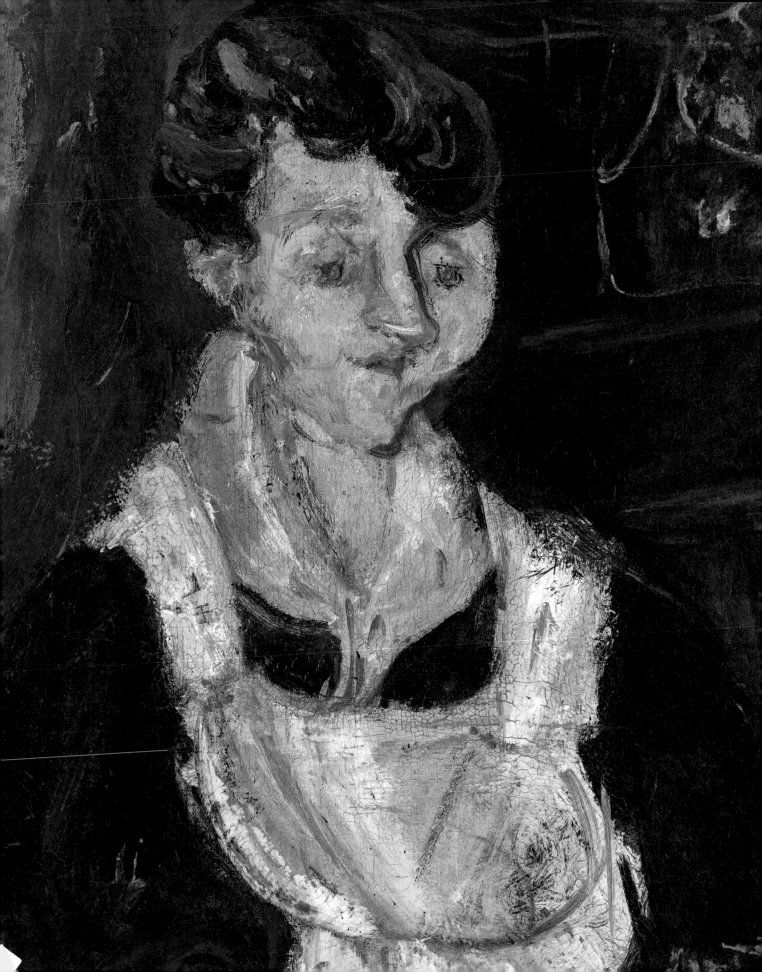

AUX HALLES CENTRALES

MAISON BRAILLON

17 15 96

20 44

98

21 19 162

43 25

PARIS — 35, rue Berger, 35 — PARIS

TÉLÉPHONE 279-37

that the painter portrayed one of the chambermaids employed by
Faure while staying at the family's summer home in Prats.[29] Another
stated that the Castaings' cook, Jeanne, also sat for Soutine.[30]
Soutine's change in lifestyle thus marked a shift in focus in his
interest in uniformed figures, moving from the commercial to the
domestic, from male to female sitters, from formal to informal
attire. Domestic servants in the 1920s and 1930s were almost
exclusively women (chauffeurs were a different category) and
operated in a different, less hierarchical environment than Soutine's
previous sitters in uniforms. Their wardrobes were less codified and
more subdued, even more so when working in the rural setting of
country estates.[31] Often, cooks and maids simply added an apron
over their street clothes to undertake their tasks. The presence of the
apron in Soutine's portraits of female domestic servants in the late
1920s denotes his continuing interest in the theme (cat. nos. 19–21).
Had he been interested solely in the individual, he could have easily
asked them to set their apron aside. The garment thus adds a layer
of meaning to their portraits and bestows a function and an identity
defined by the nature of the sitters' work.

Detail of cat. 21

As we have seen, several painters before Soutine were drawn to the dichotomy between the individual and their social role, embodied by sitters in uniform. However, few artists shared Soutine's interest and prolonged commitment to this type of portrait – anonymous yet profound, codified yet complex. One must therefore wonder what drew Soutine to this theme in the first instance and what sustained its appeal to him for over a decade. Undoubtedly, the attraction was first and foremost aesthetic. Through the bold, blocked hues of their uniforms, Soutine embraced his fascination with colour and pursued his stylistic evolution. It would, however, be remiss not to question whether Soutine identified with these sitters. Perhaps more resonant and fruitful than their status as immigrants or outsiders, as has previously been suggested,[32] is Soutine's attitude towards their profession. Soutine's particular circumstances in the 1920s and 1930s involved an unusual personal dependence on his dealers and patrons for subsistence and support. At the same time Soutine exercised control by apportioning the works these collectors craved. One can therefore speculate that he may have felt a certain empathy for his sitters as modern servants facing the contradictions of a job that gave them status but kept them subjugated.

Artists' identification with figures on the margins of society, with the downtrodden and the overlooked, is a trope of art history. However, it does not fully apply here. The bellboys, cooks, waiters and valets working in France in the 1920s were not disregarded segments of society: they were ubiquitous in bourgeois life – in many ways, the symbols of its flourishing leisure, consumer and cultural industries. They constituted a vital part of the new economy and the social changes that characterised France at that period. Many developed careers that offered promotion and advancement through the ranks. In his portraits, Soutine has extracted his figures from their environment to focus on the individual all the while maintaining the complex resonances his sitters carry, resonances linked to their condition as 'modern servants' in a booming industry and to the visual and cultural prejudices associated with their types. Although this was undoubtedly not Soutine's overt intention, his figures constitute a rich site for thinking about modernity and the renewal of portraiture.

1 Waterfield and French 2003.
2 For a comprehensive account, see Golan 1995 and Green 2001.
3 Lesur 2005, p. 188. See also Léri and Lafargue 1998–99 and Tessier 2012.
4 Orwell 1933 (2001), pp. 72–73.
5 The most influential were Léospo 1918 and Boomer 1925. See also Réal and Graterolle 1929 and Gautier 1932.
6 See the trade catalogues of Au Petit Matelot, G. Mauss. Grandes Livrées and Phares de la Bastille. 'The Old England' department store opened their commercial livery department in 1914. The Bibliothèque historique de la ville de Paris holds an extensive collection of these pamphlets (Département des documents éphémères, série 120).
7 Réal and Graterolle 1929, p. 365.
8 Léospo 1918, p. 245.
9 Françoise Dehon-Poitou, 'Syndicats, mouvements sociaux et droit du travail de la Belle Époque aux années d'après-guerre', n. p., paper given at the symposium Histoire du travail dans l'hôtellerie et la restauration sur la Côte d'Azur au XXᵉ siècle, held in Nice on 29–30 March 2007, published online at https://www.departement06.fr/documents/Import/decouvrir-les-am/rr189-hotelleriexxe.pdf, accessed 10 May 2016.
10 Werner 1977, p. 126. See also Castaing and Leymarie 1963, p. 27, Courthion 1972, p. 94, and Maurice Tuchman, 'Chaim Soutine (1893–1943). Life and Work', in Tuchman, Dunow and Perls 1993, pp. 13–26, at pp. 15 and 20.
11 Orwell 1933 (2001), p. 74.
12 Lesur 2005, p. 193.
13 Soutine's stays in Châtel-Guyon are documented in the seasonal local paper, L'Écho de Châtel, which, for a few years, recorded the names of all the tourists staying in the city. In 1926, he arrived in the week of 18 August and was accompanied by Zborowski. In 1927, he came around 8 August and was accompanied by Marcellin

and Madeleine Castaing. In 1928, he arrived before 26 August; only Marcellin Castaing seems to have been with him.
14 Courthion 1972, p. 94.
15 See for example Castaing and Leymarie 1963, p. 28; Tuchman 1968, pp. 37–41; Marevna 1972, p. 158; Michaelis 1973, pp. 57–58; Jeanine Warnod, 'Soutine and the Artists of La Ruche', in Güse ed. 1981–82, p. 30, and Collié 1944 (2002), pp. 10–11.
16 Guillaume 1923, p. 6.
17 See LeBrun 2015 and Soutine's few letters, published by Richard ed. 2015, which give a sense of his constant travels.
18 Stone 1970, p. 56. See also Matamoros ed. 2000, pp. 66–68.
19 One of Soutine's young sitters in Cagnes, Marie Jacobelli, identified, decades later, a few of his other models, including the young Georges Claret, who reportedly posed as a petit pâtissier: oral testimony to Richard ed. 2015, n. p. (notes to letter 7). We have been unable to verify whether Claret was indeed an apprentice baker or indeed find him in the Cagnes registers.
20 Williams-Mitchell 1982, p. 94.
21 Recollections of Edmond Brazès and Louis Fortunet, quoted by Joséphine Matamoros, 'Chaim Soutine in Céret: immersion in the site', in Matamoros ed. 2000, pp. 33–82, at p. 47. A sketchy painting of a butcher's shop by Soutine from that period seems to confirm these anecdotes: Butcher Stall, c. 1919, oil on canvas, 55 × 38 cm, private collection, reproduced in Tuchman and Dunow 2002, p. 147, and in Restellini ed. 2007–08, no. 27, p. 93.
22 Of the seventy-three song sheets in the Bibliothèque nationale de France that were published between 1870 and 1939 and deal with the theme of cakes and pastries, almost 80% relate to the exploits of apprentice bakers: Coline Arnaud, 'Histoire culturelle de

la pâtisserie: facteurs et enjeux de la démocratisation du sucré entre 1870 et 1914', report on ongoing doctoral research: https://bnf.hypotheses.org/791, accessed 15 November 2016.
23 Famous films include Charlie Chaplin's Caught in a Cabaret and Dough and Dynamite (1914); Buster Keaton's The Bell Boy (1918); and Le Groom no. 13 (1923). The plays La Grande Duchesse et le garçon d'étage (1924) and Un bon garçon. Opérette en 3 actes (1926) had their opening nights in Parisian theatres. See also Merlin James's essay in this catalogue.
24 Roman 1939, p. 11.
25 LeBrun 2015, pp. 347–49, recounts the unsubstantiated stories about where and when Soutine painted his series of choirboys. Richard ed. 2015, n.p. (notes to letter 7), reports that Jacobelli (see note 19) told him that her friend Marie Santignoli once posed for Soutine in her first communion outfit.
26 On Soutine's reliance on the live model and his painting practice, see Wheeler 1950–51, pp. 79–83; Sylvester and Tuchman 1963, p. 4; Castaing and Leymarie 1963, pp. 8 and 28; Marevna 1972, pp. 158–59; Madeleine Castaing, 'Memories of Soutine', in Güse ed. 1981–82, pp. 15–16, and Esti Dunow, 'Soutine as a painter from life: his relationship to the motif', in Matamoros ed. 2000, pp. 17–31, at p. 18.
27 Romy Golan makes this comparison and publishes the photograph in Golan 1995, pp. 147–49.
28 Klaus Honnef, 'Photography and Adventure', in Holten ed. 2014, pp. 62–73, at p. 70.
29 Courthion 1972, p. 94.
30 Courthion 1972, p. 99, and Castaing in Güse ed. 1981–82, p. 16.
31 See Tuchman 1968, p. 47.
32 Courthion 1972, p. 94, and Tuchman in Tuchman, Dunow and Perls 1993, pp. 13–26, at pp. 15 and 20.

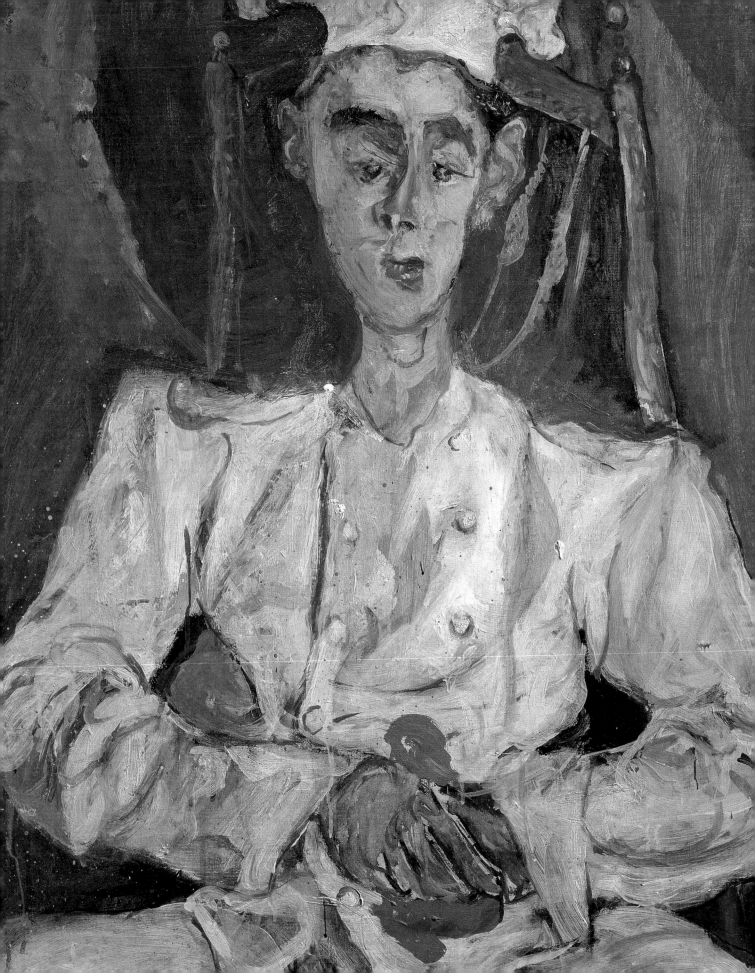

MATIÈRE AND MÉTIER
SOUTINE'S *THE LITTLE PASTRY COOK* AND OTHER PERSONAE

Merlin James

ON FIRST IMPRESSION, *The Little Pastry Cook* by Soutine (cat. 3) could be taken for an image of a clown, a sailor, even a priest. And those associations remain, even after he is clearly recognised as a cook. There is certainly some kind of comedy – and tragi-comedy – in the picture, a fancy-dress forlornness that echoes archetypes from the circus and the Commedia dell'arte.[1] This cook seems descended in part from the dreamy simpleton-saint of Jean-Antoine Watteau's famous *Pierrot* (fig. 27). But marine connotations are reasserted by the compositional sway, the tipped horizon of the figure's shoulders, the ragged rigging and billowing forms of the background. Arms are akimbo, hornpipe fashion, and there is the pennant-like signal of that red triangle at top right. Then, equally, priestly qualities keep resurfacing in the echoes of Renaissance portraits of popes and cardinals such as Diego Velázquez's *Pope Innocent X*, vested with grandeur and dignity yet making very human eye contact with the viewer (fig. 29).

But, since it is ultimately clear (even without the work's title to tell us) that Soutine's painting does depict a chef, what part do such 'ghost' readings – clown, sailor, priest – play in the work? Broadly, they open up the metaphorical registers of the image. Perhaps it invites reflection on the ways in which any individual may be a fool, may be tossed on stormy waters, or may have grace, bestow blessing. And in the light of such analogues, the role of cook itself begins to reveal its own mysteries, its poetic resonances. They are ones that may or may not have been embodied in, or 'lived' by, the particular historical person who modelled for the artist (indeed, the question of that match or mismatch of the man with his mode is partly what the picture addresses), but the character – in theatrical terms the 'part' of the Pastry Cook – is cast as something profound and iconic.

Detail of cat. 3

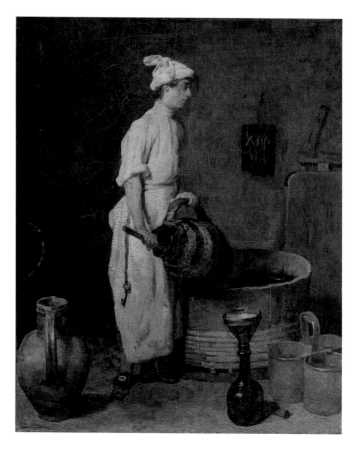

Soutine's treatment finds pain and poignancy in a motif that might easily have been dismissed as trifling, or even ludicrous.[2]

Cooks, even pastry cooks specifically (like other traditional tradesmen or types – 'tinker, tailor, soldier, sailor ... '), have a certain place in the popular imagination, not least in nursery rhyme and folklore. One French children's song, 'Ayez pitié d'un p'tit pâtissier, dont l'amour se perd' (Take pity on a little pastry cook, whose love is lost), plays on the names of pastries,[3] and in the German folktale *Das Märchen vom Popanz* (The Tale of the Bogeyman), a picaresque *Pastetenbäcker* (pastry cook) woos a princess with sweetmeats containing gold coins, and becomes a prince.[4] In European painting, prior to Soutine's renditions of them, cooks and other below-stairs servants tended to feature only in saccharine genre pictures, sentimental derivations from seventeenth- and eighteenth-century kitchen scenes (see Karen Serres's essay in this catalogue). Jean-Baptiste Siméon Chardin's *Cellar Boy* (fig. 28), strangely Liliputian

27
JEAN-ANTOINE WATTEAU
Pierrot, formerly known as Gilles,
c. 1718–19
Oil on canvas, 185 × 150 cm
Musée du Louvre, Paris

28
JEAN-BAPTISTE SIMÉON CHARDIN
The Cellar Boy, c. 1738
Oil on canvas, 46 × 37.2 cm
The Hunterian, University of Glasgow

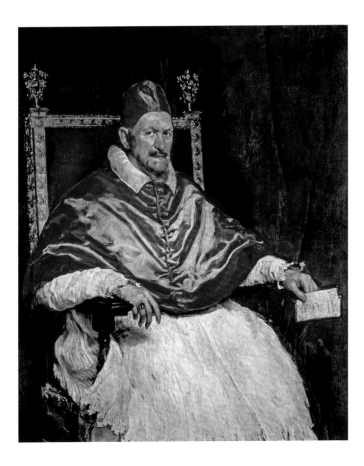

29

DIEGO VELÁZQUEZ
Pope Innocent X, c. 1650
Oil on canvas, 141 x 119 cm
Galleria Doria-Pamphilj, Rome

amid a still life of wine cellar receptacles, is a rare precedent for Soutine in the tender respect it accords its aproned subject.

Chefs and bakers had been viewed with more seriousness in nineteenth- and twentieth-century photography, for example by the Alinari studio in Italy. But the pictures were mostly either staid portraits, documentary social records or nostalgic evocations of picturesque *petits métiers*.[5] One photographic image, though, from the same decade as Soutine's cook paintings, and rivalling them in gravitas, is *Pastry Chef* (fig. 30) from August Sander's 'Face of Our Time' (*Antlitz der Zeit*) series. There is a pride and even haughtiness in Sander's chef that defy us to make light of his craft or find anything risible in the roundness of his body (and head) in relation to the bowl he is stirring. Regular rows of tiles, tins, tarts, rivets and buttons project him as a Kaiser in command of his kitchen empire. While Soutine's *Little Pastry Cook* has a different kind of presence, skinny and laconic rather than rotund and robust, the two images

30
AUGUST SANDER
Pastry Chef (Konditormeister,
Köln-Lindenthal), 1928
Gelatin silver print
Die Photographische Sammlung/
SK Stiftung Kultur – August Sander
Archiv, Cologne

achieve similar syntheses – and tensions – between the ineffable individuality of the living model and the emblematic significance of their vocation and vestments. These figures are visual equivalents to memorable ones in literature such as Wallace Stevens's *Emperor of Ice Cream* (1922), who whips up "concupiscent curds" for a wake,[6] or the warped and weary pastry cook in Raymond Carver's 1982 story *A Small, Good Thing*, whose comfort food becomes a kind of a communion as he shares it with the parents of a dead child (see fig. 31).[7]

Like *The Little Pastry Cook*, many of Soutine's other 'livery' portraits, especially of cooks and hotel or restaurant staff, induce the same double- or triple-take in the viewer, evoking other kinds of figure than that actually portrayed. *Le Chasseur de chez Maxim's* (*Page Boy at Maxim's*; cat. 9), for example, with his wounded expression and solicitous gesture, irresistibly suggests a lame military veteran asking for alms (*chasseur* in the French army refers to an infantry soldier). *Le Groom* (*Bellboy;* cat. 8) has equestrian associations, as if he could be a mounted huntsman (another kind of *chasseur*) or a Cossack. The face, at the same time, might be taken for a woman's. *Little Pastry Cook* (cat. 2) suggests an army field surgeon, a barber, even a conjurer. His pose meanwhile echoes those of renaissance full-lengths of prelates and noblemen – poses Édouard Manet had reprised for bohemian and low-life types such as his *The Absinthe Drinker* (fig. 32). This layering of identities enriches the subject in each case, helping convey the protean instability and ambiguity of human being and asking whether or not 'the cap fits' – whether the clothes make the man.

But why is this multiple-personality effect in Soutine's portraits something more than the momentary misreading one might have of any depiction of a uniformed figure? It functions within a whole complex of other associations at play in the painter's images that sets them apart from conventional portraiture. These associative meanings are largely generated and channelled by the gestural looseness, the dynamic physicality of his paint. Form becomes volatile and surfaces vibrant, facial expressions, bodily gestures and poses appear mobile, spaces unstable and objects ambiguous. Matter can be ectoplasmic, perspectives elastic, focus fluctuating. His paintings suck us into a state of consciousness in which details catch

31
Lyle Lovett as Raymond Carver's pastry cook in the film *Short Cuts* (dir. Robert Altman, 1993)

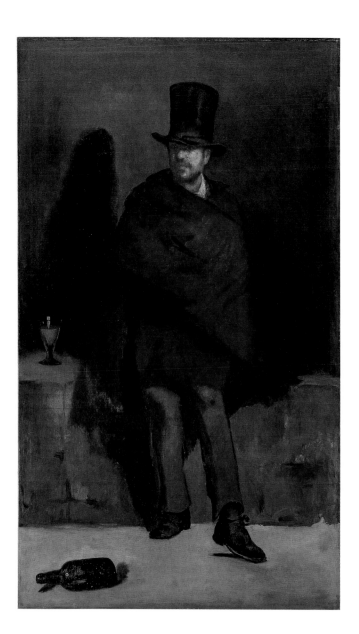

32
ÉDOUARD MANET
The Absinthe Drinker
(Le Buveur d'absinthe), c. 1859
180.5 x 105.6 cm
Ny Carlsberg Glyptotek,
Copenhagen

the eye, become disproportionately significant, then slip back into
the visual swim as some other feature takes attention. At moments he
can be close to aspects of Cubism, as in *The Little Pastry Cook* (cat. 3)
where one ear is flattened to the picture plane, one eye seemingly
seen in profile. Yet this is not calculated pictorial experimentation,
more a stirring of the mixing bowl of painting's ingredients.
The resulting distortions can even be comparable with Salvador
Dalí's Surrealism of molten bodies and objects, yet Soutine is not
illustrating ideas from psychology. Rather, in the radically energetic

Detail of cat. 2

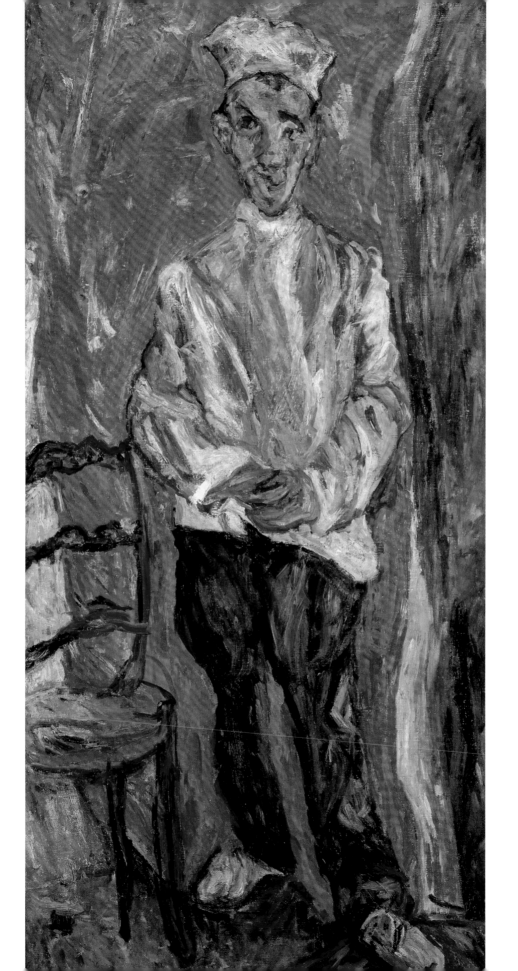

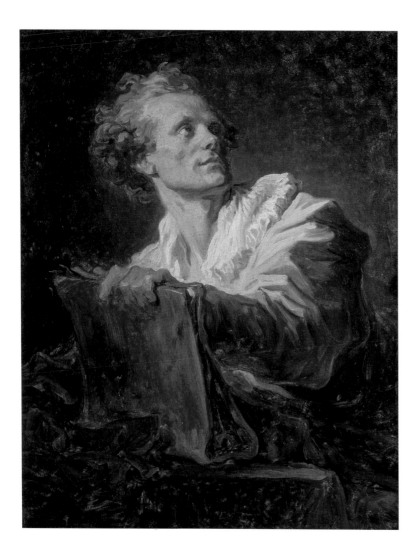

attack of his work, everything is subject to change and revision, up for grabs pictorially, and by implication emotionally and semantically.

Few painters before Soutine had unleashed such painterly vigour, or let it distort the motif as fully. In pre-modernist art, aside from the exceptional proto-expressionism of El Greco (crucial for Soutine), one might look to Rococo painting for any foretaste of Soutine's flurried, fluid energy. In Jean-Honoré Fragonard's character studies of actors and artists, paint melts into near abstract fields and pools of pure descriptive and expressive potential, then gathers into likeness and personality (fig. 33). The volatile, performative nature of human life and identity is celebrated, summoning a notion of selfhood as (like a work of art) a marriage of *matière* and *métier* (matter and craft).

34
LUDWIG MEIDNER
Max Hermann-Neisse, 1913
Oil on canvas, 89.5 x 75.6 cm
Art Institute of Chicago

Even in the context of twentieth-century painting, with its tendencies to greater abstraction, it's hard to find really close precursors to Soutine. Austrian or German Expressionists such as Oskar Kokoschka or Ludwig Meidner bear comparison (fig. 34), but in them there is typically the sense of an emotive manner that is being *applied to* the motif. Soutine's marks, by contrast, seem entirely the product of an active scrutiny of and response to the subject. The result is a far more varied and inflected emotional and formal repertoire than that of most of his Expressionist School colleagues. He rarely slips into the predictable angst and febrile existentialism of gnarled, wringing knuckles, crabbed, hunched poses, imploring or manic gazes.

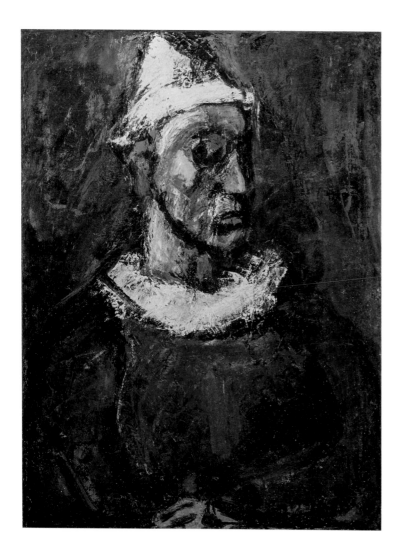

35
GEORGES ROUAULT
Clown, 1912
Oil on canvas, 89.8 x 68.2 cm
Museum of Modern Art, New York

In French painting, one might look to Georges Rouault as having pioneered a spontaneity of mark comparable with Soutine's, furthermore playing with interchangeable *dramatis personae* including clown/saviour, whore/madonna, lawyer/priest (fig. 35) – indeed, Rouault became famous for his own self-styled painter's costume, blending elements of chef, pastor and medic (fig. 36). But again, his is not quite Soutine's territory. Rouault's painted personages remain anonymous fictions, removed from the viewer in a kind of poetic, proverbial realm. Soutine hints at those dimensions, but always as part of an intense, direct encounter with a real, unique man, woman or child. We believe implicitly that his models sat there before him over a period of time, and are captured

36
YVONNE CHEVALIER
Georges Rouault in his studio, 1953
Photograph
La Fondation Georges Rouault, Paris

on the canvas, as surely as we accept the temporal instant recorded in Sander's photographs. As with those, we speculate about the identities of the models. We wonder who they *really were*, and finally what *really being* someone actually means.

Soutine's radically expressive manner is nevertheless often assumed to tell us about the artist rather than his subjects. With Vincent van Gogh frequently invoked as a precedent, Soutine's pictorial dysphasia is easily assumed to reveal his inner turmoil and traumas. He had escaped the oppression of the *shtetl*, weathered the First World War and abject poverty in France, suffered from crippling shyness and was almost a social outcast before sudden financial success. The temptation is to see even his final ordeals,

hiding from the Nazis and dying from stomach ulcers, as somehow anticipated in his work. *The Little Pastry Cook* (cat. 3), with hands anxiously clenching the red rag to his belly, can easily be read as churned up, spiritually or physically. But at least as much as they are self-expressive, Soutine's wildly activated brushwork and fluctuations of scale and viewpoint are generators of various and particular metaphoric meanings in each painting. In the case of the portraits we might surely entertain these meanings as relating first to the sitter – if not actually the historical individual who sat for Soutine, then the specimen of humanity he presents them as – on whose life experiences we can only (yet cannot help but) speculate.

For example, Soutine's expressionism gives his figures the appearance of being in various ways subject to energies outside, and greater than, themselves. *Little Pastry Cook* (cat. 2) has a lightning- struck conductivity, the live current of the composition flowing through him. *Room Service Waiter* (cat. 12) exists as a violent convergence of tectonic plates that might just as suddenly fly apart. When posed (as often) with hands clamped to the waist, Soutine's figures give the impression of gathering and condensing an ambient charge from the surrounding fields of colour and gesture into their own cores, pulling themselves together for the business of living. Without reducing his sitters to cyphers of his own psyche, Soutine proposes that to be alive is to owe one's being to a greater creativity, just as a painted figure is the creation of an artist. This condition is constantly refigured in the emphatic painted-ness of his people, and enacted most startlingly in *Little Pastry Cook* (cat. 2), where the curtain behind the figure becomes synonymous with the canvas of the painting itself, which then appears to billow, tug and rip away from the stretcher it is tacked to, in turn crumpling and warping the figure painted on it.

The powers that adumbrate and animate us also restrict and control us, and the human condition evoked by Soutine's paintings is one of inevitable mutual tension between activity and passivity, freedom and limitation. The much-reiterated negative spaces – background and in-between areas – in Soutine's portraits, painted as actively as the figures, encroach on the contours of the sitters, squeezing and moulding them, defining them, continually reasserting their boundaries. *Cook of Cagnes* (cat. 5), for example,

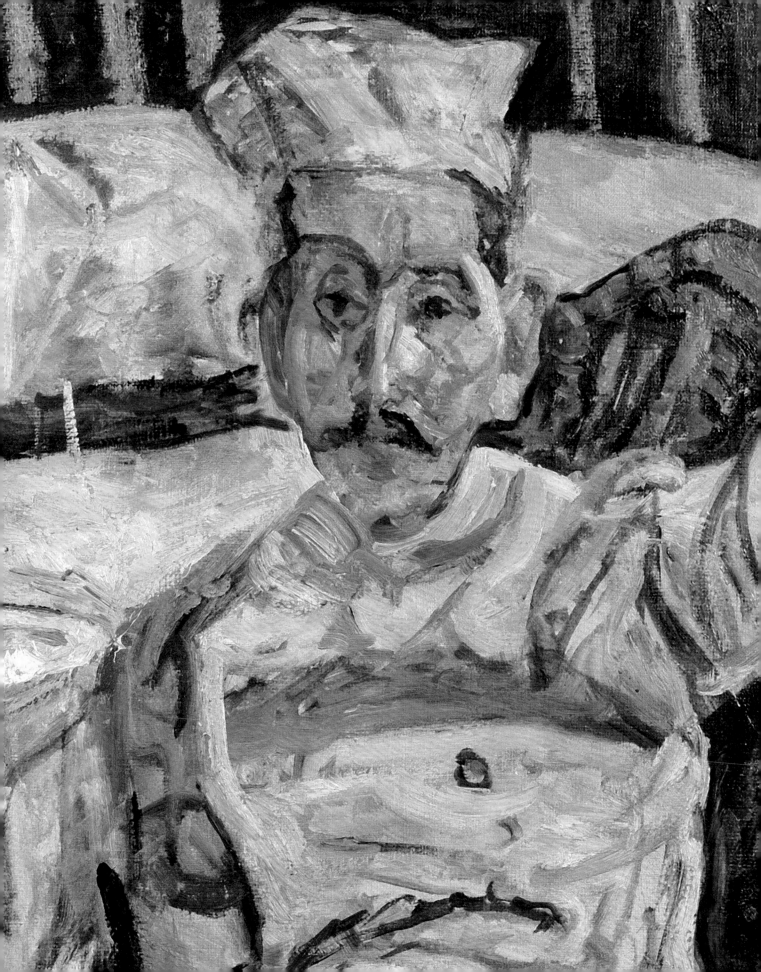

37

THÉODORE GÉRICAULT
*Portrait of a Woman Suffering from
Obsessive Envy (La Monomane de
l'envie)*, c. 1822
Oil on canvas, 72 x 58 cm
Musée des Beaux-Arts, Lyon

is crowded and compressed by the shapes round about him, and
Soutine leaves provisional the position of his arms, which flail then
flop in unresolved pictorial process, giving a final impression of
someone slumped resignedly in a kind of straightjacket. *The Little
Pastry Cook* (cat. 3) is less crushed by context but, fabricated from
braids and skeins of paint strung out across a frame, he becomes
marionette-like, as if suspended in wobbly animation from points at
the ears, shoulders, elbows and knees. The visual agitation of marks
across the surface, as well as the dynamic tilts of the composition,
suggest his potential to twitch and jerk into articulation, but not of
his own volition.

The same powers that drive us not only delimit us, they even damage and destroy us. Soutine's people are not just galvanised-yet-restrained by forces, they are buffeted and wrenched and rent by them. Their uniforms, worn to present fronts of efficiency, cleanliness, order and decorum, become in his rendering tattered and torn, stained and besmirched. Facial features repeatedly suggest expressions of hurt or sorrow, marks of mental distress (note the affinity with Théodore Géricault's asylum portraits; fig. 37) or even the effects of blows or other violence. Of course, we know these are qualities of the painterly language that describes the figures, and that Soutine is not showing us literally sullied, wounded, deformed or conflict-torn individuals. But he is allowing those connotations to travel from his facture to their form and features, and to speak of what individuals may privately endure. In *The Little Pastry Cook*, the paint is whipped, beaten and splatted, and the suggestion – as much as of someone who knows the ropes of baking and icing cakes – is of punishment and stress. The face, laced with cadmium and sporting its out-of-joint nose and slurred mouth, could be that of a punch-drunk boxer in his corner of the ring.

To be straightjacketed, to be manipulated like a puppet, to feel knocked out or dead beat – these are figures of speech one might use of many situations, perhaps most typically of a job, a living. In depicting waiting staff and servants, Soutine chose professions in which there might be especially pointed questions of exploitation, dignity versus humiliation, mutual respect or contempt between servant and superior.[8] In the ambiguously fluid features of Soutine's portraits we may well think we detect sneers (cat. nos. 2 and 10), indignation (cat. nos. 8, 12 and 18) or exhaustion (cat. 3). Again, we know Soutine is not illustrating specific facial expressions here, but he suggests them. And he sometimes gives us viewpoints looking down, as if condescendingly, on so-called *garçons* – they are often ageing – and on chambermaids (cat. nos. 19–21). Even for pastry cooks, as already suggested, there may be some similar sensitivity about their status. Soutine's *pâtissiers* are sometimes called 'petits'; among other associations, the diminutive accords with a distant derivation of Soutine's portraits from old master pictures of palace staff, servants and minor court familiars, of which the classic examples are Velázquez's paintings of dwarfs.

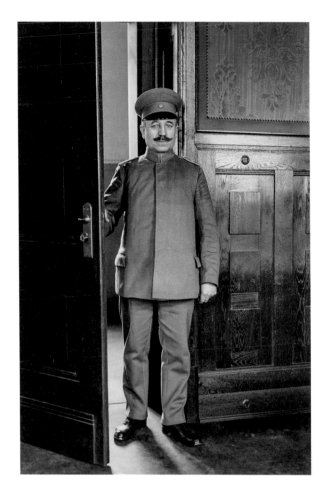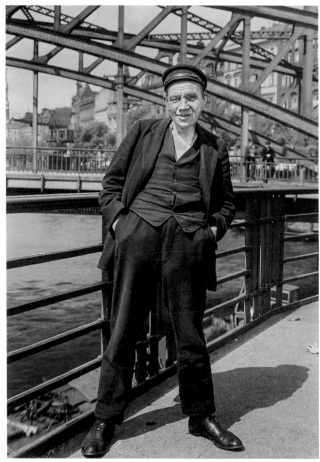

As Sander's *Pastry Chef* demonstrates, it is not only painted portraits that may address difficult distinctions between individual and circumstance, the garment and the man. Across all Sander's photographs, such concerns are crucial. His *Court Usher* (fig. 38), like some figure popping out of a panel in a mechanical clock, looks too small for his uniform, and for the big door and high dado panelling framing him. They define him as, in the larger sense, a small person, while his quizzical look attempts to find a dignity somewhere between the self and the institution of which he is a mere function. Sander's *Unemployed Sailor* (fig. 39) is by contrast a big, dynamic guy, a giant to the distant figures behind him. But again he is not high-ranking. The cap could say railwayman or postman but the missing tooth, tattoo, broken nose and rolling gait all mark him as a mariner. In his heavy old civvies under

38, 39
AUGUST SANDER
Court Usher, 1932, and
Unemployed Sailor, c. 1928
Gelatin silver prints
Die Photographische Sammlung/
SK Stiftung Kultur – August Sander
Archiv, Cologne

the midday sun, fists trapped in pockets, he'd be more in his stride at sea.

All this is very close to Soutine's portraits, but Soutine's semantic resources are hugely increased by the use of the haptic, mimetic language of painting. Lip service is often paid to the physicality of his brushwork, but too often implying that he invariably used impasto, loaded on with stiff hog-hair brushes, and that in some generalised way this fatty paint has an equivalence to 'the human clay': In fact, his paint is very varied in application, picture to picture and often within single works.[9] Frequently he uses thin paint, in sketchy filigree or washes not dissimilar to watercolour. Spatters, drips and speckles are often deployed. The paint may certainly be bodily, but in diverse and unexpected ways. Sometimes it evokes veins and circulating corpuscles, microscopic cells and slippery enzymes (one might think of the traditional character categories of phlegm, blood and bile). Often the composition seems to consist of soft tissue and membrane over a hard framework, like layers of muscle and skin stretched over a skeleton. Clothing is rendered as coatings of paint quite similar to those that describe flesh – simply as further layers and extensions of the presence, the presentation, that is the person. Soutine is no virtuoso painter of the folds of drapery nor does he expertly indicate the volume of bodies beneath. Rather, dressed torsos are treated as fields of paintwork that reiterate the flat picture plane but often simultaneously suggest a sort of x-ray transparency. They promise worlds of penetrable depth and complexity, but not extricable from surface impression.

Facial features, meanwhile, often displaced, disarrayed and asymmetric, again diverge radically from naturalism yet perhaps achieve an equivalence to the composite mental picture we have of someone, a likeness that is not fixed or precise but fleshed out by different known or intuited sides and particularities of the character. Soutine's faces are anyway plausible; we believe a likeness has been achieved, and two or more pictures often recognisably show the same individual (see, for example, cat. nos. 10–13 or 17 and 18). In fact, the scattered eyes, nose, mouth and ears in The Little Pastry Cook (cat. 3) and other works recall identikit pictures, swapped, shuffled and rearranged into the unstable ensemble of a unique personality. And this again hints at something

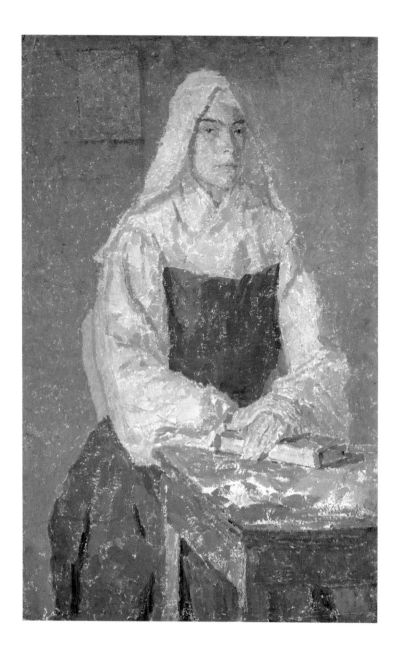

40

GWEN JOHN
The Nun, c. 1915–21
Oil on board, 70.7 x 44.6 cm
Tate, London

both aggregate and changeable in the nature of identity itself.
We are all parties of many parts.

How meaning is amplified and multiplied by medium is vividly
demonstrated by a comparison with Soutine's near-contemporary
Gwen John, who also painted single figures, almost always clothed
(she and Soutine each produced only one nude). Her sitters, like
Soutine's, are usually unnamed and they are often identified by
outfit, as she frequently painted nuns in their habits (fig. 40).

However, John is almost Soutine's opposite in terms of depictive means. She tends to give us a single layer of paint, built of discrete dabs of the brush. We cannot know in what order the touches were made and, while their accretion conveys meditative slowness, the sitter emerges as an ethereal presence suspended within the overall, simultaneous surface, as if outside or beyond time. John respects the separation between sitter and viewer, a distance restated rather than reduced by her tentative, arm's-length touches. It is significant that she painted many pictures from a photograph of a deceased nun whom she had never met: her figures are unmoving, dematerialised, eternal.

In marked contrast, we appreciate how Soutine's work, synonymously with its implications of movement and change, incorporates *duration* as such. The liquidity and malleability of paint acknowledge the mutability of faces and bodies. Agitated adjustments, *pentimenti* and elisions all speak of animation, suggesting not just that the artist's perceptions develop as he looks but that his viewpoint is perhaps shifting and that his sitters – or standers – are probably moving and talking as he works. Most immediately, his paintings make visible the time taken in their own creation. We detect the direction and speed of the strokes, the discharge of the paint from the brush, the trickle of drips. We discern the sequence of marks and layers overlaying earlier ones, building up depth. Where John is digital, Soutine is analogue, his paint continually replaying for us its own orchestration as a reaction to and recreation of the sitter. In letting our eyes trace the tracks and follow the passages of the brushwork, we inwardly mime the artist's painterly performance.

If painting is process and passage, so is life and, while we may not tell the mind's construction in Soutine's faces, they often combine infancy, youth and age, innocence and experience. The humanity of his sitters is a matter of full, empathetically felt embodiment that can only exist in time. It is mortality.

AT THE START of Raymond Carver's *A Small, Good Thing*, the baker presents an inscrutable front:

> The baker wore a white apron that looked like a smock. Straps cut under his arms, went around in back and then to the front again, where they were secured under his heavy waist. He wiped his hands on his apron as he listened to her The baker was not jolly. There were no pleasantries between them, just the minimum exchange of words, the necessary information. He made her feel uncomfortable ... she studied his coarse features and wondered if he'd ever done anything else with his life besides be a baker ... he was abrupt with her – not rude, just abrupt. She gave up trying to make friends with him.

At the end of the tale, after much more extreme alienation (the baker has made menacing anonymous phone calls and been confronted in raw hostility) some human connection is finally achieved.[10] But his 'opening up' gives on to further unknowables that leave him falling back on his occupation to describe and defend himself:

> "Lady, I work sixteen hours a day in this place to earn a living," the baker said. He wiped his hands on his apron. "I work night and day in here, trying to make ends meet I'm just a baker. I don't claim to be anything else. Maybe once, maybe years ago, I was a different kind of human being. I've forgotten, I don't know for sure. But I'm not any longer, if I ever was. Now I'm just a baker."

Still, he sits down with the bereaved couple, shares food with them and passes time:

> ... the baker began to speak of loneliness, and of the sense of doubt and limitation that had come to him in his middle years. He told them what it was like to be childless all these years. To repeat the days with the ovens endlessly full and endlessly empty. The party food, the celebrations he'd worked over He had a necessary trade. He was a baker. He was glad he wasn't a florist. It was better to be feeding people. This was a better smell anytime than flowers.

Soutine's *pâtissier* might have spoken – might speak – of similar things.

1 The collector and dealer Paul Guillaume, in his Paris apartment, hung this and other Soutines close to Harlequin and Pierrot images by Pablo Picasso and André Derain.

2 Charlie Chaplin, for example, had played the role of baker-buffoon, with more slapstick than sentiment, in the popular silent movie *Dough and Dynamite* (1914).

3 In 1929 it was adapted into a jazz tango, *Le Petit Pâtissier (In einer kleinen Konditorei)*, by Lucien Boyer and Fred Raymond, which became a hit in 1930 for the singer Fred Gouin. Another traditional song in France is the *Déclaration d'un pâtissier* (Love Song of a Pastry Cook).

4 Collected in Johan Gustav Büsching, *Volks-Sagen, Märchen und Legenden*, Leipzig, 1812, pp. 266–86.

5 Early in the twentieth century, Eugène Atget had photographed traditional artisans and traders, and filmmaker Pierre Chenal celebrated them in his 1931 short documentary *Les Petits Métiers de Paris*. Twenty years later, Irving Penn, in Paris for *Vogue* magazine, would re-stage (and somewhat sanitise) such images in his *Small Trades* series.

6 First published in *The Dial*, July 1922. The poem celebrates (in the face of death) the wonder of the workaday. Stevens commented that it "wears a deliberately commonplace costume, and yet seems to me to contain something of the essential gaudiness of poetry": Holly Stevens, ed., *Letters of Wallace Stevens*, New York, 1966, p. 263.

7 In Raymond Carver, *Cathedral*, New York, 1983, pp. 59–89. The story was dramatised in Robert Altman's film *Short Cuts* (1993), casting Lyle Lovett as a highly Soutinesque baker.

8 Soutine himself, in his lot as *artiste-peintre*, knew the ignominy of working to command during his early years in Paris, painting on a meagre allowance for the dealer Zborowski. Earlier, he had taken menial jobs to survive. After he became prosperous, he famously distanced himself from the friends of his lean years, dressed and lived expensively.

9 For example, School of London painters often cited as Soutine's progeny – Lucian Freud, Leon Kossoff, Frank Auerbach – use more limited painterly vocabularies.

10 See note 7. An earlier published version of Carver's story ends the narrative abruptly before any confrontation or reconciliation between the baker and the bereaved parents. In revising, Carver clearly felt impelled (even if risking sentimentality) to explore further – to confront for himself, as it were – the knowable/unknowable character of the baker.

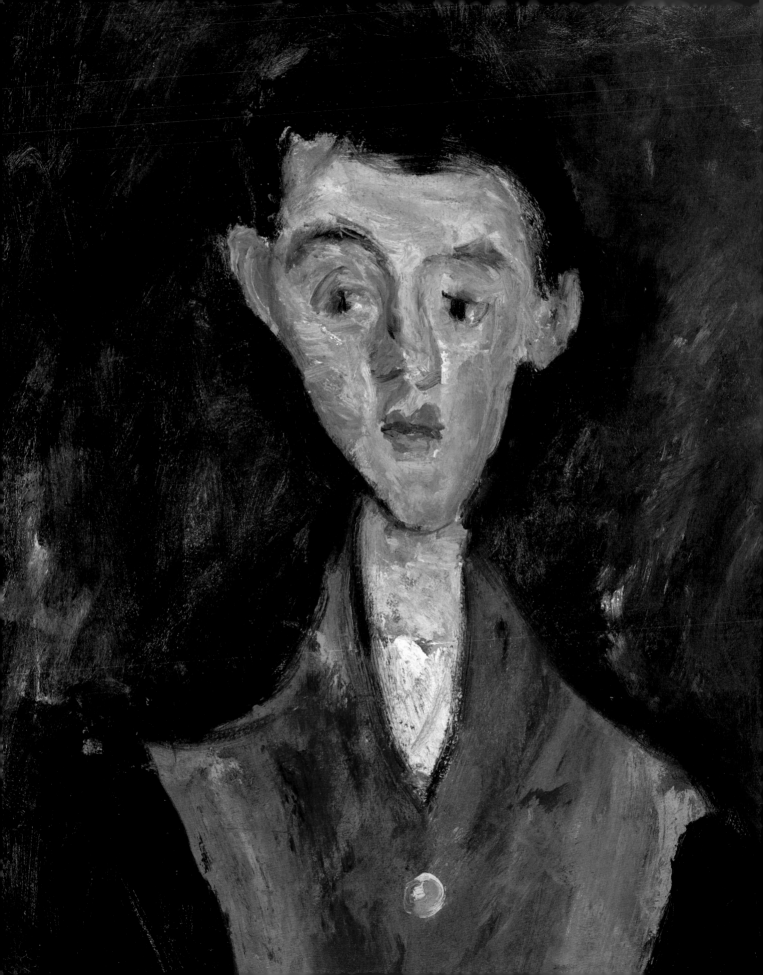

CATALOGUE

KS Karen Serres

KS Karen Serres
BW Barnaby Wright

Note to the catalogue

ORDER We have organised this catalogue by the type of sitter represented rather than strictly chronologically. This is in order to consider more clearly the serial character of Soutine's approach and to highlight his fascination with particular types of hotel and restaurant workers and with particular individual sitters. Whilst this arrangement offers a broadly chronological development, it is important to stress that Soutine did not work in such a methodical and tidy way. Although it seems he had focused campaigns of activity, producing a number of canvases of the same sitter or type over a period of months (see, for example, cat. nos. 10–13), this was not always the case. Sometimes he returned to a particular uniformed type at a later date (see, for example, cat. 6). He also seems to have worked on different portrait types concurrently; the bellboys, valets and waiters, for example, were likely painted over the same period (see cat. nos. 8–15).

TITLES There is much confusion and inconsistency regarding the titles of works in this series, both in their original French and in English translation. We have generally retained current titles but included earlier and alternative titles where appropriate. Soutine did not typically give titles to his paintings and so dealers, collectors and writers were often responsible for titling. With regard to this group of portraits, almost nothing is known about the specific identity of the sitters and their occupations have been variously interpreted. For example, one sitter posed for Soutine in his uniform for four separate portraits, each of which has been titled differently; he has been identified as a lowly 'hotel boy' in one canvas and promoted to a 'hotel manager' in another (see cat. nos. 10–11). It is difficult to resolve these discrepancies from the uniforms alone although the individual entries attempt to shed light on this issue.

DATES Establishing precise dates for Soutine's paintings is extremely difficult because he almost never dated his paintings and primary documentation is scarce. We have followed the dating given by the catalogue raisonné (Tuchman, Dunow and Perls 1993) unless more recent information has led to a revised date.

1

BUTCHER BOY c. 1919–20
(Le Garçon boucher)

Oil on canvas, 65 x 54 cm
Private collection

One of Soutine's first paintings of a sitter in working clothes, this canvas is part of a small group of such portraits made when the artist was living in the town of Céret, in the Pyrénées, between 1919 and 1922. There he produced his well-known painting *The Pastry Cook* (fig. 1), whose sitter was an apprentice cook in one of the town's hotels.[1] The present sitter is thought to be another local, this time a butcher. This identification is plausible but it is not given by an original artist's title (he typically left titling to his dealers) nor is there anything specific about his uniform to identify him as a butcher. The identification possibly came from information Soutine passed on. The dominant red coloration of the painting and Soutine's interest in butchered meat and game as a subject may have also cued such associations early on. Soutine produced a second *Butcher Boy* (fig. 41) around this time, but again the title was given later. It has been suggested that the two butcher portraits represent the same sitter and that he also posed out of his butcher's uniform and in a blue jacket for *Man in Blue* (c. 1921; The Barnes Foundation, Philadelphia). Working solely from the evidence of the paintings, it is difficult to be fully confident about these identifications.[2]

Soutine's butcher boy paintings are bound up with the later recollections of Pierre Mau, who, as a young boy in Céret, used to deliver paints to Soutine, and of Edmond Brazès, the son of a local barber.[3] Brazès recalled the artist visiting a butcher on rue du Commerce and painting one of the butchers outside the shop. A sketchy painting of such a scene is known and may be the only canvas by Soutine of a person clearly depicted at their place of work.[4] Mau recounts Soutine being very taken with the long red curtains hung up at the butcher's to keep flies off the meat. Soutine was apparently given the curtains to use in his studio and it is assumed they form the backdrop for a number of his Céret portraits, including the present canvas, the second butcher boy portrait and *Little Pastry Cook* (cat. 2).

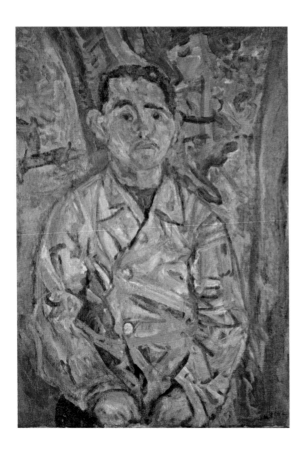

41
CHAÏM SOUTINE
Butcher Boy, c. 1919
Oil on canvas, 69.9 x 49.5 cm
Private collection

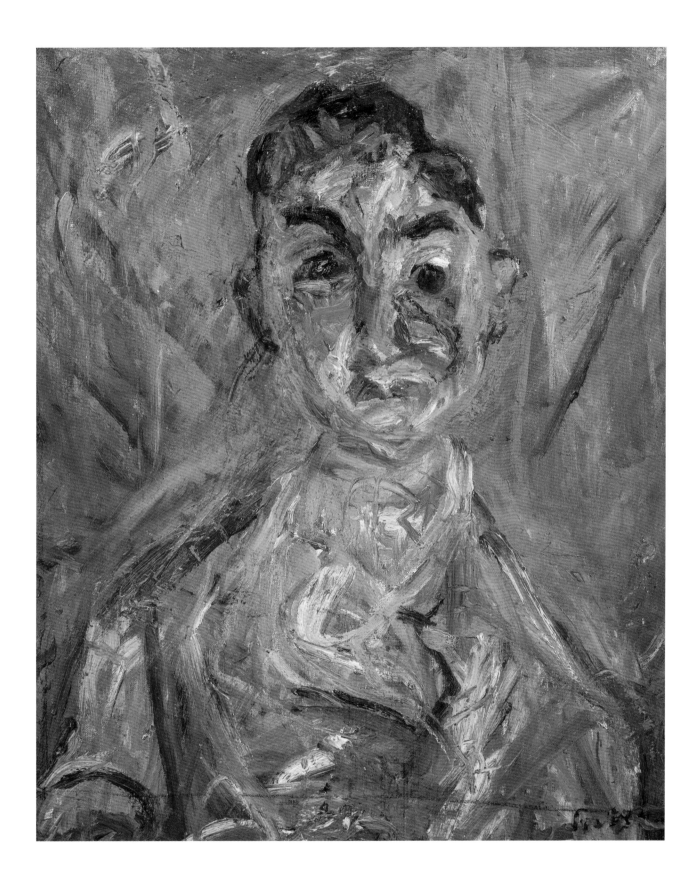

Soutine's butcher boy paintings are studies in carmine in which the slashing and smearing of paint conjoin (one wants to say coagulate) the sitters with their bloody trade. In the present canvas, the white of the man's jacket and the flesh of his face are almost completely stained and saturated with reds, making it difficult to mark distinctions between flesh and fabric. The elision is particularly radical and extreme in this portrait but the interplay between Soutine's treatment of a sitter's skin and their uniform is also characteristic of other portraits in the series (see, for example, cat. 3). Painting itself is figured here as a form of butchery – Soutine's blood-red brushwork cutting and forming his raw material. Indeed, butchery became an artistic obsession for Soutine. Around this time, he started to produce paintings of dead game and other butchered animals, which led to his famous series of beef carcasses (see, for example, fig. 2). *Butcher Boy* is one of Soutine's most striking early expressions of his interest in the materiality of flesh, not just in its surface appearance but with regard to what happens when it is cut and pulled. It is as if Soutine has flayed his butcher (he painted a flayed rabbit around this time) and revealed that even his uniform is bloody and marbled with flesh and fat beneath its white skin.

It is worth noting that, after Soutine had become well known for his motifs of butchered meat and dead game, he revealed to a friend that his connection to butchery was deeply rooted in a trauma of his childhood in the Lithuanian region of Russia: "Once I saw the village butcher slice the neck of a goose and drain the blood out of it. I wanted to cry out, but his joyful expression caught the sound in my throat …. This cry, I always feel it [in my throat]. As a child, I drew a crude portrait of my teacher to try to free myself of this cry, but in vain. When I painted the beef carcass, it was still this cry that I wanted to liberate. I did not succeed."[5] BW

2

LITTLE PASTRY COOK C. 1921
(*Le Petit Pâtissier*)

Oil on canvas, 153 x 66 cm
Portland Art Museum, Oregon (Ella M. Hirsch Fund)

Soutine produced at least six paintings of cooks in kitchen whites between around 1919 and 1927 (cat. nos. 2–7). He seems to have been attracted primarily to the painterly challenges presented by the whiteness of their uniforms. The present canvas was likely painted in Céret after he had completed his very first portrait of this type of sitter (fig. 1).[6] As Karen Serres discusses above, Soutine usually favoured young cooks for his portraits, probably because they were more willing to sit for him for a small sum. The sitters are routinely identified by later titles as 'pastry cooks' or 'little pastry cooks', perhaps because *petits pâtissiers* were a ubiquitous cultural type in France. They were a familiar sight, delivering bread and pastries as well as selling their goods in the street. Distinctive in their whites and sometimes as young as twelve, they were associated with the transition from childhood to adulthood and the world of work. In reality, Soutine's sitters may have also had other roles in the kitchen, especially if they were employed in a smaller hotel or restaurant.

The ambitious scale of this full-length painting of a pastry cook suggests Soutine's commitment to this type of worker as a subject for his portraiture, at a time when money and materials were limited. Soutine would return to this format on a few occasions for other portraits of uniformed workers, including *Page Boy at Maxim's* (cat. 9), *Cook with Blue Apron* (cat. 19), and *The Chambermaid* (cat. 20). As discussed in the previous entry, the prominent red curtain that forms the backdrop was obtained by Soutine from a local butcher's shop. It helps to throw the figure into relief but most strikingly provides a strong contrast for his treatment of the cook's white uniform, which

he streaks and shapes with colours, animating and opening up its surface. Soutine was clearly attracted to the challenge of painting dominant single fields of colour, trying to reveal visual consequence within a superficially blank white or saturated red. His abiding interest in the visual character of monochrome underpins his series of uniformed sitters as a whole. The colour red became a particular obsession for Soutine, informing his choice of later hotel and restaurant workers, the bellboys most obviously but also waiters and valets (see cat. nos. 8–15).

Soutine used the same red curtain for his two portraits of butchers (cat. 1 and fig. 41). However, whereas the closer cropping of those paintings made the advancing effect of the red almost overwhelming and unsettlingly ambiguous, the more generous format of the present work makes the artifice of the studio set-up clear. There is something wilfully crude and haphazard about this makeshift arrangement of a strung-up curtain and chair prop; it sets the tone for Soutine's elevating of the lowly rural cook to the status of a sitter worthy of a full-length portrait. For Soutine, it was a rough-and-ready way to stage his model in his primitive Céret studio. However, it is also a striking riposte to the tradition of grand portraiture, stretching from the Renaissance onwards and well known to Soutine from his visits to the Louvre. Soutine was not the first artist to adopt the full-length grand portrait format for unconventional ends. As Merlin James notes in his essay above, Jean-Antoine Watteau's *Pierrot* (fig. 27) and Édouard Manet's *Absinthe Drinker* (fig. 32) make compelling comparisons as well-known portraits of this type that also accord unlikely sitters the status of a grand format.

Soutine is able to resist turning his pastry cook into a generic uniformed type. His depiction of the man's slightly anxious pose, hands clenched, and his ambiguous expression, either smirking slightly or conveying a note of condescension, individualises rather than typifies. Most importantly, Soutine's brushwork is alive with a nervous energy that asserts the immediacy of the creative encounter between the artist and his model, leaving little scope for the painting to crystallise as an idealised or generic expression.

Various writers have noted how Soutine is able to retain a strong sense of the individual character and presence of his sitters despite the intensity of the brushwork that threatens to overwhelm them. The authors of his catalogue raisonné put it well: "Though Soutine may project his inner turbulence and most personal feelings on to his subjects, the viewer never loses sight of a particular physical entity being carefully observed and experienced. Even the distortions and exaggerations of facial features and the shiftings and dislocations of body parts do not destroy the essential recognition in each painting of a certain person and a reality specific to him or her."[7] BW

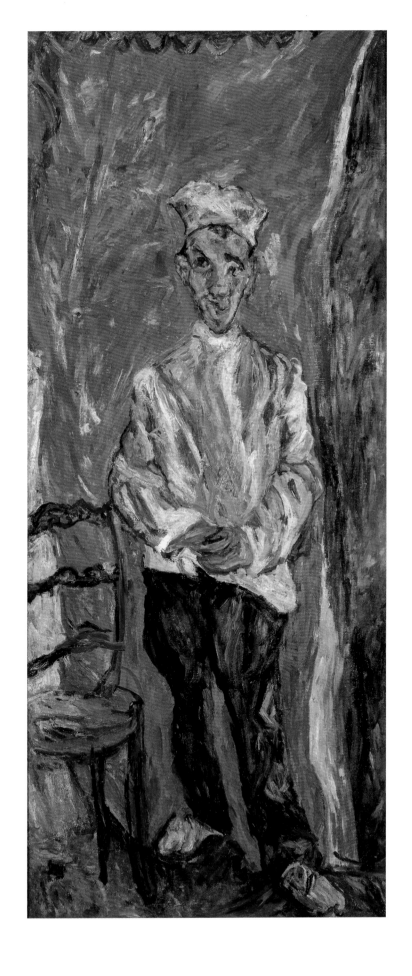

3

THE LITTLE PASTRY COOK c. 1922–23

also known as *The Pastry Cook* and *The Pastry Cook with Red Handkerchief*
(*Le Petit Pâtissier*, also known as *Le Pâtissier* and *Le Pâtissier au mouchoir rouge*)

Oil on canvas, 73 x 54 cm
Musée de l'Orangerie, Paris (Jean Walter and Paul Guillaume Collection)

This work is thought to have been painted in Cagnes, on the Côte d'Azur, where Soutine produced two further portraits of different pastry cooks (cat. nos. 4 and 5). It was made as Soutine was rising to prominence in the art world following the dramatic purchase of a large number of his canvases by the famous American collector Dr Albert Barnes. Barnes was particularly inspired by the first of Soutine's pastry cook portraits, painted in Céret a few years earlier (fig. 1). The present painting is part of an equally large collection of Soutine's work, assembled by the dealer Paul Guillaume, who was instrumental in introducing Barnes to the painter. His holdings are now housed in the Musée de l'Orangerie and constitute the largest public collection of Soutine's paintings in Europe.

The Little Pastry Cook marks a transformation in the painterly approach adopted by Soutine for his Céret portraits (fig. 1 and cat. nos. 1 and 2). He begins to handle paint in a more fluid manner. His previous use of the brush to rupture and cut surfaces is replaced by a greater concern to manipulate form through swathes, strands and sometimes drips of colour. His pastry cook swirls into a malleable existence. This fluidity is set against the painting's bold assertion of structure, achieved through the sitter's exaggeratedly assured pose. With pronounced shoulders and sharply projecting elbows, the cook could almost be wearing the ostentatious costume from a royal portrait of an earlier century; even his hat looks like a crown. Soutine was fascinated by Jean Fouquet's fifteenth-century portrait of Charles VII (fig. 9) and channels here its assertive body language and extravagant attire, a scaffolding for the shifting sensations of his paint.[8] However, whereas Charles VII's costume projects power and functions

like body armour, Soutine's treatment of his cook's whites is analogous to the softness and vulnerability of flesh, streaked through with coloured veins.[9] The portrait's tensions are further set on edge by the man's expression, teeth showing in an ambiguous and disconcerting manner.

This painting featured alongside several others from the series in the influential Soutine retrospective at the Museum of Modern Art, New York, in 1950. This exhibition helped project Soutine's work further into the consciousness of the American art world and especially into the discourse of Abstract Expressionism. Both Jackson Pollock and Willem de Kooning were emboldened by Soutine's approach. Although his landscapes and beef carcasses are usually held to have made the most impact, Soutine's fluid handling of paint in the present work and his way of seeing his subject through the filters of past paintings suggest interesting parallels to de Kooning's ground-breaking series of paintings of women, which he began around the time of the exhibition. *Woman I* (1950–52; Museum of Modern Art, New York), for example, is famous for the complex palimpsest of past imagery that de Kooning worked into the canvas's richly expressive paint surface. It is also memorable for the woman's disconcertingly toothy grin or grimace.

De Kooning's own comment on Soutine's portraits is insightful in its recognition that the character of his sitters is paramount: "Soutine distorted the pictures but not the people You can somehow see the people ... you know everything about the bellboy The painting is the painting, but he never destroyed the people."[10] KS/BW

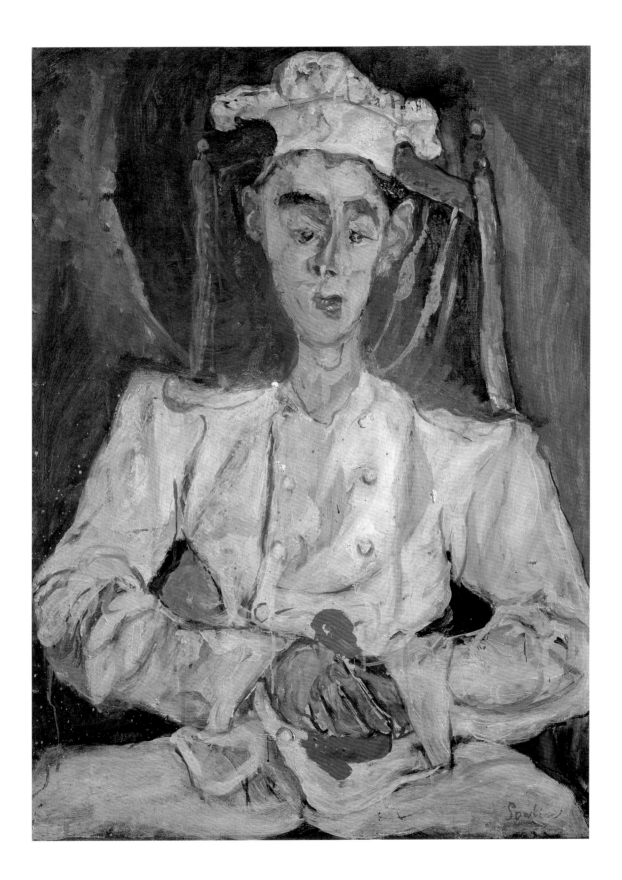

4

PASTRY COOK OF CAGNES c. 1922–23
(*Le Pâtissier de Cagnes*)

Oil on canvas, 64.8 x 50 cm
Private collection

Soutine painted this canvas at the same time as *The Little Pastry Cook* (cat. 3), seating both cooks in the same distinctive chair. However, the emotional tenor of each painting is markedly different. Whereas the other portrait has a somewhat unsettling and ambiguous character, this painting is more clearly a meditation on the theme of the sitter's youth and is imbued with a deep sense of pathos. The distinctive image of young pastry cooks was a familiar part of French culture when Soutine started to paint them. From the late nineteenth century onwards, a number of artists and caricaturists depicted young pastry cooks in sentimental or comic terms that traded off the idea of playful boys entering the serious world of work. Soutine also seems to have been drawn to these themes of innocence and experience in his painting of young cooks and other uniformed types, although, as with the present work, his portraits resist absolutely the saccharine sentimentality and simple humour indulged in other representations of such young workers (see, for example, figs. 12 and 18).

With *Pastry Cook of Cagnes*, Soutine expresses the cook's youth and slight naivety but at the same time conveys the sense that he has already experienced a full life, which has profoundly shaped and marked his appearance and character. These qualities are principally testament to the emotional range and subtlety of Soutine's brushwork. However, his approach to the composition also triggers associations with the rural portraits of Paul Cézanne and Vincent van Gogh, to whom Soutine was often compared by his contemporaries. Both Van Gogh and Cézanne

were concerned with portraying the time-honoured appearance and values of their sitters (see, for example, figs. 5 and 6). Soutine's prominent use of the provincial chair, with its distinctive 'wheat-sheaf' back, furthers connections to the rural and especially to Van Gogh. The pastry cook's exaggerated ears are decoratively incorporated into the chair's central rail as if he has somehow become entwined with it over time. Soutine comes closer here than in many of his portraits in the series to casting his sitter as a stoical French rural type. However, his brushwork is too agitated and provisional to let the image settle comfortably into such a reading. He is acutely sensitive to details of the sitter's appearance in ways that can unnerve; the slight curl of the cook's lip is enough to undercut an impression of him as a timeless country character.

Paul Guillaume, the influential champion of Soutine in the 1920s and 1930s, owned this canvas and *The Little Pastry Cook* (cat. 3). The present work hung prominently in Guillaume's dining room alongside paintings by Pablo Picasso, Henri Matisse and André Derain. In 1933, he wrote to the Swiss collector Karl Im Obersteg to say that he had reluctantly decided to offer it for sale, claiming it one of his "most important paintings by Soutine". It is a mark of Guillaume's success in helping to develop the market for the artist that he could now ask 30,000 francs for this canvas when, ten years earlier, he had sold Soutine's first pastry cook (fig. 1) to Dr Albert Barnes for less than 1,000 francs.[11] BW

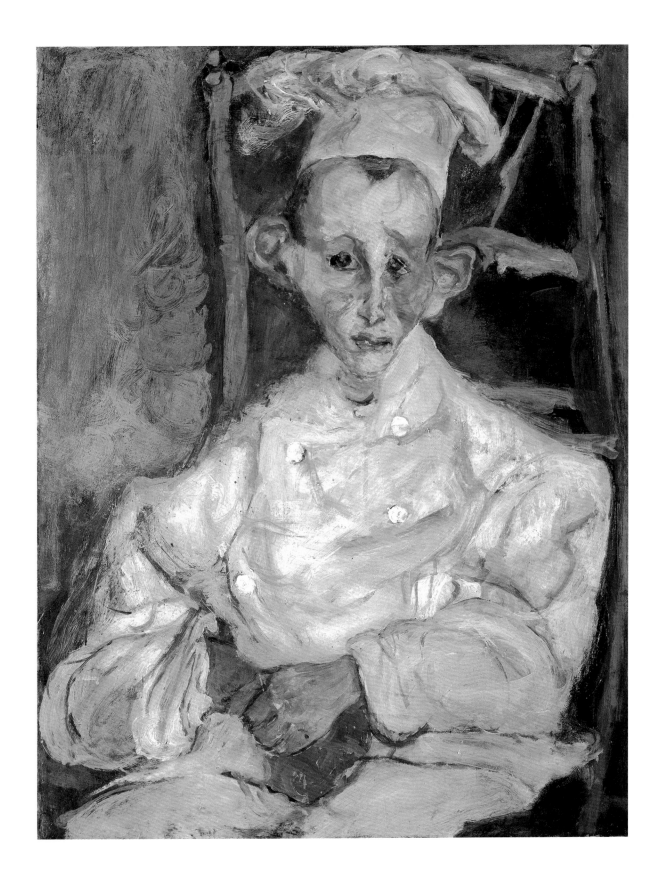

5

COOK OF CAGNES c. 1924
(Le Cuisinier de Cagnes)

Oil on canvas, 61 x 51 cm
Kunstmuseum Bern

The sitter in this portrait appears older than the young pastry cooks that comprise Soutine's other paintings of men in kitchen whites (fig. 1 and cat. nos. 2–4, 6 and 7). He is usually referred to as a cook rather than a pastry cook and was perhaps a more experienced member of the kitchen staff at the hotel or restaurant where he worked. He has nothing of the edginess or brashness that Soutine draws out of his younger subjects. In this portrait, Soutine was likely responding to the greater sense of ease and maturity projected by the older cook. He sits on a rather grand chair, perhaps at a table covered with a white cloth behind, as if taking a break in the dining room before the start of service. In comparison to Soutine's more dramatically posed and characterised sitters, this man seems settled and impassive.

Soutine restricts his palette to mainly greyish whites and yellowish browns but deploys them in jagged cuts of the brush to create a highly agitated surface. His broad and crude strokes seem determined to mark strongly the various features of the man's form and the details of the setting but the urgency of the process undoes his efforts to create structure and clarity. It seems to be an especially hard-won painting, with certain areas presenting difficulties, such as the man's arms, which remain provisional and rather awkward. Amidst this cacophony of competing marks and strokes, the cook's face retains its integrity, as if through the experience of his years he has tuned out the noise around him.

Soutine's handling of paint in this portrait is different to the approach taken for the two other pastry cooks that he painted during this same period in Cagnes (cat. nos. 3 and 4). It is closer to the style of his previous Céret paintings (see, for example, fig. 1 and cat. 2), which raises the possibility that it was painted slightly earlier than is currently thought; or else it demonstrates that Soutine revisited and adapted his way of working for this sitter. Dating aside, the distinctive character of this painting alerts us to the variety of different accounts that Soutine gives of his different uniformed workers. His serial repetition of the same type of sitters in similar formats and through limited ranges of colour – whether it be cooks, valets or waiters – leads Soutine to create paintings that have different characters and emotional charges. As the authors of the Soutine catalogue raisonné put it in their introduction to his portraits, "The confinement to certain basic repeated formulas enabled him to focus and lavish still more attention on those elements that remained open to manipulation".[12]

The present canvas is thought to have been first owned by Soutine's friend the sculptor Oscar Miestchaninoff, whose portrait he painted around this time (fig. 10). In 1916, the two men had shared a studio in Cité Falguière, well before Soutine had risen to the prominence he now enjoyed. BW

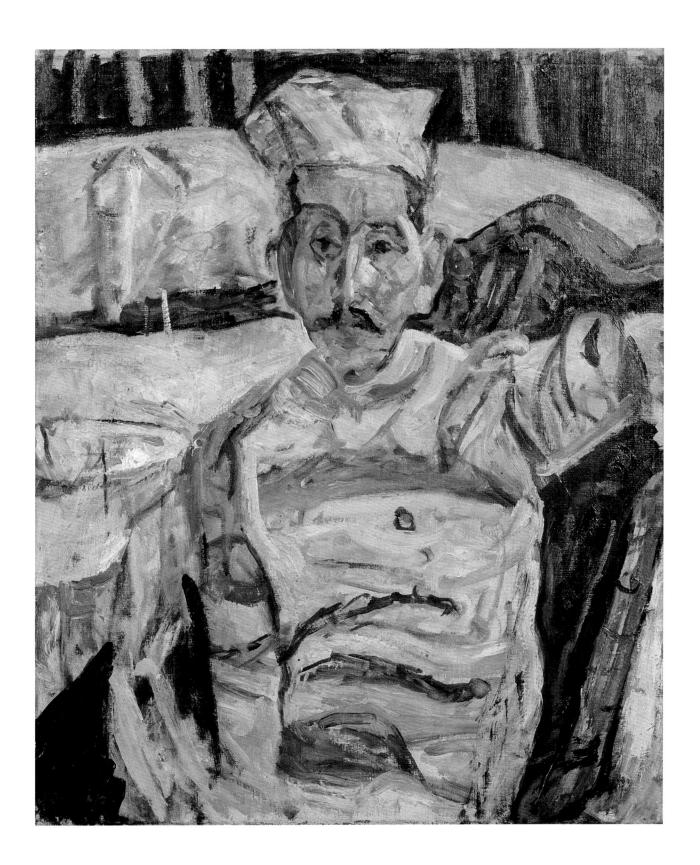

6

THE LITTLE PASTRY COOK C. 1927
(Le Petit Pâtissier)

Oil on canvas, 76.2 x 68.6 cm
The Lewis Collection

Soutine painted most of his portraits of cooks and pastry cooks in whites from around 1919 to 1924 (fig. 1 and cat. nos. 2–5 and 7), before turning his attention to other types of hotel and restaurant staff. However, he returned to his earlier subject for two further canvases in the latter part of the decade, including this striking portrait of a young pastry cook with his hands on his waist.

This painting can be seen as the culmination of his series of cooks: Soutine's exploration of the expressive possibilities of white here reaches a high point of sophistication. The cook's uniform is like a richly veined marble that shifts between whites, blues and greens so subtly that the colours appear integral to one another. Soutine conveys the impression of something fluid that is only partially crystallising, glacial in its icy tones, translucency and sense of movement just beneath the surface. The influential later curator and writer David Sylvester described how, across his oeuvre, Soutine's paint "as it lies there on the canvas appears to act like a miraculous teeming substance that actually generates life under our eyes".[13] *The Little Pastry Cook* exemplifies this observation. It is a concentrated expression of Soutine's ability to use paint as an animating force, imbuing his subjects with a sensation of being alive that exceeds our expectations of the subject itself – in this case an ordinary pastry boy.

The boy's bold, even brash, stance is a surprising departure from Soutine's earlier cooks. He had already begun posing some of his other uniformed workers in this manner (see, for example, cat. 8) and must have been interested to see how it might change his approach to a motif that was by now very familiar to him. The theatrical form of self-presentation immediately casts the cook in a tradition of grand portraiture, where projections of power and swagger were paramount. It is tempting to see this solely as Soutine's conceit to elevate his humble subject, but it is worth remembering that then, as now, ordinary people adopted such poses for their own photographs, either sincerely or with mock pride (see, for example, fig. 21). It may not have been particularly artificial for Soutine's cook to do so for his portrait sessions. Nevertheless, the effect is to heighten the contrast between the boy's cherubic youthfulness and the slightly shaky confidence of his assertive pose.

The first owners of this canvas were Marcellin and Madeleine Castaing, who began a close relationship with Soutine from the time *The Little Pastry Cook* is thought to have been painted. From the late 1920s and well into the 1930s the Castaings were friends and patrons to Soutine, amassing one of the most important collections of his work. Madeleine Castaing is one of the few people to have recounted an experience of sitting for a portrait by Soutine. She recalled his unwavering intensity and energy, painting in front of the model for extended periods until "he would become prostate with fatigue and emotion".[14] BW

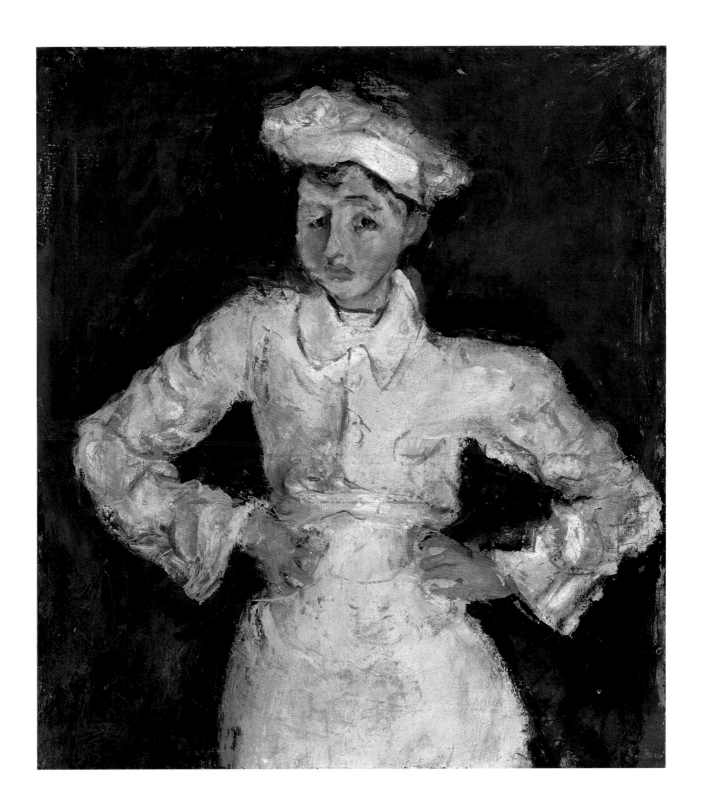

7

THE YOUNG PASTRY COOK c. 1927–28
(Le Jeune Pâtissier)

Oil on board, 70.1 x 23.8 cm
Private collection

This little-known work may be the last painting of
a pastry cook that Soutine produced. Its full-length
format looks back to his earlier *Little Pastry Cook*
(cat. 2) whilst the constrained presentation of the
figure – squeezed into the narrow shape of his support
– anticipates his slightly later paintings of domestic
servants (cat. nos. 19 and 20). However, the present
painting is significantly smaller than these works.
It is closely comparable to the scale of *Alfred, Bellhop at
Auxerre* (fig. 42), perhaps one of Soutine's last paintings
of a uniformed hotel worker. In these works Soutine
explored the effects of painting his familiar types on a
modest scale and etiolated format.

The Young Pastry Cook stands in marked contrast
to Soutine's earlier paintings in which the hotel and
restaurant staff are often bolder and brasher in their
attitudes. Here, the cook appears diminished, partly
owing to the scale but mainly because of his nervous
demeanour; he shrinks to occupy less space, quite the
opposite of the swaggering poses of his counterparts
in other portraits (see, for example, cat. nos. 3 and 6).
With this cook and the bellhop Alfred, Soutine draws
out a greater melancholic and empathetic reflection
on his sitters, expressing the spatial and emotional
constraint of their situation rather than offering a
challenge to it.

Soutine's brushwork in this painting is fluent and
assured. The painting appears to have come together
swiftly without significant reworking, and yet Soutine
is never slick or unquestioning as a painter. The
flourishes of licks and curls of paint to set off the
background and accentuate the cook's jacket and
trousers are surprisingly decorative and exuberant.
They throw into relief the young boy's nervous

42
CHAÏM SOUTINE
*Alfred, Bellhop at Auxerre (Alfred,
garçon d'étage à Auxerre)*, c. 1932
Oil on board, 60 x 25.1 cm
Private collection

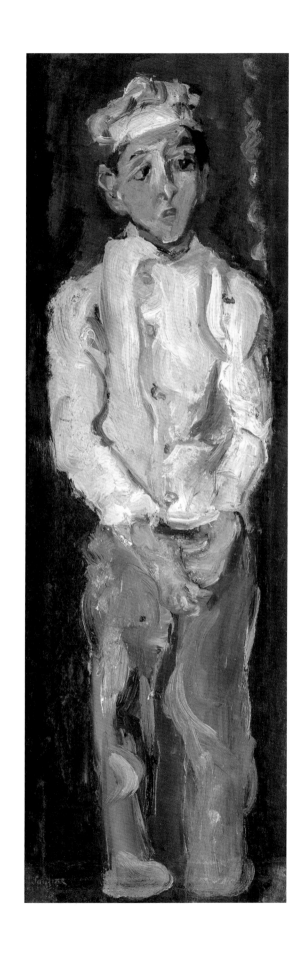

countenance. The anxiety of his character is conveyed in the complexity of his face: Soutine paints him with one eye staring directly out and the other looking sharply to the side as if he is unsure where to settle his gaze.

It is not known whether Soutine ever painted his hotel and restaurant sitters at their place of work rather than only in his studio (see Karen Serres's essay above). Given the fluency and scale of this painting, it is tempting to imagine he might have arranged the sitting during one of his stays at a French hotel, although it is perhaps more likely that his studio provided a more conducive environment and the young cook was paid to pose for him there. BW

8

BELLBOY c. 1925
also known as *Page Boy*
(*Le Groom*, also known as *Le Chasseur*)

Oil on canvas, 98 x 80.5 cm
Musée national d'art moderne/Centre de création industrielle, Centre Pompidou, Paris

This painting marks a striking change of subject and palette within Soutine's series of uniformed figures. Having focused largely on pastry cooks in kitchen whites in Céret and Cagnes during the first half of the 1920s, Soutine, now working mainly in Paris, turned to the highly distinctive reds of the bellboys who were emblematic of some of the city's finest hotels and restaurants. Soutine's bellboy portraits coincided with the start of his commercial success, which meant he could now afford a lifestyle that brought him into close contact with such modern-day servants. If pastry cooks were seen as a more traditional type of young worker in uniform, from either the city or country, then bellboys were the uniformed youths associated most readily with the excitement and glamour of modern Paris and other fashionable destinations in the Roaring Twenties.

Soutine produced three principal paintings of bellboys in red uniforms. The sitter in this portrait seems to be the same young man who adopts a similar pose in a closely related work (fig. 43).[15] The third, slightly later, canvas is a full-length representation of what is probably a different bellboy (cat. 9). All three canvases have had a variety of titles, in both English and French, in an effort to identify their subjects – *Le Chasseur*, *Le Groom*, *Bellboy*, *Page Boy*. This is not surprising, as the terms were largely interchangeable and the roles very similar. However, a French hotel manual of the period distinguishes between the *chasseurs*, whose responsibilities included assisting guests upon arrival as well as running errands, picking up guests' purchases and other tasks outside the hotel, and the *grooms*, who took care of requests inside the hotel. A similar distinction could be made between page boys and bellboys; however, the term 'bellboy' has now become the common catchall in English. Bellboys were intended to be highly visible in their liveried uniforms, often with their hotel's name embroidered around their hat bands. Typically stationed by the entrance doors or in the lobby of a hotel, restaurant, shop or nightclub, they were the establishment's public

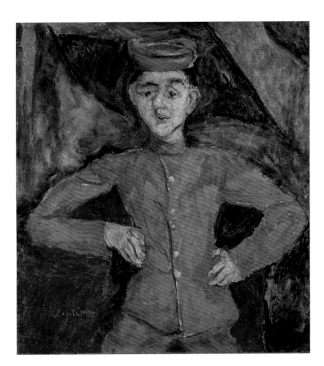

43

CHAÏM SOUTINE
Page Boy at Maxim's (*Le Chasseur de chez Maxim's*), c. 1925
Oil on canvas, 81.9 x 74.9 cm
Private collection

face: "The bellboys are young, alert and resourceful; the better looking they are, the more honour they bring to the hotel whose uniform they wear".[16]

Soutine's *Bellboy* does not come from the pages of a best-practice hotel manual. By turns confrontational and awkward, the young man's spread-eagled pose and distorted facial features undo the decorum he is supposed to embody. The painting comes close to being a caricature of a portrait of a heroic military leader or a king, such as Jean Fouquet's *Charles VII* in the Louvre (fig. 9), which Soutine greatly admired. However, *Bellboy* is painted too earnestly to be experienced as parody. In many ways, the portrait is closest to Soutine's contemporaneous paintings of beef carcasses (see, for example, fig. 2) – like them, blood red and starkly flayed

open. Soutine even removes the support of a chair from his bellboy. For his early advocate Waldemar George, the canvas was proof of Soutine's uncompromisingly visceral approach. George described "the scarlet splash of his *Chasseur d'hôtel*, quartered like a Christ on the Cross ...".[17] The work is certainly at the extreme edge of Soutine's various portrayals of his hotel and restaurant staff in its rebarbative and unsettling character, which contrasts with the gentler presentation of the same sitter in the related canvas (fig. 43). However, *Bellboy* need not be read as the quintessential Soutine – red in tooth and claw – as George was prone to do; rather, it can be seen to throw into relief the diversity of other works in the series and Soutine's ability to characterise his sitters in different and nuanced ways. BW

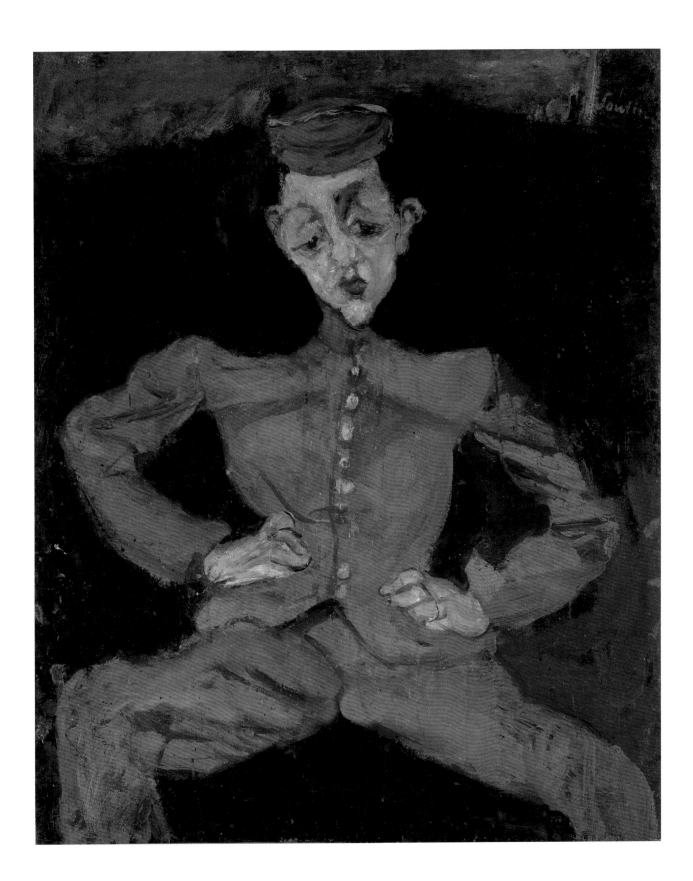

9

PAGE BOY AT MAXIM'S c. 1927
(*Le Chasseur de chez Maxim's*)

Oil on canvas, 129.5 x 66 cm
Albright-Knox Art Gallery, Buffalo, New York

This well-known painting appeared on the cover of one of the earliest monographs on Soutine, written by Élie Faure in 1929. Soutine explored a variety of traditional portrait formats in his series of uniformed sitters – half-length, three-quarter-length and, as here, full-length. The painting belongs to the group of page boys and bellboys dressed in vibrant red uniforms that Soutine painted around 1927 (see also cat. 8 and fig. 43). The sitter has been traditionally associated with one of Paris's most famous restaurants, Maxim's. Founded by a former waiter, Maxime Gaillard, in 1893, it quickly came to embody the city's fashionable Belle Époque era and continued to attract high society throughout the twentieth century. The restaurant's *chasseurs* in their distinctive red jackets and brimless hats were a quintessential part of the experience of Maxim's. A comical image of one young *chasseur* juggling guests' coats, hats and canes has, from its early years, featured on the restaurant's menu (fig. 19). Soutine may well have dined at Maxim's, as did a host of prominent artists and writers in the 1920s, but it is not known if this portrait's sitter definitely worked at the restaurant, as the title suggests. As Karen Serres notes in her essay above, Maxim's *chasseurs* typically wore dark trousers rather than the all-red uniform seen in Soutine's painting.

Page Boy at Maxim's is the only painting in Soutine's whole series to depict its sitter in what might be considered the act of working, arm outstretched as if welcoming a guest at the entrance door (or perhaps asking for a tip).[18] However, the staged awkwardness of the pose disrupts the illusion that the man is observed on duty. The result is a composition that occupies a strange territory somewhere between a portrait and a genre painting. The figure also suggests other associations beyond the work's most obvious context. An artist friend of Soutine's, Mariya Vorob'eva (known as Marevna), later suggested that the example of El Greco lay behind this painting in particular and his series as a whole.[19] The page boy's elongated form and, especially, the etiolated distortion of his head are certainly redolent of El Greco's figure types, connecting the work to earlier traditions of portraiture. Indeed, an important early writer, Waldemar George, compared one of Soutine's other *chasseur* paintings (cat. 8) to images of Christ on the Cross. In the present work, the prominent position of the man's hands, especially his right one, fully outstretched, might be compared to representations of Christ as the Man of Sorrows displaying the wounds on his hands and stomach. Soutine was deeply immersed in the legacy of European painting and it is likely that he saw much more than the fashionable world of Maxim's in this *chasseur*. BW

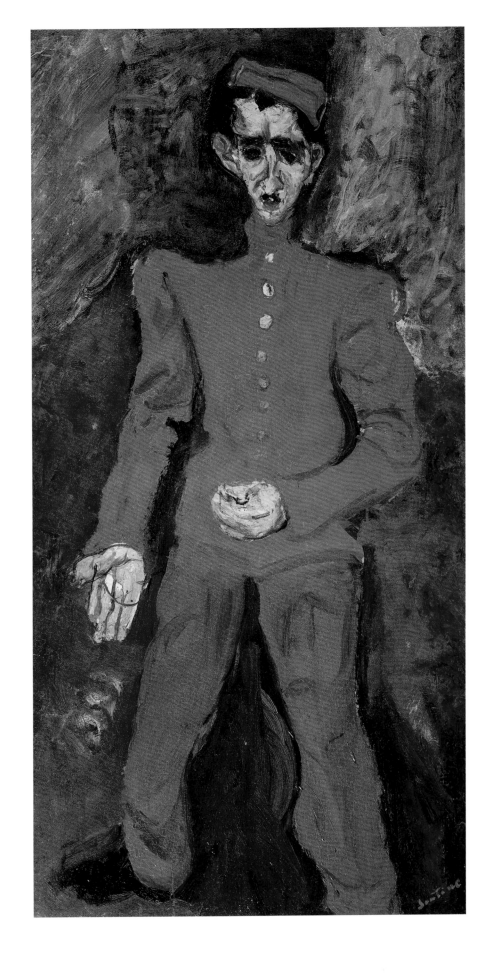

HEAD WAITER c. 1927
also known as *Hotel Manager*
(*Le Maître d'hôtel*)

Oil on canvas, 60 x 49.5 cm
Private collection

Four major portraits of this sitter are known (see also cat. nos. 11–13), all of which seem to have been produced in a campaign of activity around 1927.[20] In each incarnation, posing the same sitter in the same uniform, Soutine has managed to create portraits of a very different character. Although only slight variations occur – whether in the format of the painting, the cropping of the composition, the treatment of the surface, or the sitter's pose and expression – each portrait conveys a different mood. Soutine must have felt that this particular subject offered a well of expressive possibilities, both formally and psychologically. As Tuchman noted about Soutine's painting more generally, "some subjects were painted twenty times, and there is startlingly little significant formal variation to be found in such series. The difference is in their quality, a matter usually of the vivid, febrile *aliveness* of the surface".[21]

In each portrait, Soutine homed in on certain striking features of his sitter and emphasised them almost to the point of caricature – the mass of red hair; the large forehead that takes up half of his face; his pursed lips rendered as two quick dabs of paints sitting under his nostrils; and the large boxer nose twisting strongly to the left and seeming to throw the entire face off balance. Yet there is no mocking or derision in Soutine's approach. His subject is highly recognisable and can immediately be related to.

The figure's uniform incorporates the three bold colours most often explored by Soutine in previous portraits of hotel and restaurant workers – the white of the pastry cooks, the red of the bellboys and the black of the waiters. The sitter wears a fitted jacket with a red torso and black sleeves over a white shirt. A small black bow-tie is tied around the shirt's high collar. Soutine has distorted the jacket to the point that it looks impossibly short around the torso. It is secured by three small buttons and has long flaps over the wearer's hips. Covering his trousers is a long apron that runs from the waist down below his knees. Its loosely marked folds provide the only clues that the model is seated on a high stool: the dip in the centre and the amassed fabric on the sides indicate his knees are slightly bent.

Hands on hips, his elbows just grazing the edge of the composition, the uniformed sitter cuts an impressive figure, albeit one slightly undermined by the ill-fitting jacket and crooked bow-tie. His expression is hard to read but his swaggering attitude has often cast him as a stereotype of the contemptuous French waiter. He has also been titled *Hotel Manager*, a recognition of the authority conveyed by his powerful pose. Certainly, this particular depiction feels the most commanding of the group. It is interesting to note that in other, less blustering, portraits of the same sitter the titles have given him much lower ranks. However, the term 'hotel manager' is equally likely to be a mistranslation of the French *maître d'hôtel* (now designating a head waiter but used in the eighteenth and nineteenth centuries for the owner of a hotel). The varied titles assigned to this group (*maître d'hôtel*, *garçon d'étage*, *valet de chambre*) and their shaky translations are indicative of the enduring confusion concerning the status and professions of Soutine's sitters. The uniform provides few definitive answers about this figure's actual role and rank within the hotel hierarchy. The long apron is often associated with food service, although it could also be worn by valets and room attendants during their cleaning tasks. The two-tone jacket is also associated with these. KS

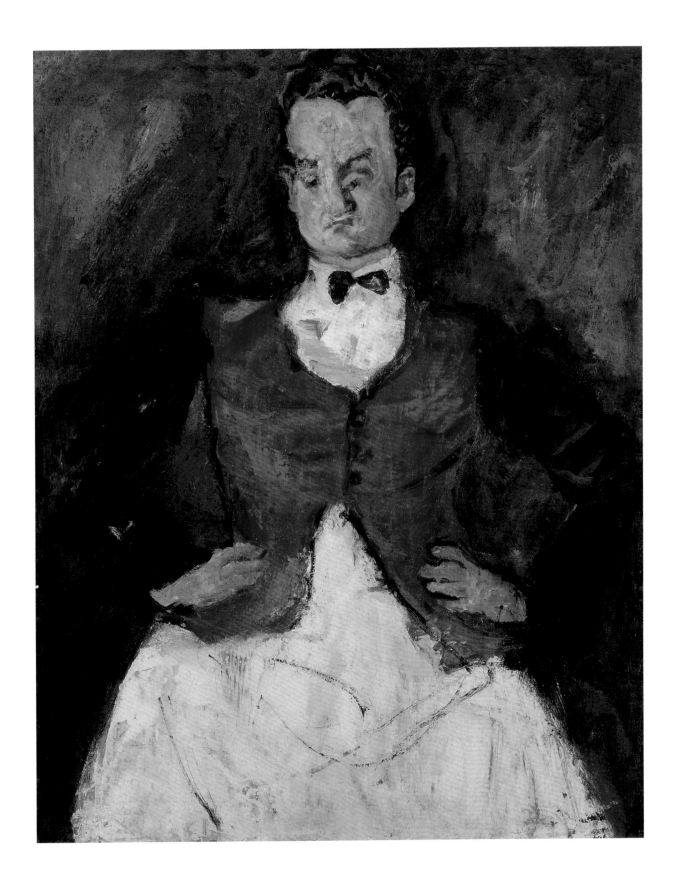

11

VALET c. 1927
also known as *Hotel Boy*
(*Le Valet de chambre*)

Oil on canvas, 72.4 x 42.5 cm
Private collection

For this portrait, Soutine posed the same red-haired sitter as in *Head Waiter* (cat. 10). He adopted a similar three-quarter-length format, with the hotel worker perched on a high stool and clad in his arresting red, black and white uniform. Despite these similarities, the two portraits convey very different attitudes. Here, the sitter appears less imperious, as his hands rest flat on his thighs and he looks out, quizzically and slightly cross-eyed, at the viewer. Instead of cementing his status and authority, the uniform now engulfs him: his body is ill defined under the long white apron and the folds of the red jacket ripple one on top of the other. In contrast to Soutine's bold depiction in *Head Waiter*, this less bombastic rendering has engendered lower ranking titles – *Valet* or *Hotel Boy*. Equally, the treatment of the surface is markedly different: the brushwork is much looser and the construction less structured. The sitter's features are barely distinguishable amidst the modelling of the pink flesh of his face. In contrast to Soutine's forceful earlier treatment of white uniforms, the large expanse of the waiter's apron is strewn with a few thin brushstrokes to indicate the fall of light on the folds of the cloth. The luminous background is a further unusual feature and adds a sense of depth to the composition, accentuated by the light blue halo around the sitter's head.

One of Soutine's few documented stays in a grand hotel occurred while he was taking curative treatments for his frequent stomach ulcers in the spa town of Châtel-Guyon in the central French region of Auvergne. He travelled there at least three consecutive summers, from 1926 to 1928, and lodged several weeks at the Palace Hotel. An oft repeated claim by one of Soutine's early biographers states that this painting (along with the other portraits of this sitter) and another *Valet* (fig. 8) were painted in Châtel-Guyon.[22] Certainly, Soutine would have been in daily contact with the plentiful service staff that populated the grand hotels and thermal baths of the town, which sought to attract an international elite clientele. While the motif may have struck him, it is unlikely, however, that he worked while staying there. Soutine never drew nor made preliminary sketches for his paintings. He started with the blank canvas, the model in front of him. As Marcellin Castaing described, "he attacked directly with colour and roused forms and life. A look, a touch".[23] Soutine's painting practice was famously arduous, demanding and messy. He would not have been able to paint in his hotel room and would thus have needed to set up a separate space. However, the obstacles were mostly psychological. As he reportedly recounted to a fellow painter in Montparnasse, the Russian artist Marevna: "... sometimes the model is all right, but then something goes wrong with the work. I lose my outline of the nose, the mouth or the eyes, or something else and things are going wrong – I suddenly see flames before me and feel them burning me. I begin to scream and throw everything on the floor. I admit that this is stupid, and even horrible, and I am always terrified at this moment, but afterwards, like a woman in childbirth, I am exhausted but certain that the picture will be better. Why is this, I wonder?"[24] It is unlikely that Soutine would have put himself through this while on a therapeutic sojourn. KS

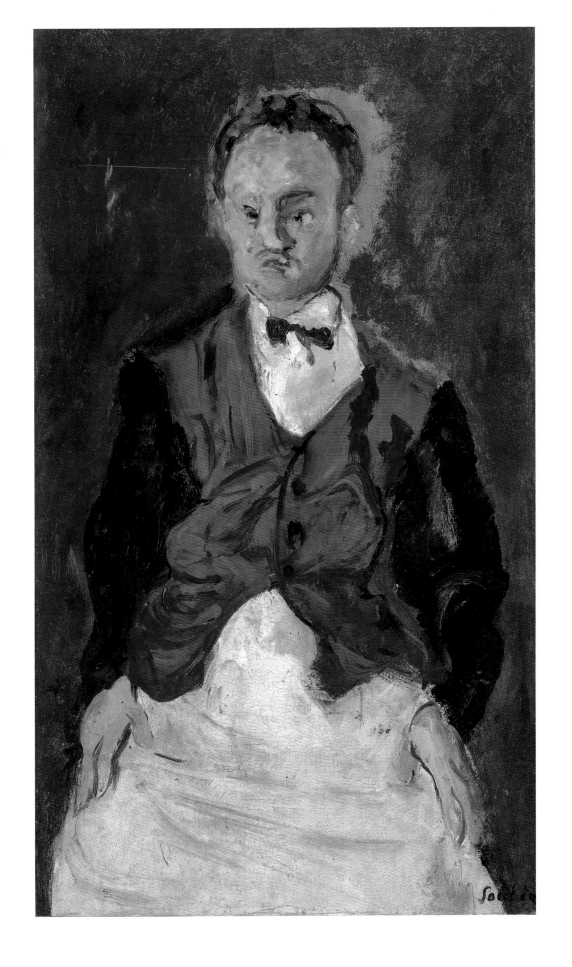

ROOM SERVICE WAITER c. 1927
(Le Garçon d'étage)

Oil on canvas, 87 x 66 cm
Musée de l'Orangerie, Paris (Jean Walter and Paul Guillaume Collection)

This half-length portrait is the largest in the group of four major works that Soutine made of the same sitter around 1927. In contrast to the three-quarter-length representations (cat. nos. 10 and 11), he is depicted much closer to the picture plane and now appears almost life-size. In adopting this change of scale, Soutine may have wanted to home in on the red jacket and the features of his sitter. The man's gaze confronts the viewer directly. His elbows jut out of field, giving the unsettling impression that he protrudes into our space.

Despite the portrait's accomplished character, a hitherto unpublished x-ray (fig. 44) reveals that Soutine was dissatisfied with it at one point and lacerated the canvas into more than 30 sections.[25] The painting was later pieced back together, although some sections were not recovered and had to be replaced with a different canvas: the changes in texture and weave are visible on the x-ray, most notably along the entire length of the top edge (including the area of the signature), the top right corner and down the right side into the figure's proper left shoulder and arm.

The x-ray confirms two stories often told about Soutine's painting practice. The first is his habit of destroying canvases, whether by fire (as in Céret), by scraping off the paint or by ripping them with a knife or razor.[26] Many of his contemporaries recounted Soutine's notoriously impetuous way of working and his volatility (see the discussion in cat. 11). To his friend the artist Marevna, Soutine explained the frustrations he felt painting portraits: "to do a portrait, it's necessary to take one's time, but the model tires quickly and assumes a stupid expression. Then it's necessary to hurry up and that irritates me. I become unnerved. I grind my teeth, and sometimes it gets to a point where I scream, I slash the canvas, and everything goes to hell and I fall down on the floor."[27]

In some cases, Soutine regretted his act and had the work repaired himself. The second story concerns what happened in other cases. Witnesses remembered that

44
X-ray of cat. 12, courtesy of the Centre de recherche et de restauration des musées de France

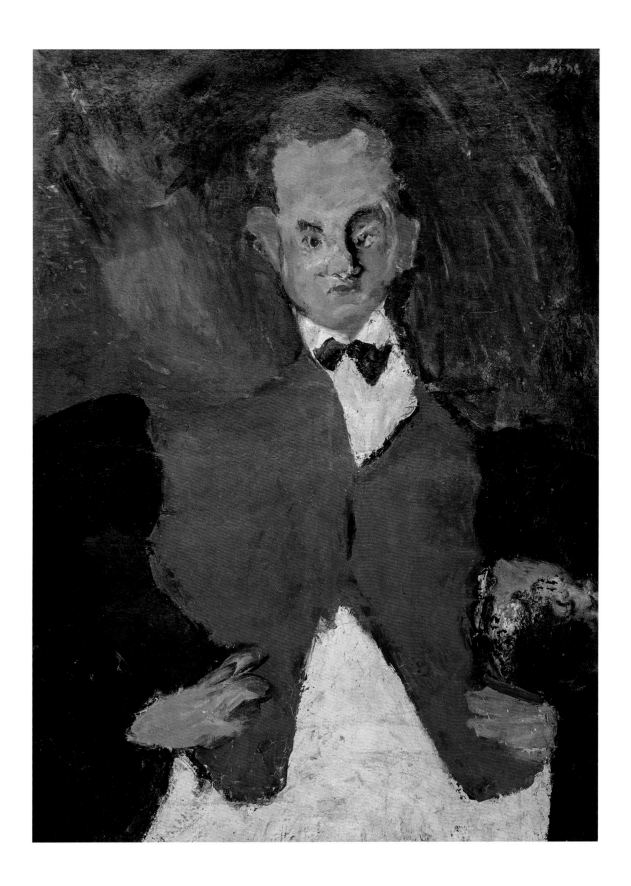

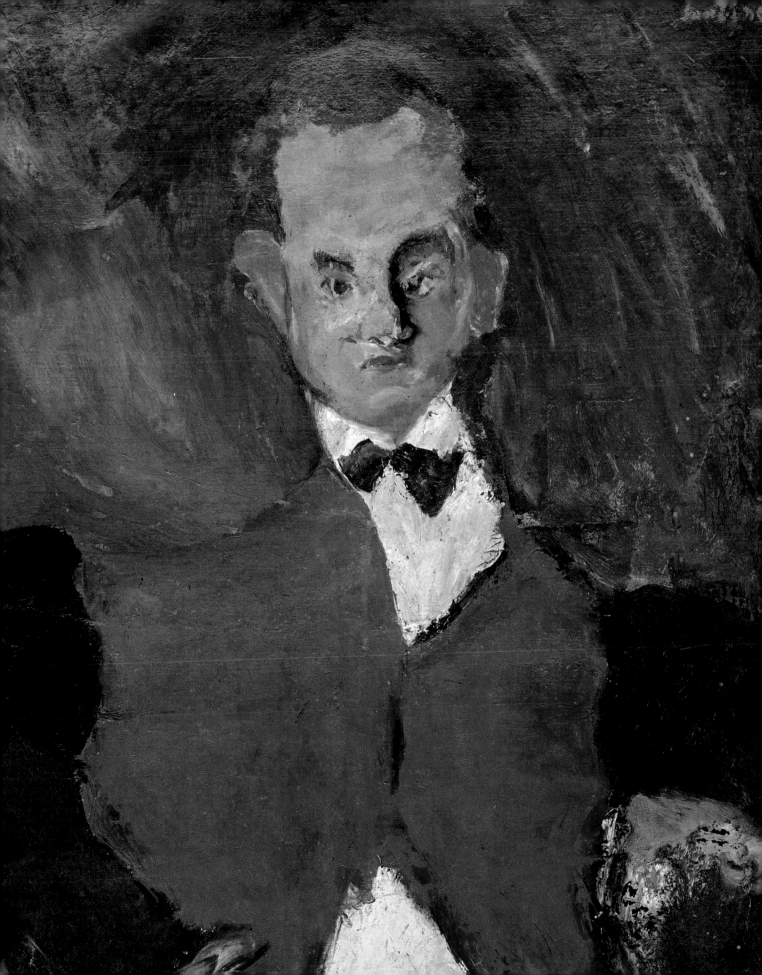

Soutine's dealer, Léopold Zborowski, sometimes tasked his wife and his chauffeur (who also drove Soutine) with going to the painter's studio at the end of his working day and picking up discarded pieces of canvas on the floor, the remnants of Soutine's destructive dissatisfaction. The strips would then be taken to a neighbouring restorer who reassembled and relined the canvas. Zborowski himself told another dealer that the theft was committed by some of Soutine's friends, eager for profit.[28]

The restorer who worked on Soutine's lacerated canvases was named as "*Jacques, le restaurateur*" by a friend of Zborowski.[29] This may have been Frédéric Jacque, whose workshop at no. 12 rue Guénégaud was not far from Zborowski's gallery in the 6th *arrondissement*. According to the *Annuaire du Commerce*, he specialised in "relinings, restorations" and was active from 1924 to 1949.[30] He advertised as 'Jacque Fils', implying that his father had also been a restorer. Jacque must have been particularly talented as his restorations are barely visible to the naked eye – if indeed he repaired and relined *Room Service Waiter*. Soutine himself also called on this restorer to rescue pieces he had mutilated and the reconstruction of this painting may have been done under his supervision.[31]

Despite his distinctive uniform, the sitter's precise role within the hotel remains unresolved. In his various portraits he has been identified alternately as a hotel manager, head waiter, room valet and hotel boy. Here, an early title indicates that he may be a *garçon d'étage*, a waiter assigned to a specific floor in grand hotels and tasked with taking orders and serving meals to guests dining in their private suites (see cat. 10 for a discussion of his uniform). KS

13

VALET c. 1927
(*Le Valet de chambre*)

Oil on canvas, 71 x 49 cm
Private collection, courtesy of Ordovas

The close-up depiction and scale of the composition match those found in *Room Service Waiter* (cat. 12), which represents the same man. In both of these portraits Soutine closed in on his sitter, painting him from a shorter distance and subjecting his features to greater scrutiny, in contrast to the emphasis on pose and uniform found in the smaller, three-quarter-length representations of the same hotel worker (cat. nos. 10 and 11).

The sense of proximity between viewer and subject is here reinforced by the dynamic asymmetry of the composition. Soutine approached his model from a slightly different angle, emphasising the left side of his face (and thus minimising the distortion of his nose) and leaving the right side in shadow. Whereas, in other portraits, the expression of the figure conveyed defiance and disdain, here it exudes a certain melancholy. The portrait also offers less contrast than in other depictions, as the variegated pinkish beige background resembles the modelling of the sitter's flesh. Although

the sitter's arms are now mostly outside the canvas, we can see that he has adopted the same assertive hands-on-hips pose as in the other representations. It should be said that, with no material or documentary evidence, establishing a chronology for this group is an impossible task and no assumptions can be made regarding the order in which they were painted.

This painting was purchased by the Argentinian collector Rafael A. Crespo during Soutine's lifetime and included in a 1936 exhibition of Crespo's collection in Buenos Aires. There, the sitter is described as a *valet de chambre*, a room attendant tasked with the cleanliness of each suite. He could also take care of the guests' clothing, pressing their shirts and shining their shoes. As discussed above (see cat. 10), the two-tone jacket was often associated with cleaning and room services, for both domestic and hotel staff. *Valets de chambre*, the male equivalents of chambermaids, were a separate profession from personal valets, manservants who attended to a specific individual. ᴋs

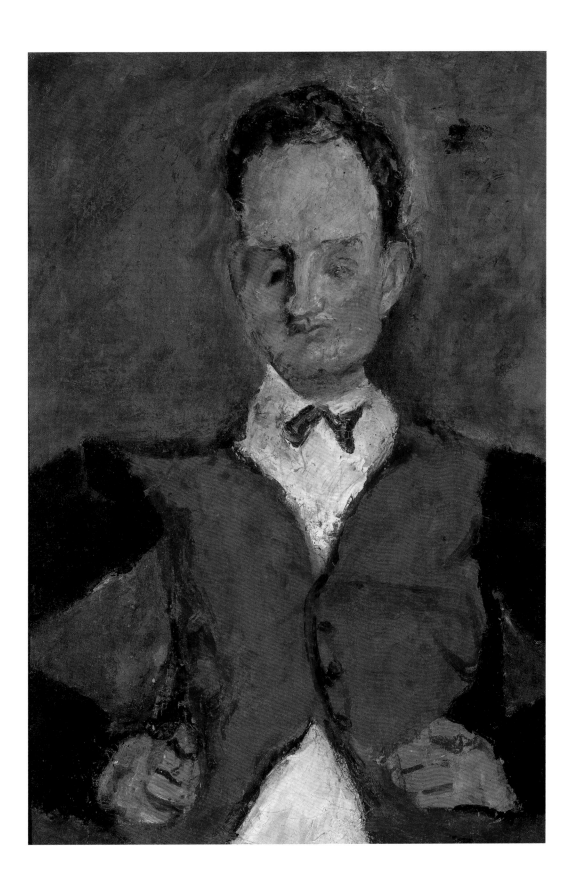

14

VALET C. 1927
(Le Valet de chambre)

Oil on canvas, 68.9 x 46 cm
The Lewis Collection

Unusually in the series, Soutine painted this sitter wearing two different uniforms. Here, he is depicted in a red and black jacket with a white bow-tie and is usually identified as a *valet de chambre*, who would have been responsible for attending to guests' rooms for cleaning and other duties (see cat. 11). In a second canvas (fig. 45), the young man appears again but this time in a black jacket. In this attire, he has been called a musician, which is surely a mistake. It is more likely that he performed two hotel service roles, wearing the black

jacket when he was on duty perhaps as a room service waiter. Soutine was clearly interested in how changing uniforms would affect his depiction of the sitter, as he explored different monochromic arrangements. In both he deployed a variety of different types of brushwork, from broad strokes to fine linear detailing, including for the bow-ties, which he draws in outline with the tip of the brush. The effect is to move the viewer around the canvas, sometimes settling on details that offer moments of intimacy amidst the more urgent and cursory passages of painting.

Soutine was sensitive to the way the man's attitude changed in his different uniforms. In both paintings, he sits neatly and politely with his hands folded in his lap, a departure from the bravado poses of the other hotel workers Soutine painted at this time. The young man seems more attentive as a *valet de chambre*; in the other portrait he is slightly distracted, as if listening for a call. It is interesting to consider to what degree Soutine conveys particular traits associated with the various roles of his hotel staff. *Valets de chambre* and room service waiters were supposed to be especially attentive and discreet given that they were serving guests in the 'private' spaces of their hotel rooms. However, if these qualities seem pertinent to the present painting, they are less so in others: Soutine painted three further portraits of young men in similar valet uniforms and in each they adopt different poses and attitudes (cat. 15 and figs. 8 and 42). BW

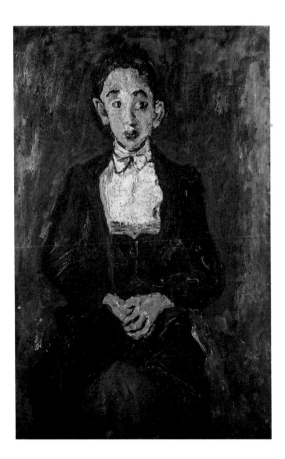

45
CHAÏM SOUTINE
The Musician (Le Musicien), c. 1927
Oil on canvas, 93 x 60 cm
Private collection

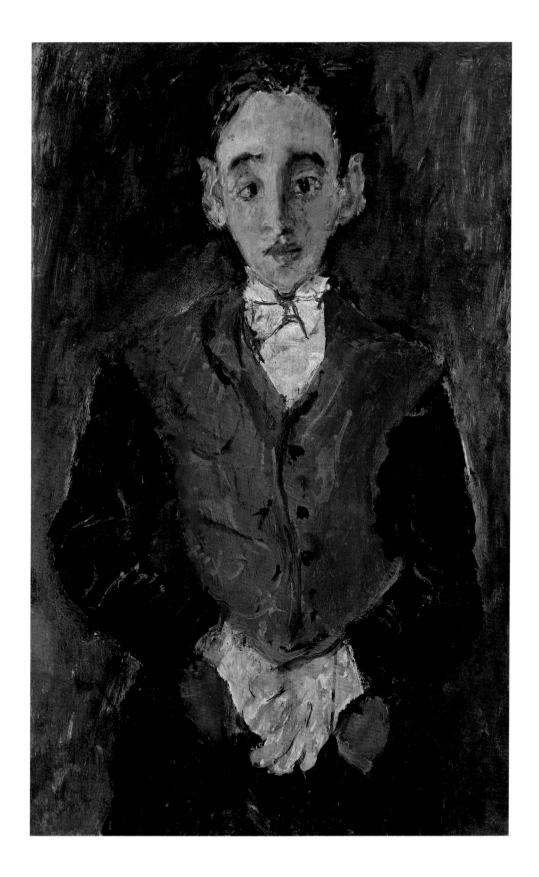

15

VALET c. 1927–28
(*Le Valet de chambre*)

Oil on canvas, 65.1 x 49.8 cm
Denver Art Museum, Colorado

Soutine often pushed and stretched the forms of his sitters as he painted them. This tendency is especially pronounced in the present work. The steep curves of the young man's shoulders rise up to an elongated neck, which supports a head of decidedly pointed and asymmetrical proportions. Particular aspects of the human body seem to have fascinated and perhaps troubled Soutine. The contours of shoulders, lopsided faces, mismatching eye positions and the placement and size of ears are all features that recur in this series of portraits; compare, for example, this painting to *Bellboy*

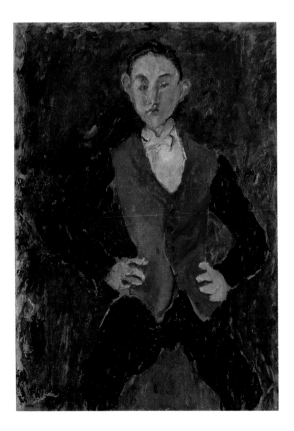

(cat. 8). Soutine never applied stylised features to his portraits. Rather, his misshapen forms are the result of his deep scrutiny of his subjects and particular fixations as he painted directly in front of his sitters, without the use of preliminary drawings. Soutine's etiolated figures, such as this valet, have sometimes been compared to those of El Greco and it is likely that he was emboldened by the old master's distinctive example. Soutine creates physiognomies that sometimes border on caricature; however, as with this work, his portraits carry a solemnity and pathos that resists farce or slapstick. These qualities of his portraiture are comparable to some of Honoré Daumier's tragi-comic figures, which helped to define working and class types of nineteenth-century French society. Soutine's series of hotel and restaurant workers carries something of this legacy into the twentieth century.

The half-length format creates a close proximity between the sitter and the viewer, accentuating the work's intimacy. It contrasts to the assertive yet awkward countenance of one of his other young valet subjects who wears a very similar uniform (fig. 46). Soutine accorded the sitter of the present painting a grander, full-length treatment in a second portrait produced around the same time (fig. 8). In their different ways, both paintings accentuate the youthfulness and slight vulnerability of this valet, who is perhaps no more than a teenager at the outset of his career in hotels. BW

46
CHAÏM SOUTINE
Portrait of a Boy, 1928
Oil on canvas, 92.1 x 65.1 cm
National Gallery of Art, Washington , D.C.
(Chester Dale Collection)

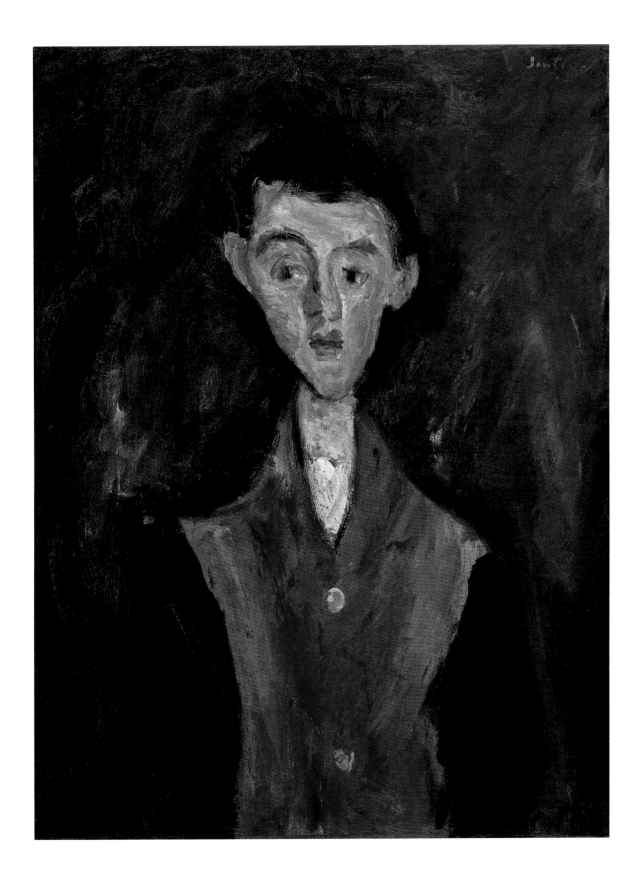

ROOM SERVICE WAITER c. 1928
also known as *Bellhop*
(*Le Garçon d'étage*)

Oil on canvas, 78.3 x 64.5 cm
Private collection

Towards the end of the nineteenth century, waiters in French hotels and restaurants adopted fashionable evening dress as their service uniform – black tail-coat, trousers and waistcoat, white shirt and bow-tie.[32] Soutine was clearly drawn to the formal qualities of this costume, as worn by the present sitter. He depicts the waiter striking a bold pose with hands plunged into his pockets and takes care to delineate the folds and cut of his jacket with strokes of vibrant red. Soutine accentuates the outline of the man's form, sometimes by leaving a reserve and sometimes by overpainting the black of his uniform with the background colours.

Soutine produced a number of paintings of sitters in similar attire, including *The Best Man* (fig. 47). Although rendered in much looser brushstrokes, the man's formal three-piece suit, with its high waistcoat and white bow tie, is clearly discernible. Long identified as a *garçon d'honneur* (a best man or groomsman), he is more likely to be a waiter in a fine hotel or fashionable restaurant. The bold placement of his prominent sprawling hands firmly set on his knees has drawn comparisons with Jean-Auguste-Dominique Ingres's famous *Portrait of Louis-François Bertin* (1832; Musée du Louvre, Paris). A frequent visitor to the Louvre, Soutine often saw his sitters through the lens of the old master and more recent paintings that he particularly admired. This was an important part of his painting process and these layers of visual resonance impart a great richness to his work. Soutine emulated the qualities of solidity and monumentality found in Ingres's *Louis-François Bertin* not only in *The Best Man* but also in the present *Room Service Waiter*. Ingres's masterful use of a limited palette – Monsieur Bertin's bright face and tentacular fingers offering a striking contrast to his dark suit and the plain background – echoed Soutine's interest in monochromatic uniforms.

This sitter has traditionally been identified as a room service waiter, who tended to guests dining in

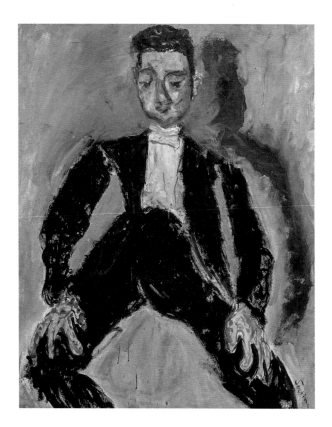

47

CHAÏM SOUTINE
The Best Man (Le Garçon d'honneur), c. 1924–25
Oil on canvas, 100 x 81 cm
Musée de l'Orangerie, Paris

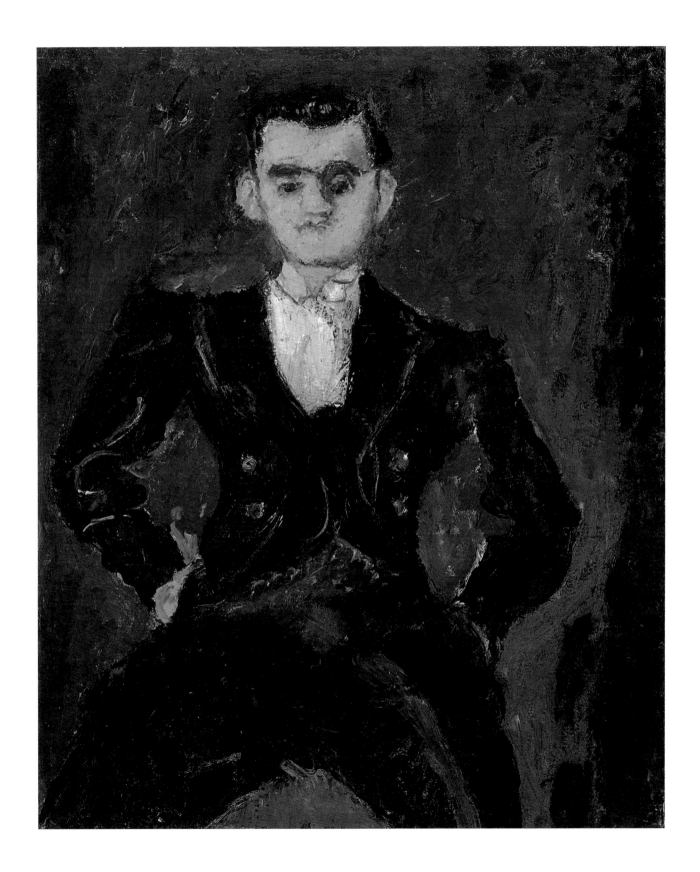

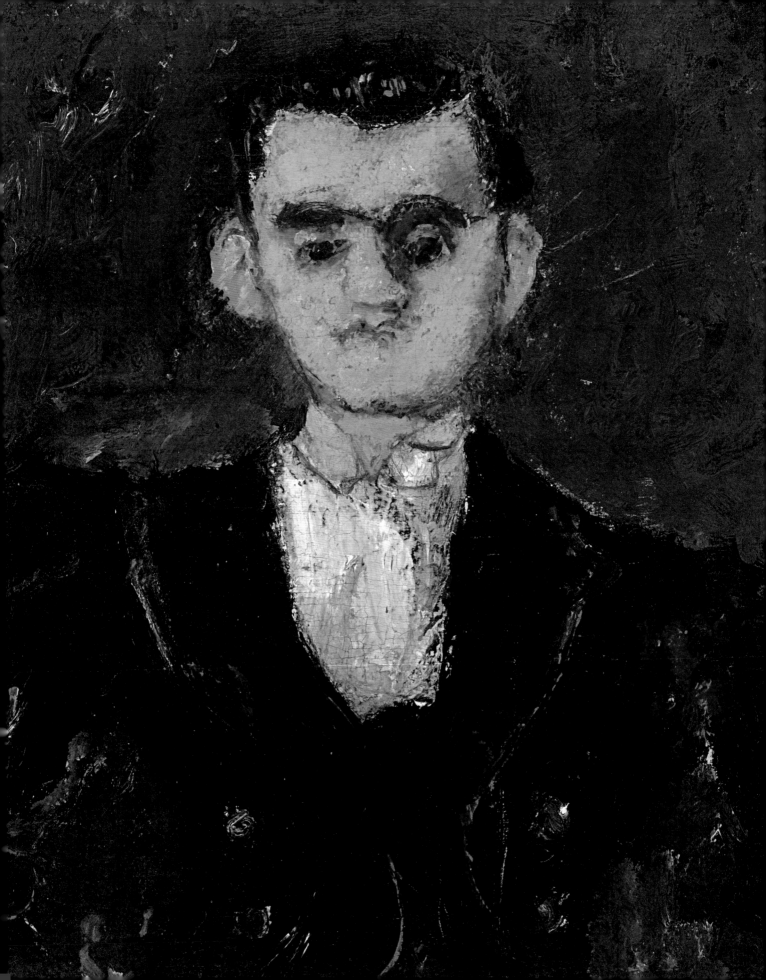

their private suites and was often drawn from among the best employees of the hotel restaurant.[33] In *Down and Out in Paris and London,* George Orwell described his own experience assisting a *garçon d'étage*:

> … by far my best time at the hotel was when I went to help the waiter on the fourth floor. We worked in a small pantry which communicated with the *cafeterie* by service lifts …. Valenti, the waiter, was a decent sort … a comely youth, aged twenty-four but looking eighteen, and, like most waiters, he carried himself well and knew how to wear his clothes. With his black tail-coat and white tie, fresh face and sleek brown hair, he looked just like an Eton boy; yet he had earned his living since he was twelve, and worked his way up literally from the gutter.[34]

Sadly, we know very little about Soutine's own experiences of hotel life and how he met the sitters in uniform that were such an important element of his art. Like Orwell's waiter, Soutine himself had worked his way up almost from the gutter. When this portrait was painted, Soutine had been a wealthy man for only a short time, achieving financial success after years as a penniless artist. The rising demand for his paintings amongst collectors meant that he was now able to dine in fine restaurants and stay in grand hotels. Soutine would have witnessed the army of service staff that were one of the defining characteristics of these establishments, although he probably painted most of his sitters in his studio rather than in their places of work. This portrait series thus charts, in some ways, Soutine's encounters with hotel and restaurant staff over more than a decade, from young cooks in the family-run hotels he stayed in as a struggling artist in the late 1910s and early 1920s to the bellboys and smart waiters (such as the present sitter) of the grander hotels he was able to frequent later on.

KS/BW

17

THE PAGE BOY c. 1928
also known as *The Groom*
(*Le Chasseur*)

Oil on canvas, 65.1 x 50.2 cm
Private collection

While *Room Service Waiter* (cat. 16) offered a glimpse of starched white beneath the black evening suit, this painting is uncompromising in its darkness. It presents a particularly striking contrast between the young sitter's glowing face and his black uniform, set against a midnight blue background. The peculiarities of his features thus stand out to an even greater degree – the long, flat nose that divides his face; his full, round lips; the jet-black hair that echoes his costume. His face demonstrates Soutine's remarkable ability to model with pure colours, as single touches of light blue form a trail of highlights running from the right corner of his mouth to his nose and eyebrow on to his forehead. Red is also used to emphasise his ears, his brows and the outline of his face. Having broadly positioned his figure, Soutine must have left the central area in reserve as he built up his composition: the brown ground layer is still visible in areas that have not been fully covered, along, for example, the sides of the arms and the boy's hairline. However, Soutine's thoughtfulness and careful construction come through in the striking way he has manipulated the reserve to fashion the sitter's right eyebrow: he has left that area blank but, with a few highlights of colour, managed to evoke the light falling on it. Soutine also used the dark blue background colour to adjust the contour of the sitter's torso and revise the outline of his neck and right ear.

One senses that the sitter is a fashionable lad, with his hair parted on the side and a cowlick falling on his forehead. He poses hands in pockets, although that section of the composition is so difficult to read that only the glint of light on his left inner elbow tells us that his arms are bent. At the bottom of the canvas, forms seem to dissolve into a stormy sea of black and blue. This sullen pose is echoed by the sitter's inscrutable, slightly dour expression. His face could belong to any number of young types, from a rascal on the street to a schoolboy. However, his uniform brings his identity into closer focus. He wears black trousers and a matching, close-fitting jacket with a row of large buttons, whose metallic sheen is rendered with the quickest flicks of blue brushstrokes mixed with white. Visible underneath the jacket is a high white collar, cravat or neckerchief fastened with a tie at the front. The uniform could be that of a schoolboy but, given the rather formal tie and Soutine's interest in hotel workers, the sitter is more likely to belong to this series.

He has traditionally been identified as a *chasseur*, the rough equivalent of a page boy or bellboy in hotel service (see cat. 8 for a discussion of these terms). On the lowest rung of the hierarchy, page boys undertook a variety of tasks: among other duties, they helped with baggage and ran errands. At the Grand Hotel in Paris for example, twenty were active at any one time.[35] They ranged in age from fourteen to eighteen, although they could sometimes be as young as twelve, a characteristic suggested by this portrait. They earned the lowest salaries in the organisation but, in constant contact with guests and aided by their youth and dynamism, they were ideally placed to receive generous tips. The tasks of a page boy overlapped with those carried out by a bellboy; their identities and functions are often interchangeable, along with their uniforms, which could be alternately flamboyant red or, as here, sober black (see figs. 24 and 25).[36]

The same model recurs in another, albeit more closely cropped, portrait (cat. 18). KS

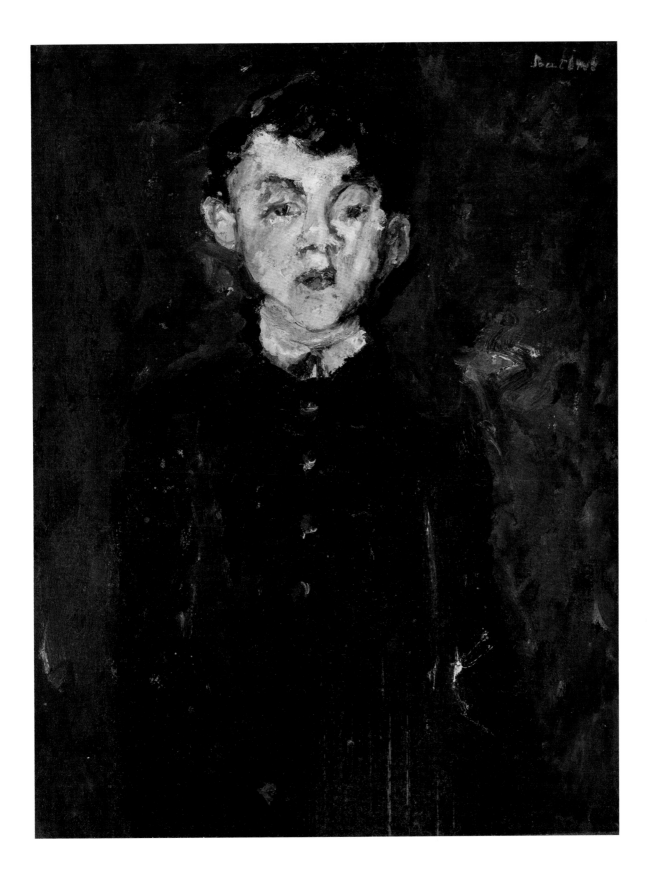

PORTRAIT OF A BOY c. 1928

Oil on canvas, 43.6 x 38.1 cm
Worcester Art Museum, Massachusetts

The sitter in this portrait appears in another, larger work by Soutine (cat. 17). Both paintings are on the same scale (indeed, the size of the two heads are strikingly similar) but this representation is more closely cropped, focusing on the young boy's face, his small, twisted mouth, his long chin and his nose, which flattens around the nostrils. His features, however, are treated with less precision than in the half-length portrait. The brushstrokes are wider and more fluid, the use of pure colour less precise and purposeful. Despite the difference in treatment, strikingly similar schemes recur in both works: we find the same touch of white and light blue to define the contour around the model's neck and right ear, the red hotspots on his left ear and the outside of his cheeks, the long blue brushstroke conjuring the space between his torso and left arm. The link with the larger painting clarifies the sitter's costume, which is otherwise difficult to distinguish here. He wears the same fitted black jacket with a row of buttons and the same high white collar as in the other portrait, indicating that he is once again represented in his page boy uniform. As with Soutine's repeated depiction of the auburn-haired sitter in a red and black jacket (cat. nos. 10–13), this return to a motif was part of the artist's process, as he sought to explore and exhaust all the possibilities of his subject.

Soutine, notoriously impetuous, sometimes slashed canvases that dissatisfied him (see cat. 12). In other cases, he carefully cut out particular sections to preserve areas of the composition that he liked (most often the face). It is possible that this portrait is one such example: tantalising is the fact that the paint surface continues over the fold of the stretcher and on to the tacking margin. This indicates that the painting has been reduced in size and then nailed through the paint layer on to a smaller stretcher. The signature on the lower left fits the corner perfectly and must date from after this restretching.[37] This portrait might therefore have originally been larger, although technical examination of the work remains inconclusive. KS

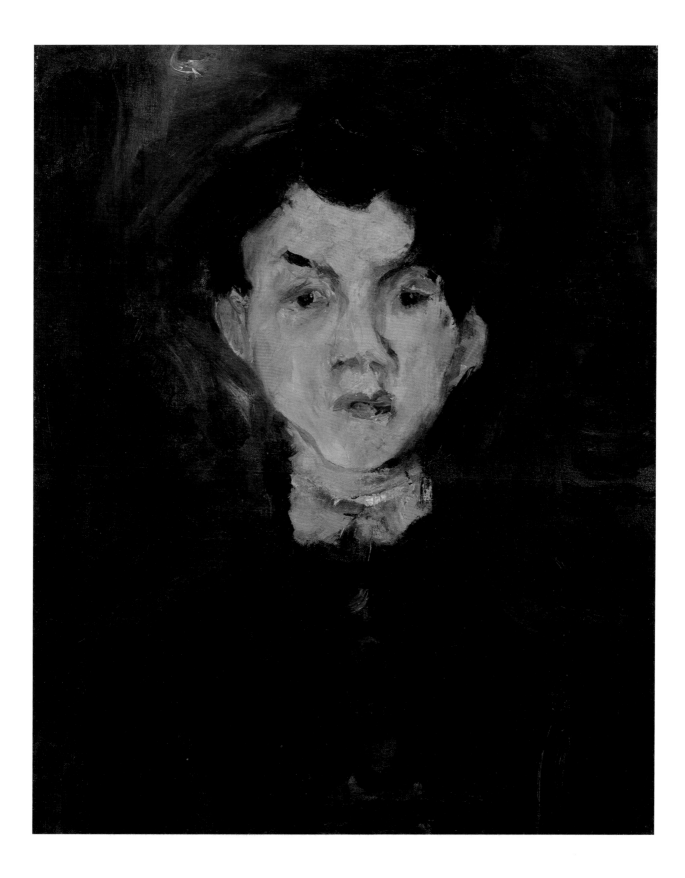

19

COOK WITH BLUE APRON c. 1930
(La Cuisinière en tablier bleu)

Oil on canvas, 128 x 50.5 cm
Im Obersteg Foundation, on long-term loan to Kunstmuseum Basel

This portrait of a female servant recalls the elongated composition adopted by Soutine for earlier, full-length representations of a pastry cook and a page boy (cat. nos. 2 and 9). Here, however, the format is narrowed to the point of constriction and the figure now seems hemmed in. The mood of the painting has also shifted dramatically. It is imbued with a strong sense of isolation; the figure appears removed and lonely. While she still gazes out at the viewer, she seems disengaged. Resignation and apathy dominate the representation.

The attire worn by Soutine's *Cook with Blue Apron* makes it likely that the sitter was drawn not from hotel life but from the sphere of domestic service.[38] Instead of donning a formal uniform, the cook has probably slipped the blue apron with a ruffled white border over her everyday clothes, a pink blouse with an open collar and a long black skirt, perhaps with red tights and matching shoes. This shift in interest from hotel employees to domestic servants mirrored changes in Soutine's life-style in the late 1920s and early 1930s. At that period, the painter was moving away from the hotels and restaurants he had once frequented and spending increasing amounts of time as a house guest in the country estates of wealthy supporters, including Élie Faure and Marcellin and Madeleine Castaing. There, he was able to set up a work space and is reported to have painted not only the local villagers but also the house servants.

One of the earliest accounts of Soutine painting a domestic servant was given by Zborowski's chauffeur, who recalled that, in the summer of 1928 or 1929, he drove Soutine to the Faures' country house, where Soutine "painted a chambermaid, with a red apron".[39] *Cook with Blue Apron* has sometimes been associated with a painting acquired in autumn 1930 by one of Soutine's neighbours in Paris, the painter Léonardo Bénatov. He purchased it for 10,000 francs at the behest of Soutine, who was then in financial difficulty. As reported by one of Soutine's biographers, "the cook's listless manner, her hands on her stomach, her dazed appearance, the quality of the blue of her apron, the delightfulness of the thick paint layered with skill and confidence immediately garnered the collector's admiration. You should have seen this piece when Soutine had just finished painting it, he [Bénatov] told me: the dark madder cheeks, painted with a palette knife, the bulging eyes (you felt able to touch them just by pressing on them). You know: Soutine was remarkably able to render physical likeness."[40]

Soutine is said to have painted this canvas during one of his earliest sojourns with the Castaings in the countryside south-west of Paris. Madeleine Castaing recalled how Soutine had enlisted their cook, Jeanne, into posing for him in a nearby stream for *Woman Entering the Water* (c. 1931; private collection).[41] She may also be the sitter for this portrait, wearing her working clothes. Jeanne is said to be the subject of three further portraits usually dated around 1935–36, *The Cook (Woman in Blue)* (Botero Museum, Bogotá); *French Cook* (private collection); and *Jeanne with Bread Basket* (private collection). However, any resemblance with *Cook with Blue Apron* is difficult to judge. KS

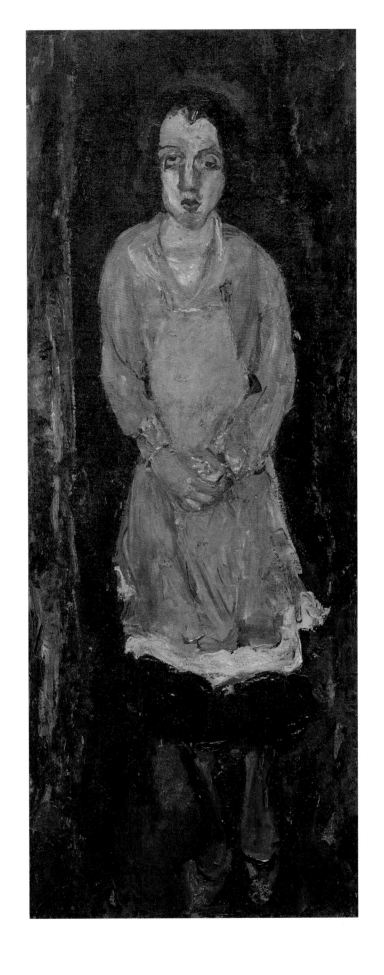

THE CHAMBERMAID c. 1930
(La Femme de chambre)

Oil on canvas, 110 x 34 cm
Kunstmuseum Lucerne

This portrait depicts the same sitter, wearing the same pink blouse, as in *Cook with Blue Apron* (cat. 19). Her features are recognisable – the long face, large eyes and protruding chin, as well as her short helmet of hair styled in the latest finger-wave fashion. She adopts the same strict standing pose, feet together and hands clasped across her waist. Her position at a slight angle gives the impression that she struggles to fit into the picture. Used to powerful effect, the narrow format chosen by Soutine accentuates the feeling of reserve conveyed by the young employee. In portraits from the early 1930s onwards, as noted by Tuchman, "timidity and passiveness replace the more animated or anguished expressions of earlier subjects Rarely do the later figures confront us directly. For the most part they do not gesticulate but stand or lie inertly, their hands at their sides or supporting the head. They are tired. Their eyes are veiled or downcast."[42] Indeed, the sitter's gesture, hands clasped over her apron, is the diametrical opposite of the assertive hands-on-hips pose adopted by the sitters of the previous decade.

Many features of this painting have more in common with the portraits of shop girls and servants painted by Soutine's close friend Amedeo Modigliani around 1916–18 (see fig. 13) than with Soutine's own earlier depictions of hotel employees. The set format adopted by Modigliani finds an echo in these later portraits by Soutine with their tight composition, slightly elevated viewpoints and suggestions of a setting (note the slanting floor here and the drapes on either side of the figure in *Cook with Blue Apron*). Modigliani suffused his portraits with subdued emotion. He represented his models as restrained and hushed, holding their arms across their waist. However, this melancholy spell does not quite translate in Soutine's work, as his palpable application of paint and the treatment of the sitter's features confer a power and self-consciousness absent from Modigliani's.

Despite her resemblance to *Cook with Blue Apron*, Soutine's subject has been identified not as a cook but as a chambermaid. This may stem from her clothing, which appears closer to a standard uniform: she wears the same shade from shoulder to knee and has traded the blue rustic apron for a smarter, more conventional white one. In daily contact with guests in both hotels and large houses, chambermaids were expected to wear an appropriate and pristine uniform (see fig. 26). They were responsible for keeping bedrooms, bathrooms and assorted linens immaculate, as well as cleaning and pressing the clothes of their employers and guests. The pink worn by this chambermaid, however, is an unconventional colour for a uniform and it is possible that the young woman wears her personal clothes underneath the white apron.

The portrait is one of four works from Soutine's series of uniformed workers to enter a public collection during the artist's lifetime.[43] It was donated to the Kunstmuseum Lucerne in 1937 by Walter Minnich (1864–1940), a German-born doctor who had settled in Switzerland in the early twentieth century. Minnich was a passionate advocate of the arts and a lifelong supporter of the German Expressionist painter Max Pechstein.[44] Over three decades, he assembled an extensive collection of contemporary art. Upon retiring and moving to Italy, he tasked his daughter Alice with overseeing the donation of a selection of his paintings to the museum, including this work by Soutine. KS

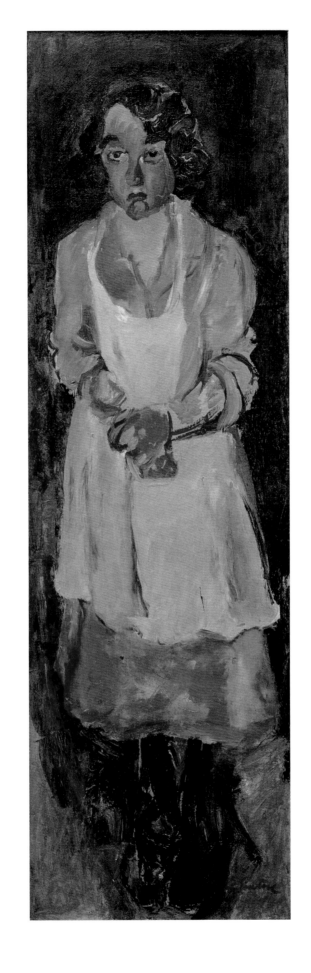

WAITING MAID c. 1933
(*La Jeune Servante,* also known as *La Soubrette*)

Oil on canvas, 46.5 x 40.5 cm
Ben Uri, London

In the early 1930s, Soutine painted at least seven portraits of female servants in aprons, the last group in his decade-long exploration of service staff in uniform. This representation is usually dated a few years later than *Cook with Blue Apron* and *The Chambermaid* (cat. nos. 19 and 20) and shares their reserved and subdued character. The young woman is depicted with downcast eyes, her hands tucked under her apron. In a departure from the neutral background against which he set his male hotel workers, Soutine has introduced slight variations of form and colour behind his figures, hinting at a setting.

In the late 1920s, Soutine shifted his attention from hotel workers in their bold and codified uniforms to domestic employees, who operated in a less hierarchical environment. However, a number of elements in this portrait set the sitter in a more formal milieu than the two earlier representations of female servants. Her hair pulled back, the young woman wears a sober black outfit with a contrasting white collar. Her apron, with its thick straps and small bib, appears more decorative than practical. It is an integral part of the uniform, in contrast to the one worn by the cook and chambermaid over their everyday clothes. This sitter's more refined uniform indicates that she could be a chambermaid in a hotel or a personal attendant (a 'waiting maid') at the service of a wealthy employer who valued decorum. Early titles have cast her as a 'young servant' and a 'soubrette'. Used principally in theatre and opera to designate a mischievous or flirtatious servant, the latter term demonstrates the extent to which the reception of Soutine's portraits of uniformed workers has been influenced by popular culture and entertainment of the period (see the discussion in the present author's essay above).

Waiting Maid is one of only two portraits by Soutine in British public collections. The other is *Young Woman in a White Blouse*, c. 1923, in The Courtauld Gallery. KS

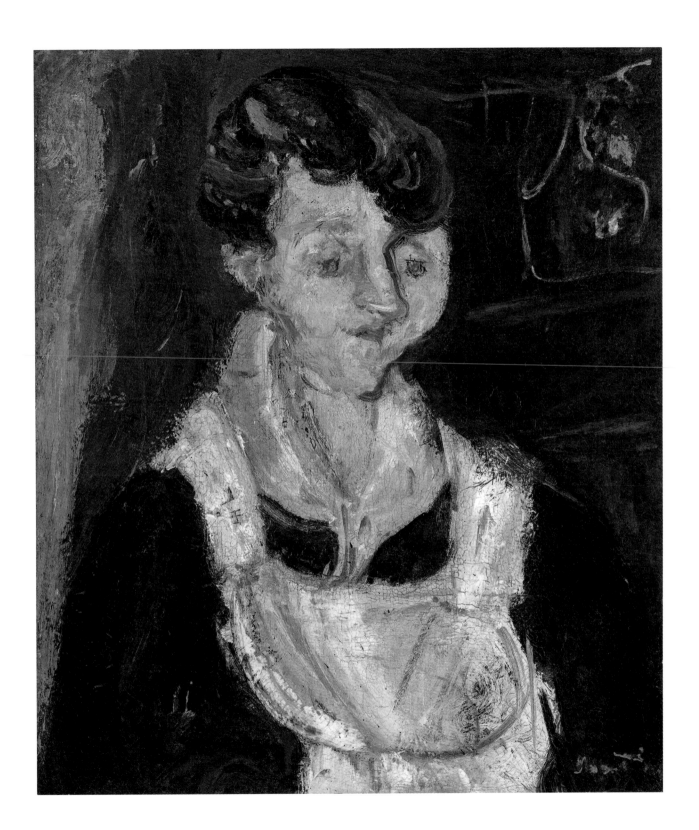

1 See the essay by Karen Serres above.

2 *Chaim Soutine, The Passion of Painting*, in cooperation with Maurice Tuchman and Esti Dunow, exh. cat. Galerie Thomas, Munich, 2009, pp. 104–05; and Richard R. Brettell and C.D. Dickerson III eds., *From the Private Collections of Texas: European Art, Ancient to Modern*, exh. cat. Kimbell Art Museum, Fort Worth, 2009, pp. 396–99. It had previously been thought that the present canvas was originally purchased by Dr Albert Barnes along with *The Pastry Cook* (fig. 1) and later sold. However, it is now known that the title had been confused with Barnes's *Man in Blue* (perhaps hinting that there was early information to suggest the sitter was indeed the same in each painting). I am grateful to The Barnes Foundation for this clarification.

3 Quoted in Matamoros ed. 2000, pp. 44 and 46.

4 *Butcher Stall*, c. 1919, oil on canvas, 55 × 38 cm, private collection, reproduced in Tuchman and Dunow 2002, p. 147; and Restellini ed. 2007–08, no. 27, p. 93.

5 Quoted in Szittya 1955, pp. 107–08.

6 It has been tentatively suggested that this cook was the son of the owner of the Garetta Hotel in Céret: see Matamoros ed. 2000, p. 74.

7 'Portraits: Introduction', in Tuchman, Dunow and Perls 1993, II, pp. 509–13, at p. 509.

8 Soutine owned a reproduction of the Fouquet painting, as discussed in the essay by Barnaby Wright above.

9 The connection between Soutine's treatment of his sitters' uniforms and flesh is well made in Tuchman, Dunow and Perls 1993, II, p. 512.

10 Willem de Kooning quoted in Tuchman and Dunow 2002, p. 102.

11 For a discussion of Guillaume offering this work for sale, see Henriette Mentha, 'Karl Im Obersteg, an Early Collector of Chaïm Soutine', in Krebs, Mentha and Zimmer eds. 2008, pp. 99–114, at p. 110. A recent overview of the circumstances of Barnes's Soutine purchases is given in Kathryn Porter Aichele, 'Albert C. Barnes, Chaim Soutine, and the Art in Seeing', in Aichele 2016, pp. 37–68.

12 Tuchman, Dunow and Perls 1993, II, p. 510.

13 David Sylvester, 'Introduction', in Sylvester and Tuchman 1963, pp. 4–15, at p. 15.

14 John Yau and Rachel Stella, 'Madeleine Castaing Reminisces about Chaim Soutine', *Arts Magazine*, vol. 59, no. 4, December 1984, pp. 71–73, quoted in Krebs, Mentha and Zimmer eds. 2008, pp. 238–41, at p. 238.

15 A fourth portrait perhaps of the same sitter, *Pageboy*, 1926, oil on canvas, 66 × 52 cm, is reproduced in the catalogue *Chaim Soutine 1893–1943*, exh. cat. Marlborough Gallery, New York, 1973, no. 49, p. 65.

16 Réal and Graterolle 1929, pp. 324–25.

17 George 1928, p. 23.

18 The suggestion that his hand is extended for a tip is made in Castaing and Leymarie 1963, p. 26, and Werner 1977, p. 126.

19 Marevna 1972, pp. 195–97.

20 A fifth, smaller painting of this sitter, depicting only his head, appeared on the art market (*Valet de chambre*, 1927, oil on canvas, 46.4 × 33 cm, sold Christie's, London, 9 December 1998, lot 631).

21 Tuchman 1968, p. 36.

22 Courthion 1972, p. 94.

23 Castaing and Leymarie 1963, p. 8.

24 Marevna 1972, pp. 158–59.

25 A photograph of the x-ray is reproduced in a 2004 MA dissertation, which examined Soutine's paintings in the Musée de l'Orangerie from a technical standpoint: Maujean 2004. We are very grateful to Bruno Mottin and the Centre de recherche et de restauration des musées de France for allowing us to publish this image for the first time.

26 See Faure 1929, p. 6; Castaing and Leymarie 1963, pp. 10 and 28; Gimpel 1966, p. 310; Courthion 1972, pp. 78 and 80; Marevna 1972, p. 150; and Michaelis 1973, pp. 42 and 57. The scraping of his canvases is mentioned in a letter to Zborowski written in Cagnes in 1923: Richard ed. 2015, letter 5. In another, much later letter to Gerda Michaelis (Groth), he asks her to bring back to Paris several works, including "the torn paintings" (letter 32, dated 1939). The only published technical overview of Soutine's work was carried out by Ellen Pratt, 'Soutine Beneath the Surface. A Technical Study of his Painting', in Kleeblatt and Silver eds. 1998–99, pp. 118–35. See also Maujean 2004, II, for a useful compilation of sources. Other paintings in the hotel and restaurant portrait series that have been slashed and mended include *Bellboy* (cat. 8) and *Portrait of a Boy* (fig. 46).

27 Marevna 1972, p. 158.

28 Gimpel 1966, pp. 374–75. For a useful summary, see LeBrun-Franzaroli 2015, pp. 392–95.

29 Courthion 1972, pp. 78 and 99.

30 We are grateful to Nathalie Volle, Institut national d'histoire de l'art in Paris, for this information.

31 See the conservation file on the painting at the Centre de recherche et de restauration des musées de France and Maujean 2004, I, p. 46.

32 Williams-Mitchell 1982, p. 97.

33 Réal and Graterolle 1929, pp. 329–30.

34 Orwell 1933 (2001), p. 68.

35 Tessier 2012, p. 172.
36 The portrait has also sometimes been titled *The Groom*, which is a slightly misleading term. In English, it does not relate to hotel service but to a manservant or a person who works with horses. The title thus probably stems from a mistranslation of the French term *groom*, the general equivalent of a hotel page boy or bellboy.
37 We are grateful to Roxane Sperber for providing information on the canvas.
38 See Tuchman, Dunow and Perls 1993, II, p. 512.
39 Courthion 1972, p. 94.
40 Courthion 1972, p. 99.
41 Madeleine Castaing, 'Memories of Soutine', in Güse ed. 1981–82, pp. 15–16, at p. 16.
42 Maurice Tuchman, 'Chaim Soutine (1893–1943). Life and work', in Tuchman, Dunow and Perls 1993, I, pp. 13–26, at p. 24.
43 The other three entered American collections: *The Pastry Cook*, purchased by Barnes (fig. 1); *Page Boy at Maxim's* (cat. 9), acquired by the Albright-Knox Art Gallery in Buffalo in 1939; and *Little Pastry Cook* (cat. 2), purchased by the Portland Art Museum in 1940 (the latter two from the Bignou Gallery in New York).
44 Isabel Greschat and Christoph Lichtin eds., *Der Sammler Walter Minnich und das Kunstmuseum Luzern. Pechstein, Melzer, Soutine, Terechkovitch*, Heidelberg, 2006 (published to accompany the exhibition *Modell für ein Museum* at Kunstmuseum Lucerne, 2006–07).

BIBLIOGRAPHY

AICHELE 2016
Kathryn Porter Aichele, *Modern Art on Display. The Legacies of Six Collectors*, Newark, 2016

BARNES 1927
Albert C. Barnes, *The Art in Painting*, 2nd edn, London, 1927

BOOMER 1925
Lucius Messenger Boomer, *Hotel Management: Principles and Practice*, New York, 1925

CASTAING AND LEYMARIE 1963
Marcellin Castaing and Jean Leymarie, *Soutine*, Paris and Lausanne, 1963

CATALOGUE OF EXHIBITION OF FRENCH ART 1919
Catalogue of Exhibition of French Art, 1914–1919, Arnold Bennett (pref.), exh. cat. Mansard Gallery, London, August 1919

COLLIÉ 1944 (2002)
Andrée Collié, *Souvenirs sur Soutine*, Paris, 2002 (first published in *Le Spectateur des Arts*, December 1944)

COURTHION 1972
Pierre Courthion, *Soutine: peintre du déchirant*, Lausanne, 1972

DRIEU LA ROCHELLE 1930
Pierre Drieu La Rochelle, 'Soutine', *Formes. Revue internationale des arts plastiques*, no. 5, May 1930, pp. 4–5

FAURE 1929
Élie Faure, *Soutine*, Paris, 1929

FORGE 1965
Andrew Forge, *Soutine*, London, 1965

GAUTIER 1932
Marcel Gautier, *L'Hôtellerie. Étude théorique et pratique*, Paris, 1932

GEE 1978
Malcolm Gee, *Dealers, Critics and Collectors of Modern Painting: Aspects of the Parisian Art Market between 1910 and 1930*, 2 vols., PhD dissertation, The Courtauld Institute of Art, London, 1978

GEORGE 1926
Waldemar George, 'Soutine', *L'Amour de l'art*, vol. 7, no. 11, November 1926, pp. 367–70

GEORGE 1928
Waldemar George, *Soutine*, Paris, 1928

GEORGE 1929
Waldemar George, *La Grande Peinture contemporaine à la collection Paul Guillaume*, Paris, 1929

GIMPEL 1966
René Gimpel, *Diary of an Art Dealer*, London, 1966

GOLAN 1995
Romy Golan, *Modernity and Nostalgia: Art and Politics in France Between the Wars*, New Haven, 1995

GREEN 2001
Christopher Green, *Art in France, 1900–1940*, New Haven and London, 2001

GUILLAUME 1923
Paul Guillaume, 'Soutine', *Les Arts à Paris*, no. 7, January 1923, pp. 5–6

GÜSE ED. 1981–82
Ernst-Gerhard Güse, ed., *Chaim Soutine 1893–1943*, exh. cat. Westfälisches Landesmuseum für Kunst und Kulturgeschichte, Münster; Kunsthalle Tübingen; Hayward Gallery, London; and Kunstmuseum Lucerne (organised by The Arts Council of Great Britain), 1981–82

HOLTEN ED. 2014
Johan Holten, ed., *Room Service. On the Hotel in the Arts and Artists in the Hotel*, exh. cat. Staatliche Kunsthalle Baden-Baden, 2014

KLEEBLATT AND SILVER EDS. 1998–99
Norman L. Kleeblatt and Kenneth E. Silver, eds., *An Expressionist in Paris. The Paintings of Chaim Soutine*, exh. cat. The Jewish Museum, New York; Los Angeles County Museum of Art; and Cincinnati Art Museum, 1998–99

KREBS, MENTHA AND ZIMMER EDS. 2008
Sophie Krebs, Henriette Mentha and Nina Zimmer, eds., *Soutine and Modernism*, exh. cat. Kunstmuseum Basel, 2008

LEBRUN-FRANZAROLI 2015
Michel LeBrun-Franzaroli, *Soutine, l'homme et le peintre*, 2nd edn, Concremiers, 2015

LÉOSPO 1918
Louis Léospo, *Traité d'industrie hôtelière. Cours théorique et pratique*, Paris, 1918

LÉRI AND LAFARGUE EDS. 1998–99
Jean-Marc Léri and Jacqueline Lafargue, eds., *Du Palais au palace: des grands hôtels de voyageurs à Paris au XIX^e siècle*, exh. cat. Musée Carnavalet, Paris, 1998–99

LESUR 2005
Jean-Marc Lesur, *Les Hôtels de Paris: de l'auberge au palace, XIX^e-XX^e siècles*, Neuchâtel, 2005

LEYMARIE ED. 1973
Jean Leymarie, ed., *Soutine*, exh. cat. Orangerie des Tuileries, Paris, 1973

MAINGON 2016
Claire Maingon, *Le Musée invisible. Le Louvre et la Grande Guerre (1914–1921)*, Mont-Saint-Aignan (Presses universitaires de Rouen et du Havre) and Paris, 2016

MAREVNA 1972
Marevna, *Life with the Painters of La Ruche*, London, 1972

MATAMOROS ED. 2000
Joséphine Matamoros, ed., *Soutine. Céret 1919-1922*, exh. cat. Musée d'art moderne de Céret, 2000

MAUJEAN 2004
Camille Maujean, *La Technique et la pratique picturale de Soutine à travers l'étude des œuvres, des sources, des témoignages contemporains et de la bibliographie, dans le cadre de la campagne de réaménagement de l'Orangerie*, Mémoire de muséologie (MA dissertation), École du Louvre, Paris, 2004

MICHAELIS 1973
Gerda Michaelis (called Garde), *Mes années avec Soutine : souvenirs présentés par Jacques Suffel*, Paris, 1973

ORWELL 1933 (2001)
George Orwell, *Down and Out in Paris and London*, London, 1933 (edn used London, 2001)

PAGÉ, ANDRAL AND KREBS EDS. 2000–01
Suzanne Pagé, Jean-Louis Andral and Sophie Krebs, eds., *L'École de Paris, 1904–1929: la part de l'Autre*, exh. cat. Musée d'art moderne de la ville de Paris, 2000–01

RÉAL AND GRATEROLLE 1929
Claude Réal and P. Graterolle, *L'Industrie hôtelière*, Paris, 1929

RESTELLINI ED. 2007–08
Marc Restellini, ed., *Soutine*, exh. cat. Pinacothèque de Paris, 2007–08

RICHARD ED. 2015
Pierre E. Richard, ed., *Soutine. Lettres et billets*, self-published, 2015

ROMAN 1939
José Roman, *Mes souvenirs de chasseur chez Maxim's*, Paris, 1939

ROTH 1929–30 (2015)
Joseph Roth, *The Hotel Years. Wanderings in Europe between the Wars*, ed. Michael Hofmann, London, 2015 (first published as essays in *Frankfurter Zeitung*, 1929–30)

SILVER AND GOLAN EDS. 1985
Kenneth E. Silver and Romy Golan, eds., *The Circle of Montparnasse: Jewish Artists in Paris, 1905–1945*, exh. cat. The Jewish Museum, New York, 1985

SILVER 1992
Kenneth E. Silver, *Esprit de Corps. The Art of the Parisian Avant-Garde and the First World War, 1914–1925*, Princeton, 1992

STONE 1970
Peter Stone, 'Soutine at Céret', *Art and Artists*, vol. 5, no. 1, April 1970, pp. 54–57

SYLVESTER AND TUCHMAN 1963
David Sylvester and Maurice Tuchman, *Chaim Soutine 1893–1943*, exh. cat. Tate Gallery, London (organised by The Arts Council of Great Britain), 1963

SZITTYA 1955
Émile Szittya, *Soutine et son temps*, Paris, 1955

TESSIER 2012
Alexandre Tessier, *Le Grand Hôtel: l'invention du luxe hôtelier, 1862–1972*, Tours (Presses universitaires de Rennes), 2012

TUCHMAN 1968
Maurice Tuchman, *Chaim Soutine, 1893–1943*, exh. cat. Los Angeles County Museum of Art, 1968

TUCHMAN, DUNOW AND PERLS 1993
Maurice Tuchman, Esti Dunow and
Klaus Perls, *Chaim Soutine (1893–1943).
Catalogue raisonné*, 2 vols., Cologne,
1993

TUCHMAN AND DUNOW 2002
Maurice Tuchman and Esti Dunow, *The
Impact of Chaim Soutine (1893–1943): de
Kooning, Pollock, Dubuffet, Bacon*, exh.
cat. Galerie Gmurzynska, Cologne, 2002

VIAL AND BERNARDI EDS. 2012–13
Marie-Paule Vial and Claire Bernardi,
eds., *Chaïm Soutine (1893–1943),
l'ordre du chaos*, exh. cat. Musée de
l'Orangerie, Paris, 2012–13

WARNOD 1988
Jeanine Warnod, *Les Artistes de
Montparnasse. La Ruche*, Paris, 1988

WATERFIELD AND FRENCH 2003
Giles Waterfield and Anne French,
*Below Stairs. 400 Years of Servants'
Portraits*, exh. cat. National Portrait
Gallery, London, 2003

WERNER 1977
Alfred Werner, *Chaim Soutine*, New
York, 1977

WHEELER 1950–51
Monroe Wheeler, *Soutine*, exh. cat.
Museum of Modern Art, New York,
and Cleveland Museum of Art, 1950–51

WILLIAMS-MITCHELL 1982
Christobel Williams-Mitchell, *Dressed
for the Job. The Story of Occupational
Costume*, New York, 1982

PHOTOGRAPHIC CREDITS